PULLING
YOUR PAINTINGS
TOGETHER

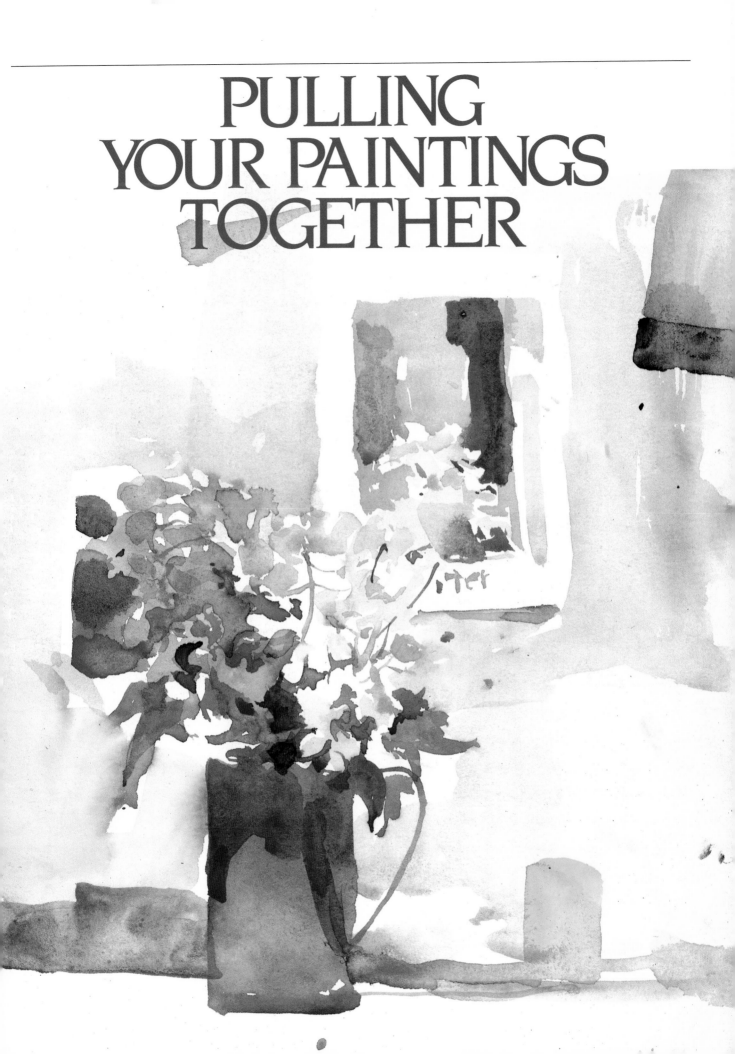

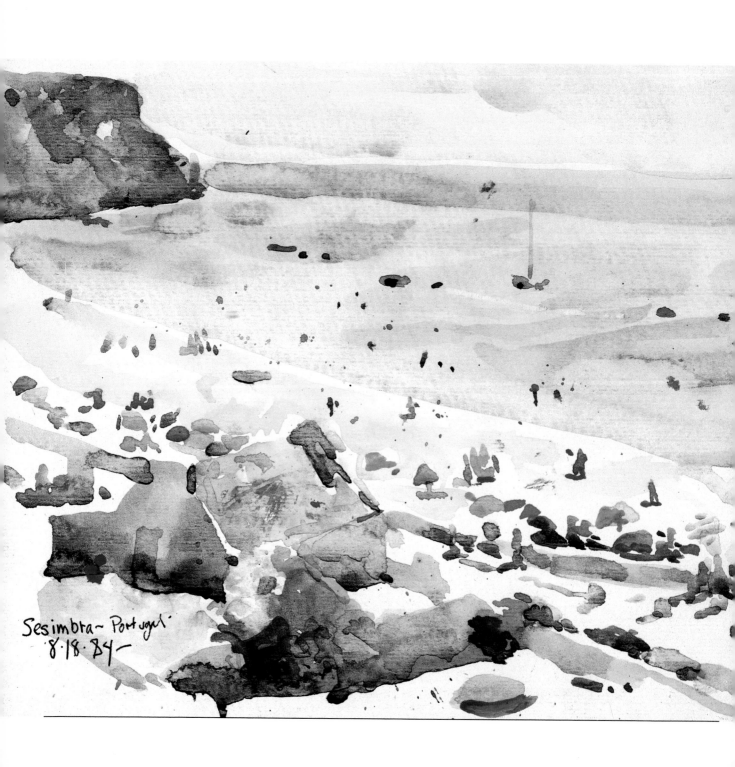

Sesimbra ~ Portugal
8·18·84 —

PULLING
YOUR PAINTINGS
TOGETHER

by Charles Reid

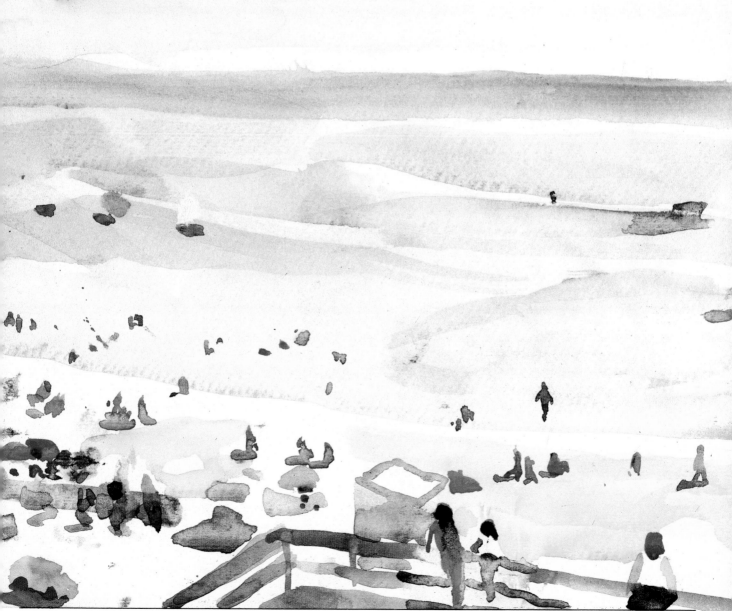

WATSON-GUPTILL PUBLICATIONS/NEW YORK

This book is for all who love to paint.

To my editor
Bonnie Silverstein
who totally understands
what I want to say.

First published in 1985 in New York by Watson-Guptill Publications,
a division of Billboard Publications, Inc.,
1515 Broadway, New York, N.Y. 10036

Library of Congress Cataloging-in-Publication Data

Reid, Charles, 1937–
 Pulling your paintings together.

 Includes index.
 1. Painting—Technique. 2. Watercolor painting—
Technique. I. Title.
ND1500.R385 1985 751.4 85-11107
ISBN 0-8230-4447-5

Distributed in the United Kingdom by Phaidon Press, Ltd.,
Littlegate House, St. Ebbe's St., Oxford

Manufactured in Japan

2 3 4 5 6 7 8 9 10 / 90 89 88

Concept and structure by Bonnie Silverstein
Edited by Candace Raney
Design by Bob Fillie
Graphic production by Ellen Greene

Note: Most of the paintings and drawings in this book were taken from
my sketchbooks, all of which are standard sketchbook sizes:
5½″ × 8½″, 8″ × 10″, 10″ × 12″, 8½″ × 10½″, and 9½″ × 12½″. Unless
otherwise indicated, all works come from the sketchbooks and only
the title of the work is given. Those works where medium, support, and
dimensions are given are considered finished paintings.

Thoughts on Becoming an Artist

I've been painting since I was twelve, when my father brought home a book on how to draw horses along with some illustrations by Frederic Remington. My father was right. Children aren't interested in "Art." They just want to draw and paint things that interest them. Here are some "artistic" signs to look for in your child: Does your child draw on assignment papers and work sheets? Is your child accused of daydreaming? These aren't necessarily signs that there's a great artist in the family, but they aren't grounds for annoyance either. My parents never scolded me for daydreaming or for illustrating my homework. In fact, they said very little. Yet my father always left pencils, crayons, and paper in my room to encourage me.

[NOTE: This photo, "Whiskey and Me," was taken by a very talented photographer, Brian Lanker. He does work for *LIFE* and *Sports Illustrated*. Whiskey is a special friend who deserves a spot in the book.]

CONTENTS

This is a book about making connections: interweaving lines, shapes, colors, moving backgrounds into foregrounds, positive shapes into negative ones, lost edges into found boundaries—all with the intention to create a painting or drawing that is a harmonious unit, with all the elements subordinated to the effect of the whole.

The medium is unimportant. Watercolor, oil, pen-and-ink, charcoal—all are here, each with its own set of rules and techniques. Yet each is surprisingly unfixed in its treatment. Oil can be handled like watercolor, charcoal like oil, pen lines can be smudged and softened, solid boundaries left broken and open. Because even between media there are relationships, interconnections. All is woven together, one into the other, media, treatments, brushstrokes—like the golden threads of a giant tapestry.

Like a magician, with brush or pen as his wand, with the flick of a brush you can open or close a line, move in or out of an area, relate one section to another, shift the emphasis of a composition to redirect the eye.

With the shift of a single color you can return a passage to the quiet depths of the painting, or force it out into the spotlight. Like some little god, in control of your own painted world, you are master of your vision.

The lessons of this book appear to be many, yet they all boil down to three—three ways of seeing, of integrating a drawing or painting:

1. Through contour or shape, to emphasize a flat pattern or a linear quality.

2. Through rhythm or gesture, to capture the spirit or essence of your subject.

3. Through broad masses of colors and values, using a lost-and-found quality to characterize your subject.

Yet even here the methods merge. A strong light may force heavy contrast in one section and softer colors in another. Characterization may cause certain features to predominate and others to be downplayed. The broad, abstract lines of a scene may force certain details to be lost. Even in these examples, the boundaries are not fixed. Defining them is only a tool to help you learn.

Many students assume they know what they're drawing without really seeing the subject. But they are really drawing from their heads, putting down what they think is there rather than trying to understand what is actually on the model stand. For example, I often find students are drawing their own faces rather than the model's.

What we all need is a *tabula rasa*, a Latin term meaning "blank state" or "smooth tablet"—hence, the mind before receiving impressions. In other words, when you start to draw, you must draw as if you've never seen or experienced anything before the moment you first see your subject. You should literally be seeing for the first time.

In this section, I will describe three different ways of seeing, each a valid perception of reality, each with its own purpose. It is impossible to see all three ways at once. Yet with practice and concentration, you will begin to sense when to emphasize one way of seeing over another, according to the needs of the situation. The lessons—shown in terms of drawing—apply to painting as well.

CONTOUR DRAWING

When I begin to draw, my mind is completely blank. I'm not aware of how I'm going to go about a drawing—or even conscious that I can draw at all. Of course, because I've been drawing for years, certain technical problems are taken care of, which makes my job a lot easier. Still, I try not to resort to tricks or all-purpose solutions. I want each subject to be a new adventure. And that's where contour drawing comes in.

When you do a contour drawing, you must think of your pen or pencil as being on the model, not the paper. You must concentrate totally on the model. The drawing itself, good or bad, doesn't matter. This doesn't mean that you're slashing about with your pencil. On the contrary, you're working slowly, with great care, totally absorbed in your subject. For once this communion is gone, you will never have more than a passable drawing.

Contour drawing is a constant process of drawing a bit of the outside shape (figure boundaries), then zipping into an inside form (features, hair, folds of drapery). For example, I left the model's right elbow unfinished and went off to show some dress folds instead.

In contour drawing, it's also important to attach the subject to background shapes without explaining all the subject's boundaries. For example, I deliberately left out the model's left shoulder to avoid a common fault—the "showing everything" syndrome. Most students want to dot every "i" and cross every "t"—but a good drawing, like any piece of good art, should *suggest*. Learn to leave things out. In art, you're not required to tell everything!

In contour drawing, shape is everything—not necessarily accurate shapes, but interesting and expressive ones. Notice the woman's left upper arm. Can you see how many small directional changes I made instead of drawing two parallel lines? I also exaggerated the curve in the front of her right lower leg.

Along with large, simple, and empty places, a contour drawing should also have some clutter and small details. I've shown some hair texture and features here (eyes, nose, mouth), but I didn't put in any expression lines, though they were there. You must be selective.

And don't worry about the proportions. It's literally impossible to get them completely correct. Here, I've made her head a bit small, her right shoulder too broad, and her lower right leg too short. We've been taught to strive for accuracy, and this can drive some people crazy. But unfortunately, accuracy doesn't make good art!

A Note on Pens: Most of the line drawings in this book were done with a Pelikan brand fountain pen (extra-fine point). Unfortunately, that pen is no longer available. I found the LAMY Safari fountain pen an adequate substitute, although it's not quite as flexible as the Pelikan. There are also many excellent fine-tip, felt-tip pens on the market that are fun to draw with.

I normally use a water-soluble ink with my pens, since I often use my finger with a little water or saliva to create tonal areas in my drawings. Naturally, if you're planning to use color washes over your drawing, you'll need waterproof ink or the ink will bleed through the color.

RHYTHM OR RELATIONSHIP DRAWING

In contour drawing, we finish one section at a time, moving gradually across the surface of the paper, relating every new area to what has already been stated. But in rhythm drawing, just the opposite occurs. Here we try to capture the essential nature of a pose, the gesture or movement, the action, the longest line. Individual shapes are not important. With the sweep of a line we join one shape to another. We see broadly, sensing the pose as a whole, seeing the way separate elements merge into specific directions. Instead of relating one element to its neighbor in a linear process, we sense the unity of areas in distant parts of the figure.

Look at the shoulder line. It starts at the model's right sleeve, picks up her left shoulder, continues down her left arm, finds the unseen leg, then moves down to the foot. This one line sets the pose. It shows the slant of the shoulder as well as the position of the arm and leg. And there are other relationships, too. The hairline along the left side of the face continues into the neck. The outside boundary of the hair goes into the chin.

In rhythm drawing, you begin with the first long sweeping lines that set the pose and relate the forms. Then you gradually modify them as you build more specific forms and shapes, as in the shoulders and right leg. Don't erase the first relationship line. Put the smaller shapes on top of it, and then erase it if you wish. There's a strong case for leaving these lines, however, and we'll be discussing this later. For now, let me point out that Edgar Degas, a master draftsman, would build each succeeding correction line on previous ones without erasing them.

DRAWING WITH MASS
(positive and negative shapes)

In many situations we are forced to see in terms of masses rather than lines. An obvious example would be when trying to draw in a darkened bar, one of my favorite drawing spots. Straining in the darkness, trying to see boundaries, features, and clothing details, all you can see are silhouettes and shapes. The same situation also occurs in strong sunlight, the opposite effect, yet essentially the same. Blinking in the bright light, all I see are shadow shapes, dark against light. In both cases, line seems less important than mass. Later in the book when we talk about color, you'll see how light and shade merge with color-value in many paintings.

SHAPES AND CONTOURS

Good shapes make good drawings. A good shape has variety —it has angles, straight lines, and curves. It is never symmetrical in its description of a form, and it is fluid and graceful. Looking at the two diagrams, it's probably obvious which shapes are more interesting.

SKETCH 1

Why does the first sketch look so boring? For one thing, look at the repetitious shapes there. If you were to cut the female figure in half, both halves would almost match. Notice that there are no indications of small forms, the little ins and outs and smaller shapes. Both figures are generalizations. The figures are symmetrical—but nature is rarely symmetrical.

SKETCH 2

Now look at this sketch. No shape is repeated on the opposite side of the silhouette. When one side is straight, its neighbor is crooked. Notice the many changes of direction my pen took. The silhouettes are a series of long, medium, and short "jogs," trying to find that eloquent shape that would give the drawing life.

ASSIGNMENT

Study Sketch 2, then find a photograph with obvious outside shapes. You are going to pretend that your pen or pencil is on the photo rather than the drawing paper and let your pen copy each little directional change that's on the figure in the photo. Don't worry about proportions. Just concentrate on getting an interesting and expressive outside shape.

Getting Good Inside Shapes

We've seen how important outside contours are for expressing the form of the figure, but inside contours are equally important. In this exercise I'm going to look for interesting shapes within the figure. I started in the left eye of the female figure. Strictly speaking, I shouldn't have worked down the nose since it's an outside shape, but don't worry if you include some outside contours. It doesn't matter. . . . (You'll see I also wandered to the outside in the male figure's jodhpurs.) Remember to keep your pen or pencil on the paper as much as possible. Don't erase, and don't worry if you make mistakes. We're not trying to make a "correct" drawing. Rather, we're trying to make an *expressive* drawing.

I think you can see the path my pen followed, but I could have taken several different routes, so don't worry if you get confused. There is no one "correct" path. If there is a rule, it would be to complete the work on the face before going on to the rest of the figure. I suggest this since the completed face will be our guide to approximate proportions. Don't worry too much about proportions, you can see mine aren't correct. Finally you'll see that my line is continuous for the most part. It wanders from one form to another, often not completing a thought. And places I pick up my pen when there's no place to go. (We see this in the woman's face.) Do try to keep your pen or pencil "anchored" to the paper as much as possible, though.

ASSIGNMENT

Find a photograph with *diffused* light—one with little or no light and shade pattern. Now follow the procedure I've outlined. Avoid drawing outside contours. Just keep your pen on the paper as much as possible, and concentrate on the shape. Show small details in some places (where you want people to look) and leave them out in others. You have to strike a balance. If you put in too many details, your drawing will look jumbled and confused. If you leave out too much, your drawing will look boring.

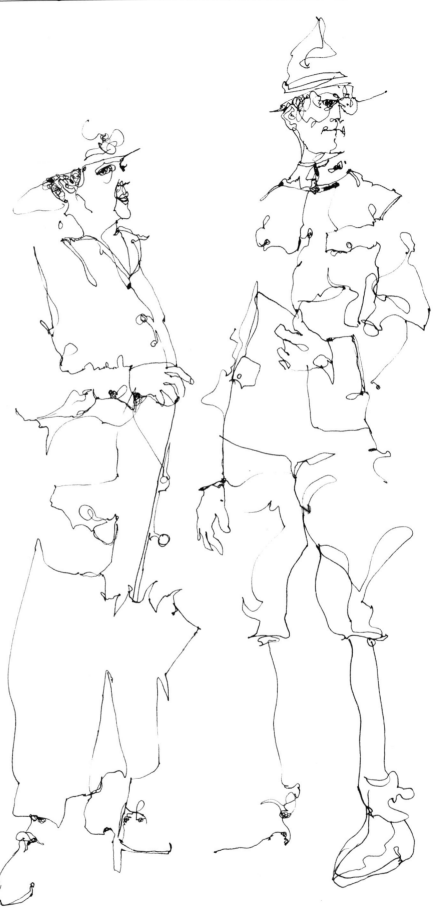

Combining Inside and Outside Shapes

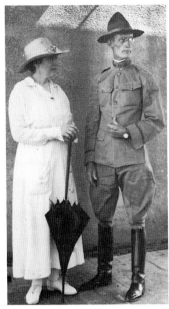

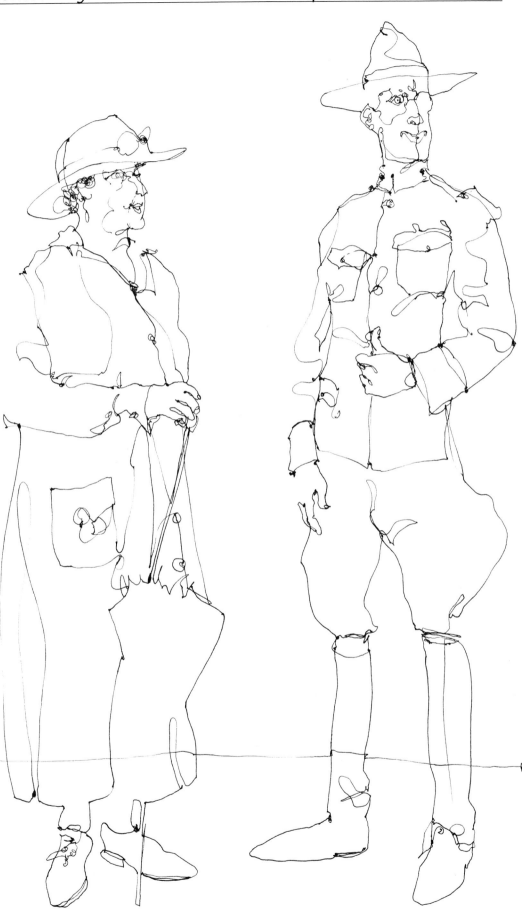

In this final project of this series, I want you to combine outside and inside shapes in one drawing. It's important that you see that my line goes back and forth from outside shape into inside shape, then back to outside shape. Notice how different this drawing is from the one I did for "inside shapes." Obviously, this one has some outside boundaries. But more than that, notice that the pen has followed different paths in many places. The point is that in each drawing you'll connect forms in different places and you'll leave out other forms. There are no rules as to what lines should be where. This approach to drawing should be a creative experience. It should also be fun. So if your figures look a bit silly, like mine, that's all to the good.

ASSIGNMENT

Try several versions of the same subject. Don't worry about making mistakes; it's inevitable. Just keep going and finish the drawing. Then put it aside and make another. Don't copy a previous drawing. Try to make each drawing a unique, individual experience.

BETTINO'S, MAUI

It's important to realize that drawing is based on the ability to see shapes. You must be able to determine their length and size. You must also understand angles. Learning to draw is a problem of geometry. Not the geometry of a mathematician, but the geometry of shapes, angles, and curves.

The approach in most of my sketchbook work is based on the idea of establishing a small but important area—an eye, nose, or eyeglasses—drawing it correctly, then using this established form as the basis for all of the angles and sizes of shapes to follow. To see how this works, let's look at the final drawing and my cutouts. My approach to contour drawing is much like the "dot-to-dots" we older folks used to do.

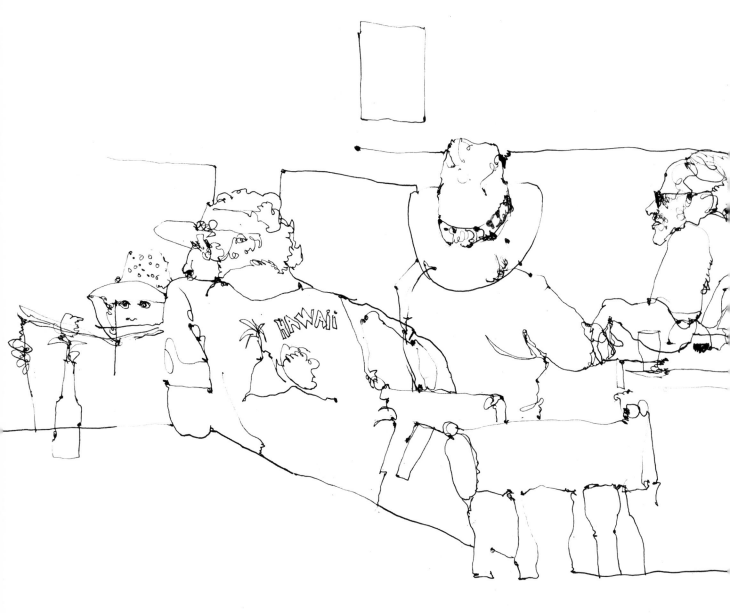

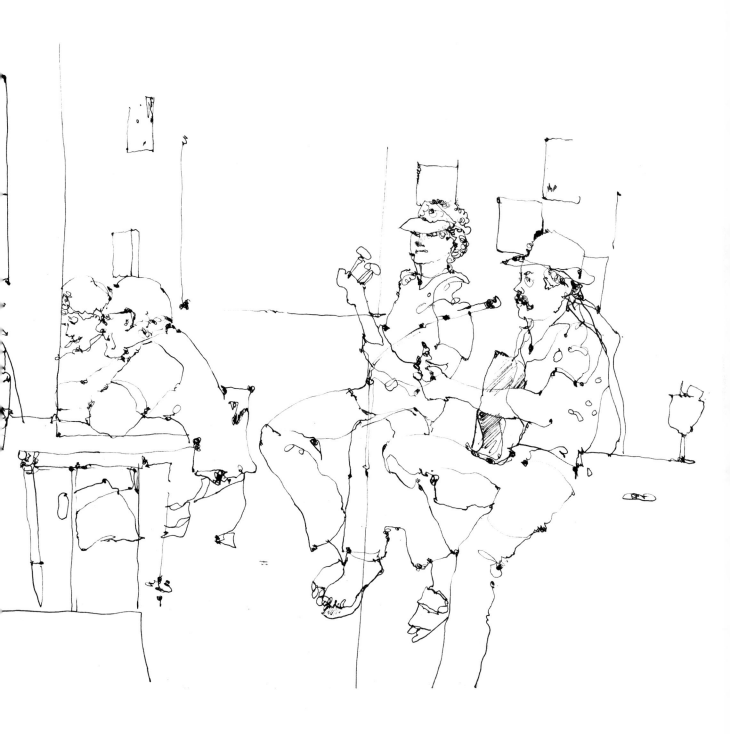

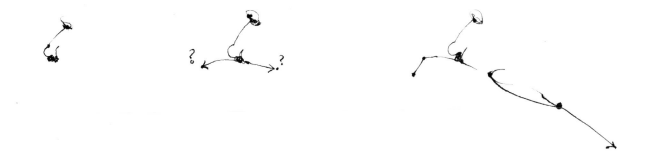

"MAN AT BAR" IN BETTINO'S MAUI

Step 1. My starting dot is the eye. Then I make a quick circle and return to this dot. Now I've established the eye socket. It's small but I've made my first definite form. Now geometry comes into the picture as I try to figure the angle of the nose in relation to the eye. I suppose it's about 33 degrees, but don't think in terms of numbers unless it helps. (Sometimes I suggest pointing the pencil at the model and pretending we're actually drawing the model's nose angle directly on the model rather than on the paper.) This model has a knob at the end of his nose. After deciding the angle of my line, I have to figure out how long a line to make until I get to the bulge of the tip. I check the size of the eye socket and decide the distance is a little more than two eye-socket lengths. Each time I come to a change in direction of the form I'm drawing, I stop my pen, which makes a dot. I don't lift the pen off the page if I can help it. It stays anchored to the paper. Then I make a quick curving line to form the bottom of the nose and moustache.

Step 2. Holding the pen on the paper, I see that the shoulder dissects the moustache. This is important because the shoulder line and its relationship to a feature on the head determines the action or gesture of the pose. We've now established two very important things: We have a definite nose shape, angle and size, and we're establishing the length and angle of the shoulder. If I'm sure about these, I can relate all future proportions to them. I ask myself: how far out to the tip of the shoulder? How far is it from the moustache to the neck? I look at what I already know, the nose length, and try to relate it. Is the distance from the moustache to the eye about the same as the distance between the moustache and the neck? Is it more or less? Don't worry about being absolutely "correct." The thing is to start relating and comparing one form to another.

Step 3. The second thing I have to know is the key to the figure's gesture. It's the relationship of the shoulder line to the face. I know that it butts up against the moustache, so I can't see the chin. But I have to find the angle of the shoulder line. Is it level and horizontal? No, it makes a nice, easy downward slope to the right. Now we've got the essence of the pose.

I'll just go through some more steps to show how I might have finished this figure. Remember, there are no rules about where to go next. It's whatever makes sense to you. The important thing to remember is that whatever direction you move in, whatever part you want to finish next, all must be compared and related to the part you've just completed. You're drawing from your drawing as well as drawing from the model.

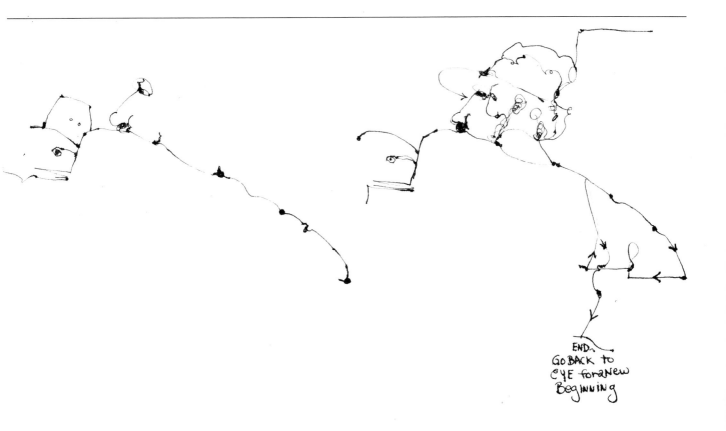

END.
GO BACK to
eYE foraNew
BegINNINg

"WESTERN HAT" IN BETTINO'S MAUI

Step 4. Now I place the figure next to our friend, relating her hat to a spot or "dot" on his arm. As I finish the shoulder line, I find convenient stop-and-check points. The first one curves around the collar line until it hits the right shoulder line. I've already found the distance between the moustache and the left end of the collar. Now I've got to find the distance to the right side of the collar. Compare my cutout with the drawing. (Remember, these "cutouts" are not an actual sequence. They're drawn individually so they don't match perfectly.)

Step 5. Now I complete the drawing. Working down the right arm, I come to the end of a thought. When this happens, I go back to my starting point, the eye. (Whenever you're stopped and can no longer go any further, always return to your starting point, your first dot.) Now compare this step with the actual drawing. Do you see the difference in gesture? I've tried to copy the original drawing, but certain relationships have changed in the transition. In my cutout, the man seems to be drawing back while in the original drawing he seems to be thrusting forward to his left. Compare the drawings and try to see what angles and relationships are different.

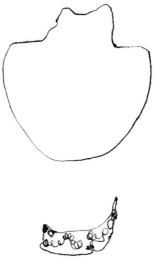

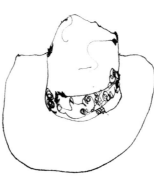

Naturally, every situation calls for different solutions. Let's try the back view of the western hat this time. There is no face, so where do we start? Most people think of starting with an outline shape, but I always suggest starting within the form. I feel that the outline is wrong for several reasons. The most obvious one is that it encourages the tendency to think of outlined, contained shapes that don't connect or relate to surrounding shapes. In this case, I think it's too hard to do the outline of the hat brim and then add the inside shapes. Let's try it both ways. First try copying the outline of the hat (Sketch 1), then start with the much more contained small form of the hat band (Sketch 2). When I started with the hat band, I seemed to be more in control; I had an established point of reference before striking out into that expanse of hat brim. But try it both ways and see which approach seems to work best for you.

One final note on *Bettino's, Maui*. Look at the last figure on the right. Can you see how many times I tried in getting the correct shoulder line?

Contouring: Another Example

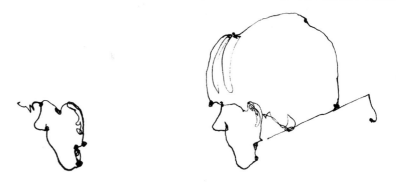

PETER READING

Remember, drawing is a problem of shapes, angles, and distances. It's also based on being able to see exactly where one line intersects another. I seem to always start with an eye. If I can't see it, I'd start with a nose in a near profile like this. Try an imposed situation like this, that would be impossible to draw out of your head.

Step 1. First establish your key area, the basis for the geometry of the drawing. I couldn't really see the eye here, but I could see a definite intersection where the hair meets the nose. Now I make a specific shape with definite proportions, a complete thought. Notice the dots where I stopped and checked.

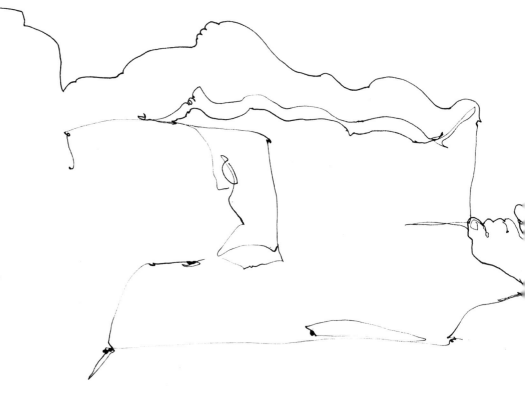

Step 2. From now on, I measure everything I draw in relation to the key area in Step 1. I see that there's about the same distance between the eye dot and chin as there is between the eye dot and top of head. Notice that in the original drawing I had to try several times to get this distance right.

Step 3. Once I have the head and collar decided, I base the rest of my decisions on this major premise. For example, I know that the leg intersects with the cheek. I check and see that the leg is about a head length (top of the chin to uppermost dot in the hair).

Step 4. I've already done the hard part. Here I want to know how long to make the upper arm. I see that the distance from the bottom of the collar where the seam runs from the neck to the point of the shoulder is about two-thirds the distance from the shoulder point to the elbow. I've finished the upper leg and have found the spot where the hand almost intersects the leg and draw the hand and lower arm backward toward the elbow.

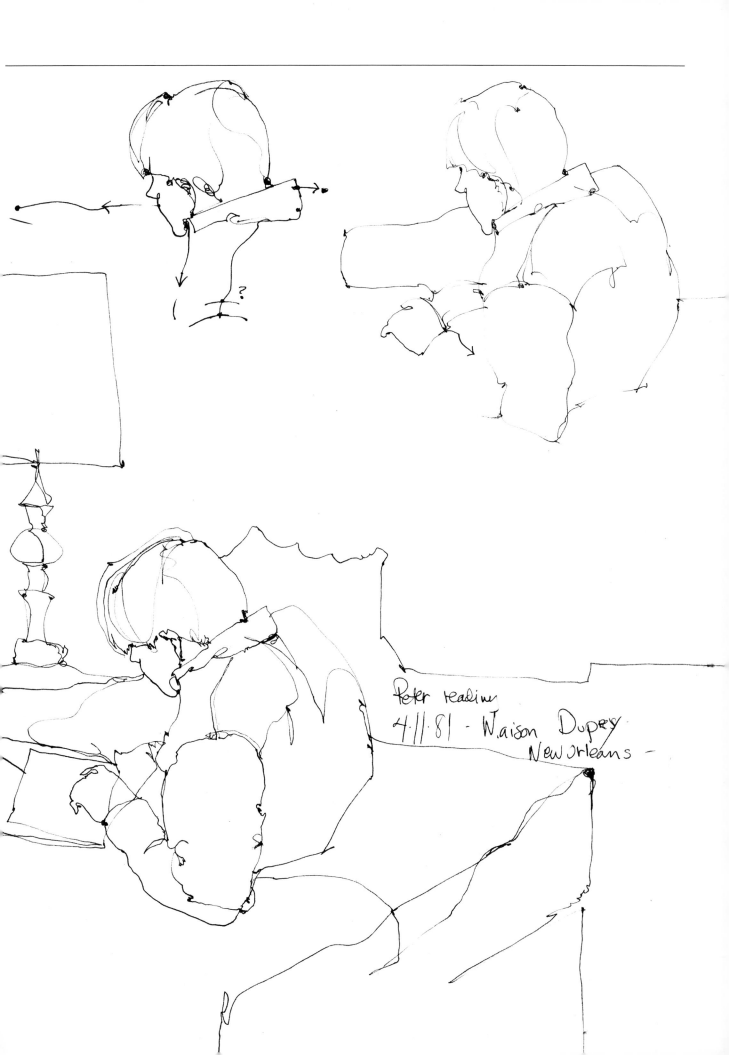

Peter reading
4.11.81 - Waison Duprey
New Orleans -

Look for relationships between one form and another, like the back of a collar in relation to a nose or mouth. Always find the collar or shoulder line—sometimes it's the line of the back—and check its angle. Where does it meet the neck? On the same level as the nose or mouth?

BAR AT CRYSTAL LAKE

This drawing is more difficult to follow than *Bettino's Maui* in that there are more skips in line, fewer dots where the pen stopped. It's partly because I was drawing easily, everything falling into place. A lot of this type of drawing simply takes practice, but to help you look for some of the relationship guidelines we talked about in *Bettino's, Maui.*

KEN AND COMET

How have I caught Ken's gesture? Look at the collar line in relation to his moustache and mouth. Isn't this the key to the whole pose?

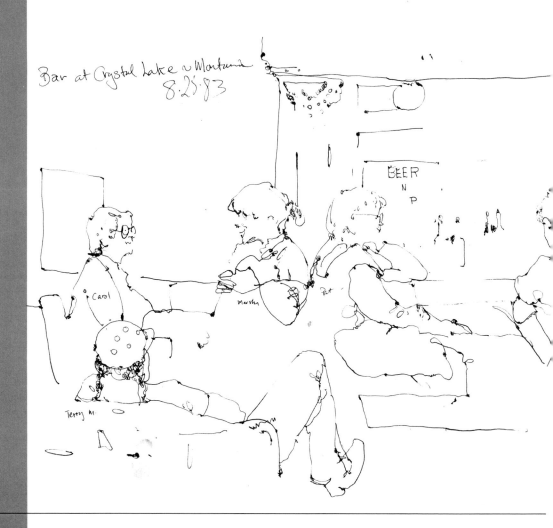

Bar at Crystal Lake ~ Montana
8.25.83

BEER
N
P

Carol

Marsha

Pat

Terry M.

MAKING CONNECTIONS

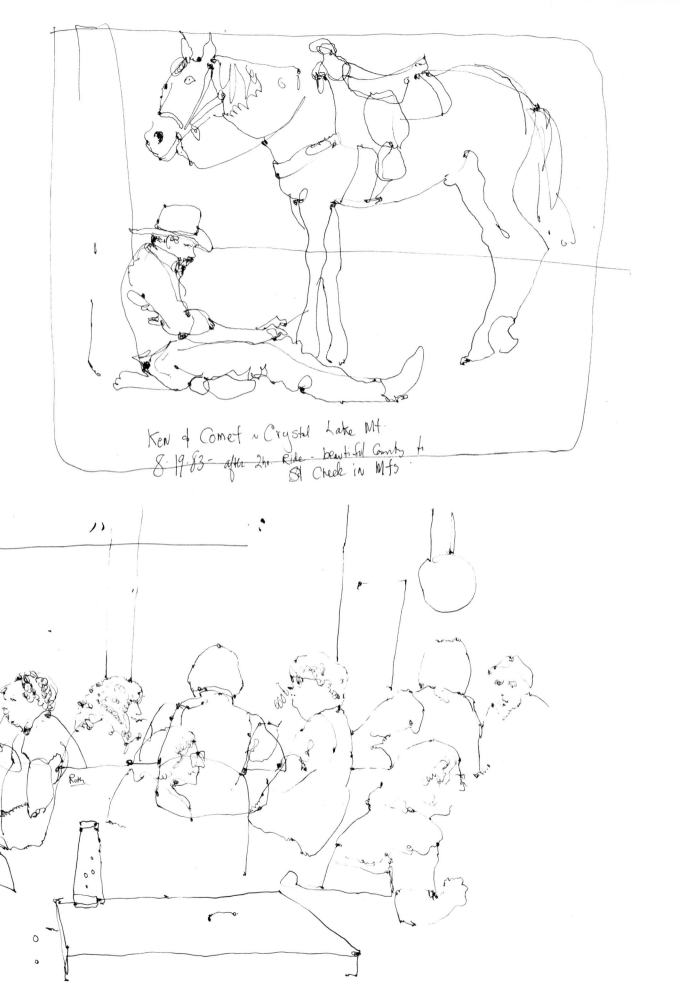

Ken & Comet ~ Crystal Lake Mt.
8·19·83 — after 2hr. Ride - beautiful Country to
St Creek in Mts.

Many students paint the subject first, then try to fill in the surroundings until they finally get to the picture borders. In other words, they work from the subject out to the margins instead of from the picture boundaries, into the subject.

As I'm writing this, I'm looking at two Rembrandt reproductions, *The Night Watch* and *Dr. Tulp's Anatomy Lesson*. It's amazing how Rembrandt confronted his picture boundaries. In the *Anatomy Lesson*, he pressed figures into the left corner, leaving the right-hand side of the picture quite empty. In *The Night Watch*, he butted the heads against the picture borders on both sides of the painting. Rembrandt wasn't trying to save canvas. In fact, it's possible that he cropped the pictures after he finished painting to get this feeling of "pushing" into the picture boundary. And he did it to get a good composition. The point is that many students don't think of boundaries when they start a drawing or painting, but it's something you should do.

PETER AND SARAH, MANY GLACIER

Using this as an example, start your sketchbook drawing an important subject. It can be an object or a person. (I've overlapped my subject with the picture border.) Work from the border, across the picture space, until you get to the opposite picture margin. Think of this as making a trip across the page. Don't worry about the composition. That will take care of itself, though it will help to start with something that's near you. But in any case, start with something important, something that you'd normally place in the center of your composition. Remember to keep your pen or pencil on the paper and travel with it. Don't worry about completing each object or person. The point of the exercise is to make the trip from one margin to another.

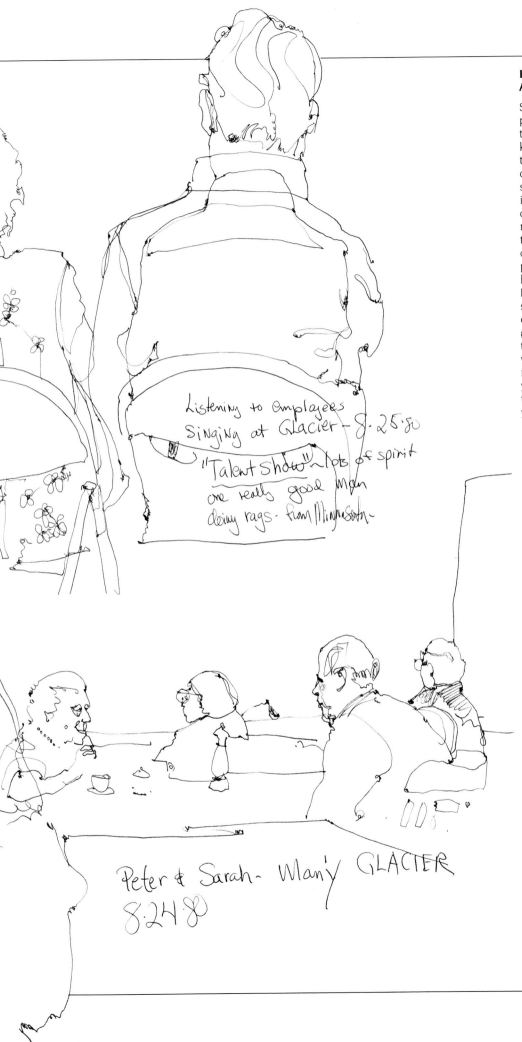

Listening to employees
singing at Glacier – 8·25·80
"Talent Show" – lots of spirit
one really good Man
doing rags – from Minnesota.

Peter & Sarah – Many GLACIER
8·24·80

LISTENING TO EMPLOYEES AT GLACIER PARK

Sitting behind this group of people gave me a good chance to draw them without their knowing. I didn't need to see their faces to practice figure drawing, and their rapt conversation meant they'd be staying in the same place for a while. I completed each figure before moving on to the next, which is the way I work. The proportions of the man on the left were a problem. After I'd finished the head and started the shoulders, I found I'd made them too small. Working in ink, I couldn't erase—but this was all to the good. It's important to be able to accept our mistakes. And wrong lines can give you a reference for new ones. Even if you decide to erase, it's better to leave the wrong line in until you've made the correction.

McSORLEY'S, 12/2/83

My figures generally have complete (or filled-in) boundaries because I get so intrigued with the gesture and character of the person I'm drawing that I forget to connect them to each other, drawing them one at a time. But I continually draw my outside boundaries into the inside of a figure—and you should do this, too. Don't draw just the outside silhouette and fill in the inside details later. Do both at the same time, always connecting the outside to the inside shapes.

It's odd that I've so often stressed making connections, yet here I'm saying that I wasn't thinking about the connection between the people in my drawing and the surroundings. I think it's because there are no "nevers" or "always" in drawing and painting. Something always has to be sacrificed. And when you're working in a bar where people are always coming and going, connections and relationships are difficult. (Bit of unintentional philosophy here!)

The dots you see are where my pen stopped and the paper absorbed more ink. But my pen is on the paper most of the time, and I keep it anchored as I look at the model to check for a new line or direction or angle. Notice that when I got to the stove and table on the left, I tried to do it "right" and let the shape of the hot water kettle flow into the stove by not drawing the boundary of the kettle. I also skipped a couple of lines in the stove so the background could get in.

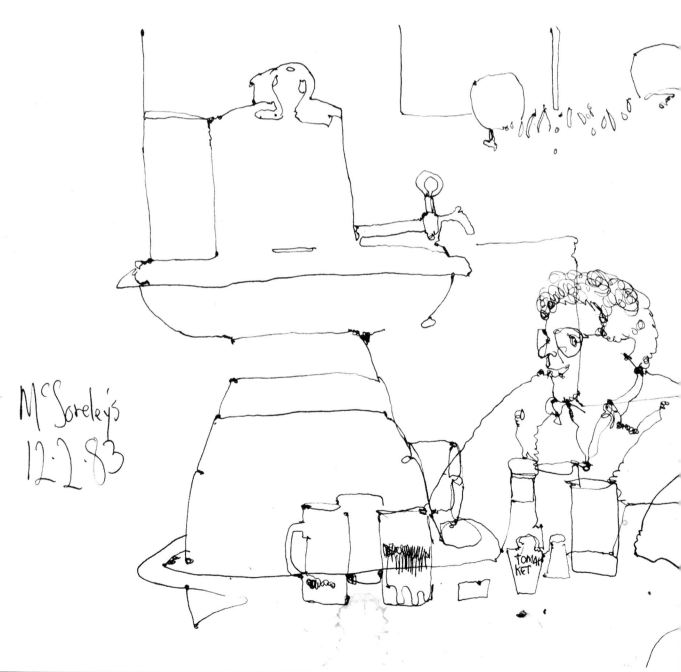

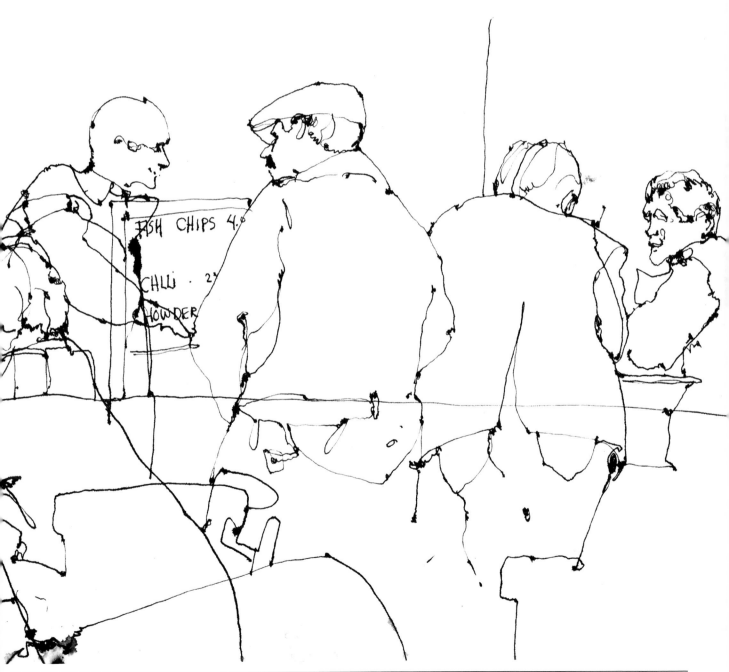

Overlapping Boundaries

OLD OPERA HOUSE, NEW ORLEANS

I started at one end of this drawing and slowly worked my way to the other, as usual. See if you can follow my pen route. Notice the way I grouped the people into sections, then anchored the people to the background. As always, you are making connections between foreground and background, in and out, side to side, back and forth, until the drawing works as a whole.

McSORLEY'S, 3/14/83

Drawing in a sketchbook gives me a chance to do things I wouldn't dare do in a painting. For example, the figure on the right side and the central group are caricatures rather than realistically drawn people. But I think it's important to be willing to take chances in order to keep your eye fresh.

I started the drawing with the profiled figure on the bar stool, probably because I liked the head. Then another man came in and blocked my view and, without thinking, I overlapped the first head with the new figure, allowing his shoulder to run into the face I'd so enjoyed drawing. I had worked according to the laws of perspective, but was I right? Perhaps I should have moved the new figure farther to the right to avoid the overlap (assuming there was room on the paper). Or maybe I should have left him out altogether. What would *you* have done?

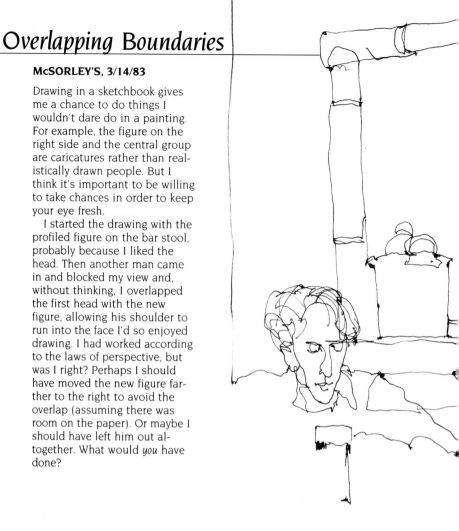

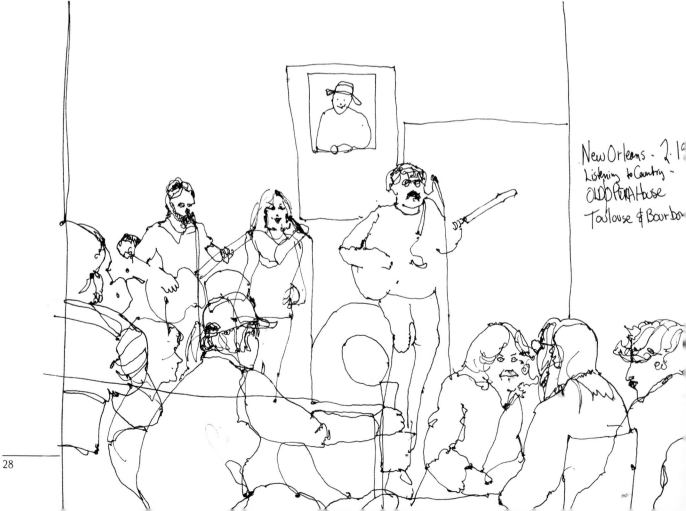

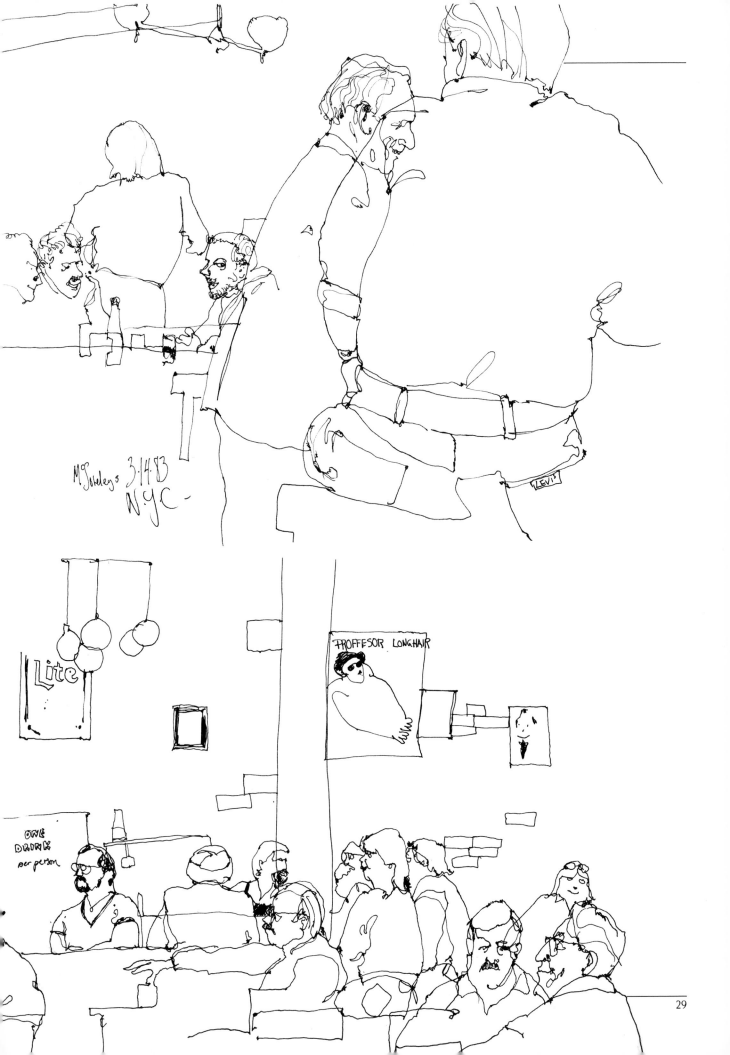

McSorley's 3.14.83
N.Y.C.

Lite

ONE
DRINK
per person

PROFFESOR LONGHAIR

Losing Boundaries

SARAH, BATON ROUGE

Make a start in losing boundaries in your drawings. I usually use water-soluble ink since I rarely do overwashes. Here I blurred a few edges with some saliva and my finger.

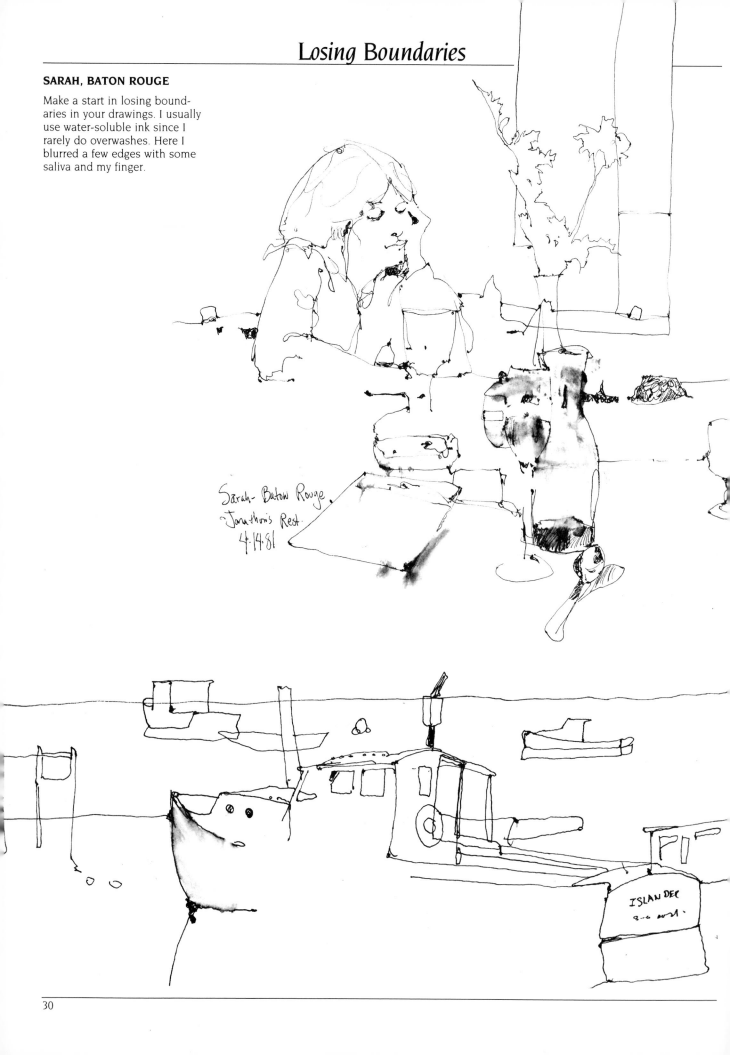

Sarah- Baton Rouge
Jonathon's Rest.
4·14·81

ISLANDEC

SOUTH BRISTOL, MAINE

Artists have trouble losing boundaries. Often when painting, with so much to think about, boundaries are filled in before you realize it. Then, the only thing to do is go back and try to lose and soften edges that are already dry if your medium is watercolor. But even in oil, softening after the fact can cause an overworked look.

ASSIGNMENT

I want you to practice losing edges in a drawing. Here you have nothing else to think about—no color, values, or shapes—nothing but losing boundaries. In the beginning, don't worry too much about where the boundaries should be lost. Simply make yourself drop one or two boundary segments somewhere—anywhere.

Notice all the incomplete thoughts in my drawing of South Bristol, Maine. I used the "traveling-pen approach" in working from one area to another. Notice that I work both inside and outside the form, and that I'm aware of negative shapes. On the other hand, I try not to have preconceived boundaries either. For example, the lobster boat in the foreground has no water line because the hull and its reflection have merged into one large shape. It was easy to leave out the water line. I just squinted and when I found it too hard to see, that was my clue.

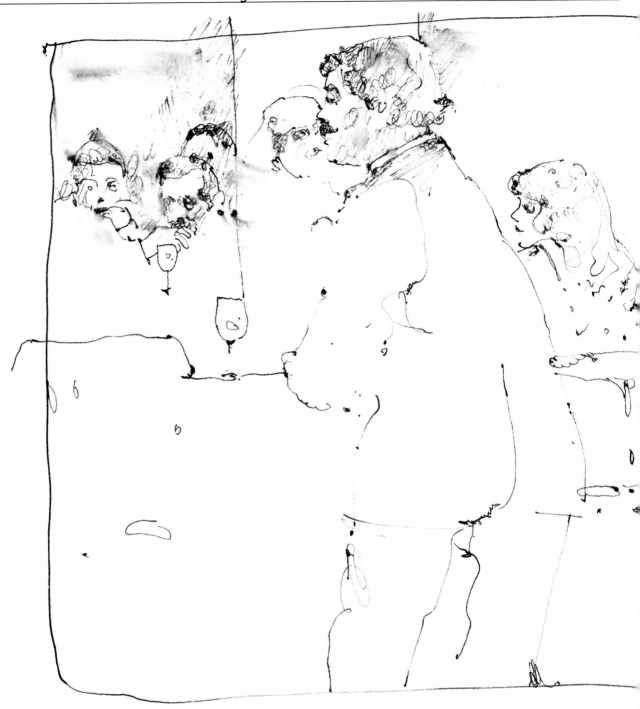

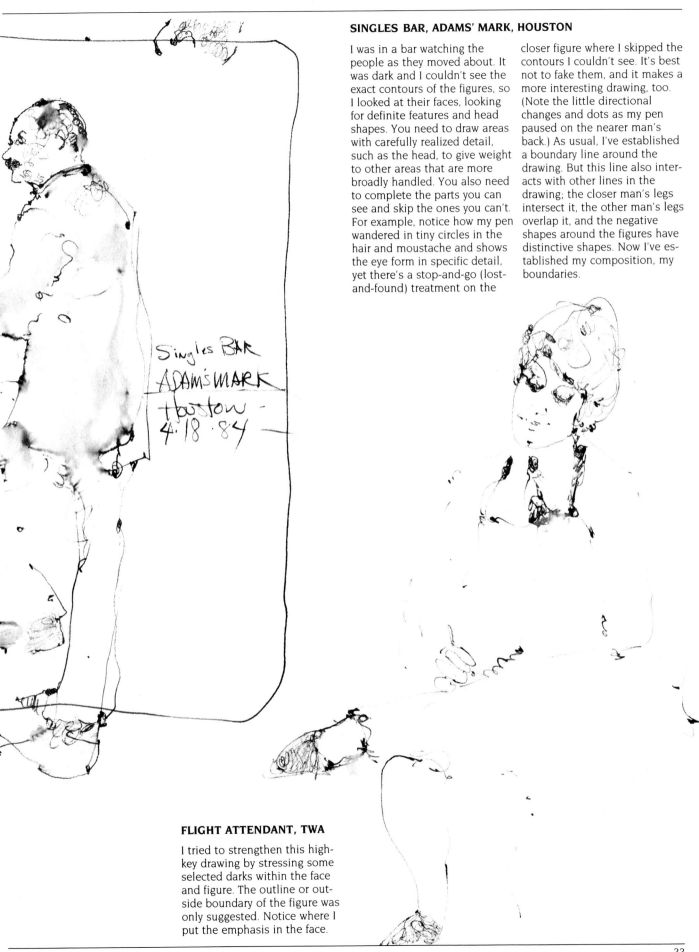

SINGLES BAR, ADAMS' MARK, HOUSTON

I was in a bar watching the people as they moved about. It was dark and I couldn't see the exact contours of the figures, so I looked at their faces, looking for definite features and head shapes. You need to draw areas with carefully realized detail, such as the head, to give weight to other areas that are more broadly handled. You also need to complete the parts you can see and skip the ones you can't. For example, notice how my pen wandered in tiny circles in the hair and moustache and shows the eye form in specific detail, yet there's a stop-and-go (lost-and-found) treatment on the closer figure where I skipped the contours I couldn't see. It's best not to fake them, and it makes a more interesting drawing, too. (Note the little directional changes and dots as my pen paused on the nearer man's back.) As usual, I've established a boundary line around the drawing. But this line also interacts with other lines in the drawing; the closer man's legs intersect it, the other man's legs overlap it, and the negative shapes around the figures have distinctive shapes. Now I've established my composition, my boundaries.

Singles BAR
ADAM'S MARK
Houston
4·18·84

FLIGHT ATTENDANT, TWA

I tried to strengthen this high-key drawing by stressing some selected darks within the face and figure. The outline or outside boundary of the figure was only suggested. Notice where I put the emphasis in the face.

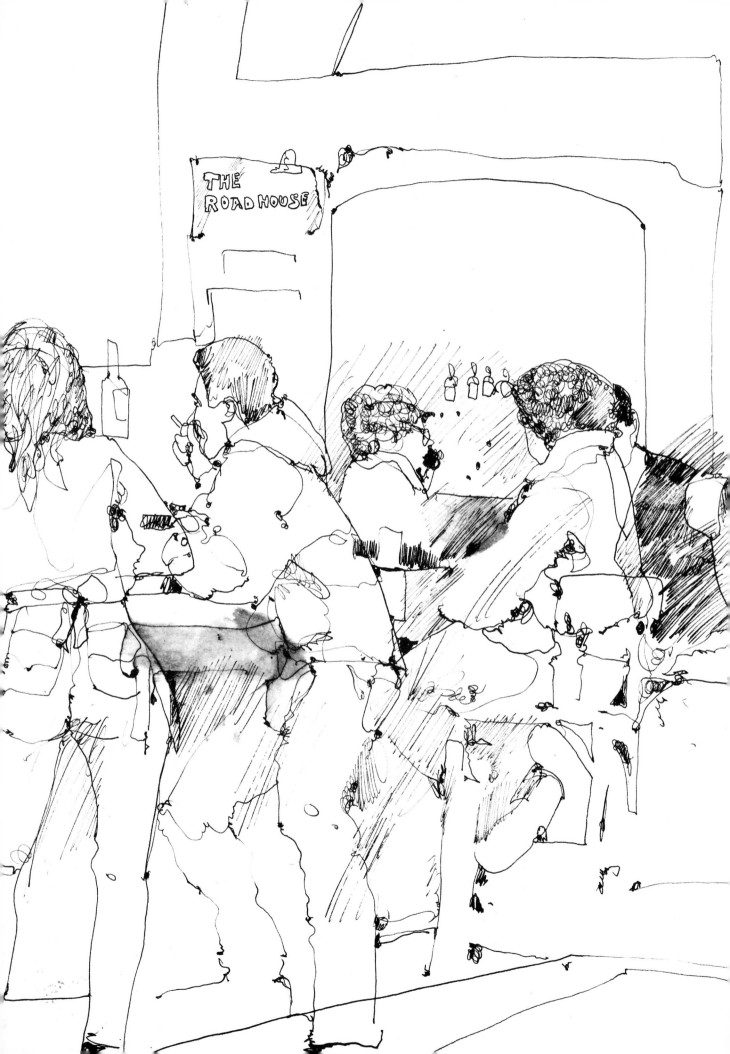

Placing Darks

It takes experience to know where to place the darks in a drawing. You have to learn to react to the drawing itself. You can't learn it from a book. To help train your eye, do the following assignment. Begin with a simple contour drawing of a scene. I'm working from a drawing I've entitled *The Road House*.

THE ROAD HOUSE, STATEN ISLAND

Contour Drawing. I started with the *foreground* figure on the right, under the exit sign. Then I worked the right, adding two figures until I got to the right margin. I then worked up around the exit sign and continued working left until I got to the left-hand border and then backtracked. I drew the seated woman (center) before adding the man in the black vest with an arm resting on the bar.

Positive Darks. Look at your subject and choose one dark on your subject to shade. To help you decide, turn away and ask yourself which dark you remember. What is the important dark? Then shade this one. The core of the problem is that of selection. We must force ourselves to choose just one dark out of the many shades of dark—we see the dark that is the essence of the area we're looking at. In this case, I chose the man in the right foreground as my subject and looked for an area within this positive shape to shade—the hair.

Negative Darks. Now look for a negative or background shape to shade. I picked the man facing my subject as the negative shape, and shaded him. The lesson here is to see the drawing as a whole, to see that it's made up of an approximately equal amount of darks within the figures and darks within the background. As soon as you shade a positive shape, go on to do a negative one immediately, so you are constantly moving your eye from subject to background and back again. The positive and negative darks happen to be connected, but sometimes they're separated by positive light shapes. I want you to see that negative background shapes can be just as important as positive shapes on the objects or people we're drawing.

In this case, I added the shading as I drew. Sometimes I just work in line, but since this was at night and there were so many darks around, I made them part of the drawing. Since I was working in pen on a large paper, it was impractical to shade all the dark masses in, so I had to be selective. I had to choose areas that would "suggest" a composition. I didn't add shading just because it was there. Remember, a drawing is like a poem. It suggests and implies, but it never tells a literal story.

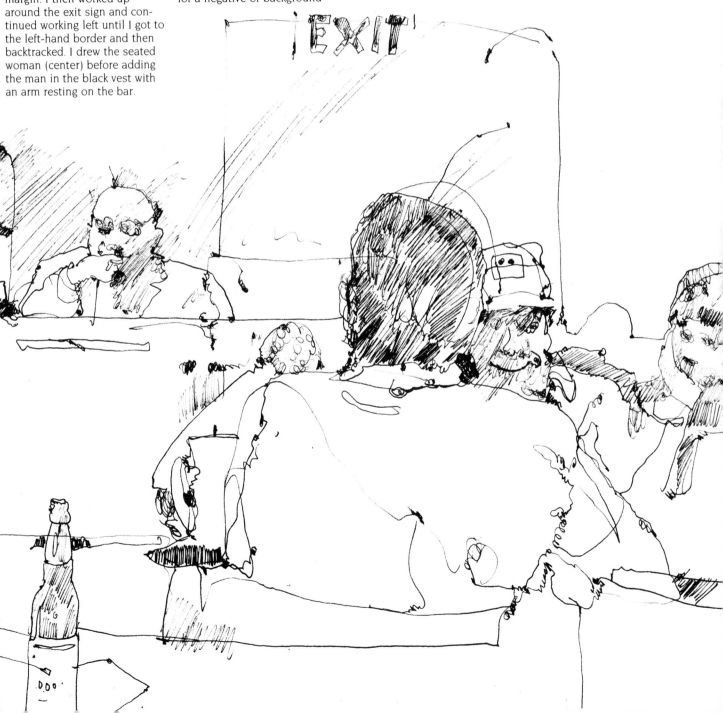

Simplification

NANTUCKET BAG

It's hard to think of all the thing's we're supposed to remember as we're painting color, shape, lost and found, simplification, placement of objects in a picture space. The trick is to make some of them part of your natural vocabulary so you don't have to think about them. And this comes with practice.

In drawing, you don't have to worry about color. But you can still practice:

a. Placing object and choosing size in relation to the picture space.
b. Making connections and separations (lost-and-found edges).
c. Deciding places where you'd stress or lose detail.
d. Thinking about shapes.
e. Connecting objects to picture borders.

And you can practice this with the simplest of objects in just a few minutes. If you do enough drawings like this, many of these points will become automatic and they'll be second nature when you're doing a painting.

Turning Sketches Into Complete Thoughts

Don't just make sketches. Sketches should be finished and complete thoughts. They should have a point and a composition, even if they aren't intended as a basis for a painting. This kind of thinking is good practice and will help you later when you make a painting.

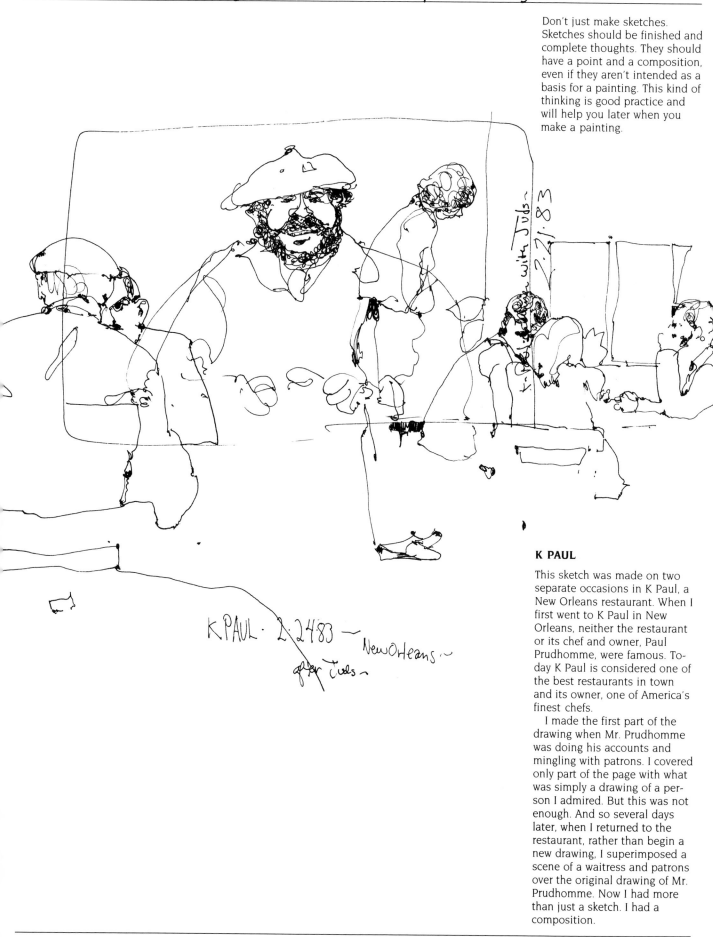

K PAUL · 2·24·83 — NewOrleans~
after Tues~

K PAUL

This sketch was made on two separate occasions in K Paul, a New Orleans restaurant. When I first went to K Paul in New Orleans, neither the restaurant or its chef and owner, Paul Prudhomme, were famous. Today K Paul is considered one of the best restaurants in town and its owner, one of America's finest chefs.

I made the first part of the drawing when Mr. Prudhomme was doing his accounts and mingling with patrons. I covered only part of the page with what was simply a drawing of a person I admired. But this was not enough. And so several days later, when I returned to the restaurant, rather than begin a new drawing, I superimposed a scene of a waitress and patrons over the original drawing of Mr. Prudhomme. Now I had more than just a sketch. I had a composition.

Uniting a Complex Composition

**ADAM'S MARK,
FOUNTAIN COURT**

Now that you know how contour drawing works, look closely at this drawing and see if you can determine where I started and how I worked across the page. Then look at the boundaries— where I linked foreground and background, how I accentuated my main subjects, and where I lost edges. How would *you* have handled this scene?

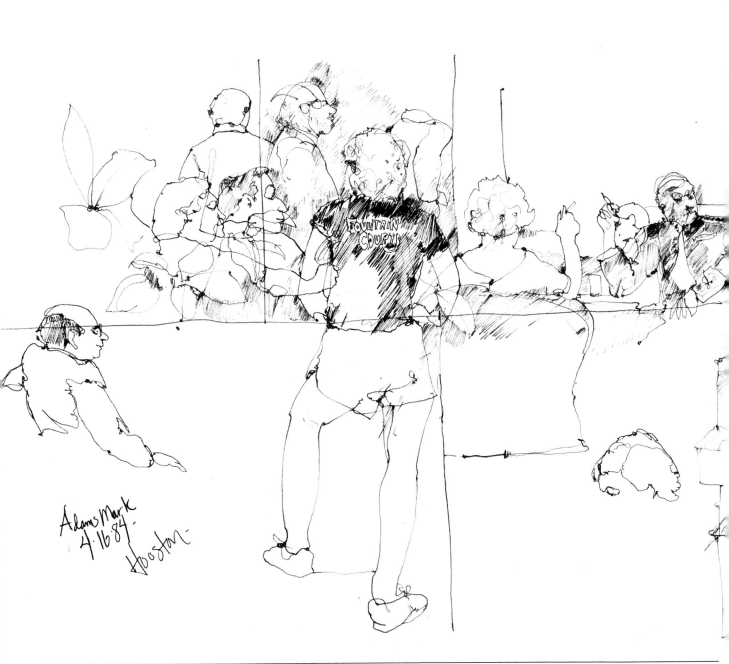

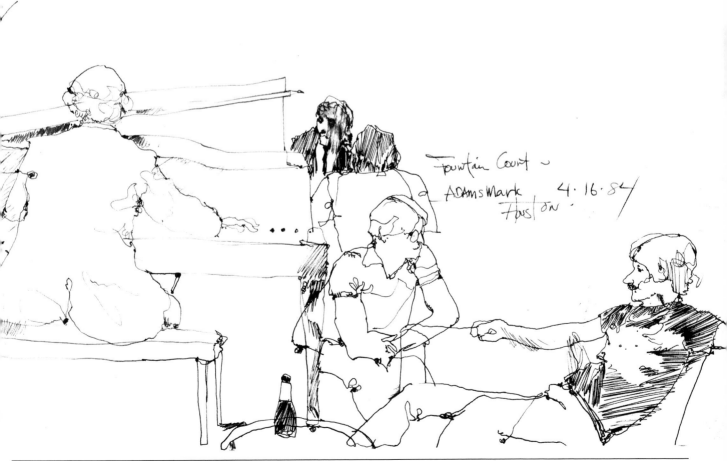

Fountain Court ~
AdamsMark 4·16·84
Houston.

39

KITCHEN OBJECTS

You've probably said to yourself: I don't have time to paint. Too often with a family or another job, there is simply no time or energy left over for painting. These three drawings suggest an alternative. The materials are simple. No need to set up equipment or an elaborate still life. All three were drawn before or during supper preparations.

We all need to work on our drawing skills. It's the greatest weakness in our paintings. Specific shapes, the key to drawing anything, are here on my kitchen counter. I can plan with my darks. I've simply used my pen line, a small no. 2 round sable, some water to make the darks (no watercolor was used). I could think about negative shapes and lost-and-found edges, all while I was cooking supper.

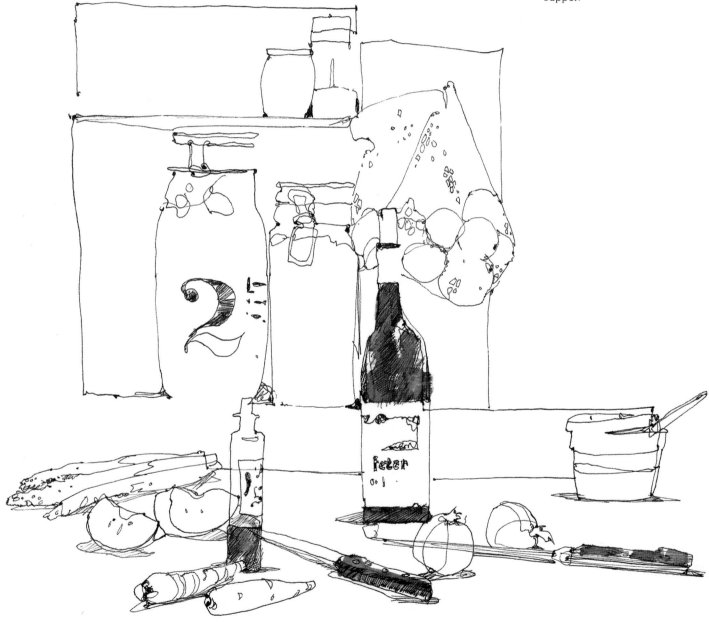

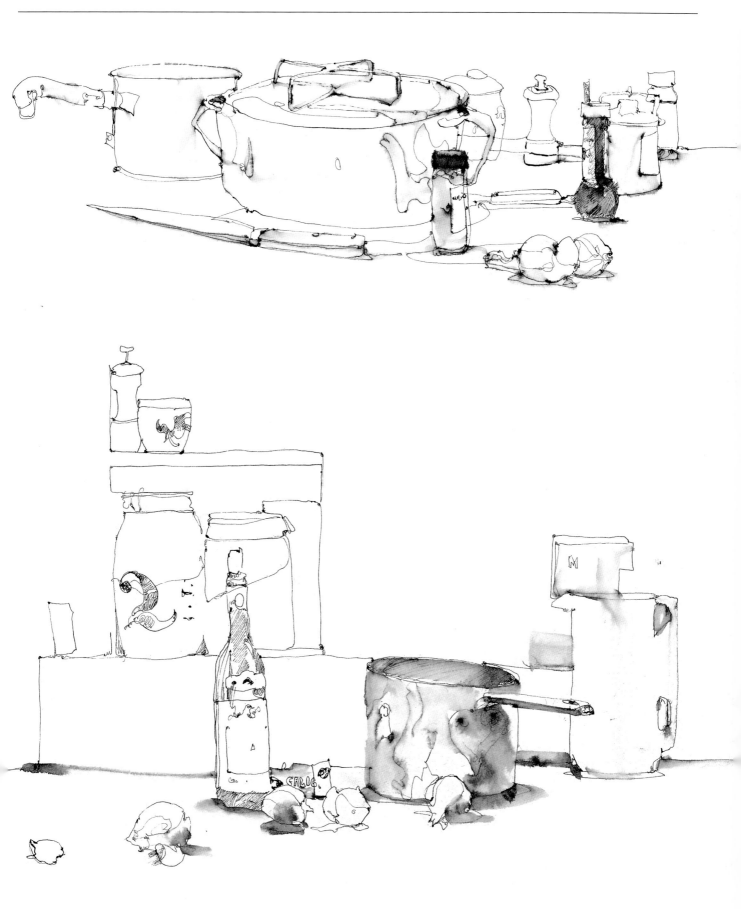

The trick in learning how to paint is to get certain painting ideas firmly implanted so we can do them naturally, without conscious thought. One such idea that is absolutely necessary in all painting is "lost and found." Remember, lost and found doesn't only mean hard and soft edges. Lost and found can be accomplished with hard and soft edges, but it can also be done by making adjoining color-value areas similar or compatible in color and value in some sections, while making adjoining colors or values different or incompatible in others.

Technically, everything we draw and paint should have lost-and-found edges. The idea is that you can stress or emphasize some boundaries with a found or hard boundary while minimizing other areas with a lost or soft boundary. Soft or lost edges help you to connect and mass together adjacent objects and shapes, avoiding the cut-out-and-pasted-down look of a painting done entirely with hard, found edges.

You can decide which edges are hard and which are soft by squinting. When you squint your eyes, you can still see boundaries, but the less obvious ones are lost. This is the way you would paint them, too.

While lost-and-found edges are indeed valid, sometimes a shape is so inherently interesting that I often forget about lost and found and concentrate on making all my shapes equally important. Rules are fine, but there are many reasons for making a drawing or painting. And rules should never get in the way. Interesting and descriptive shapes are also vital to a good picture.

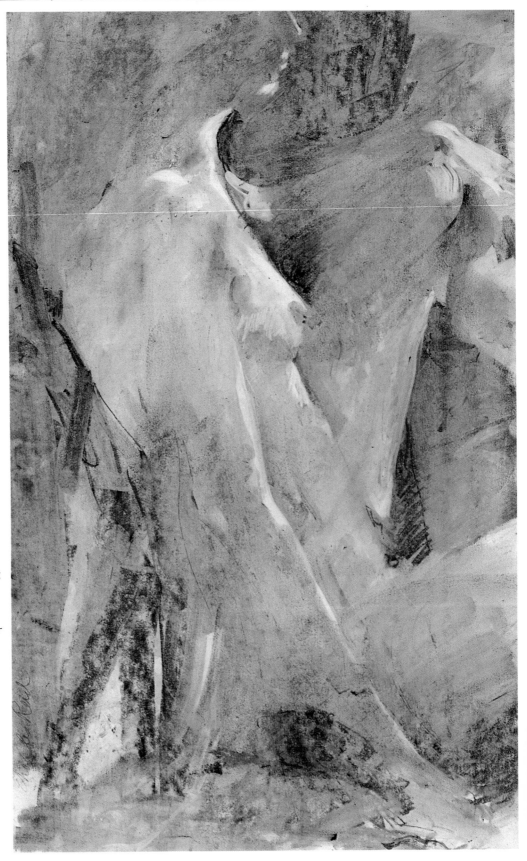

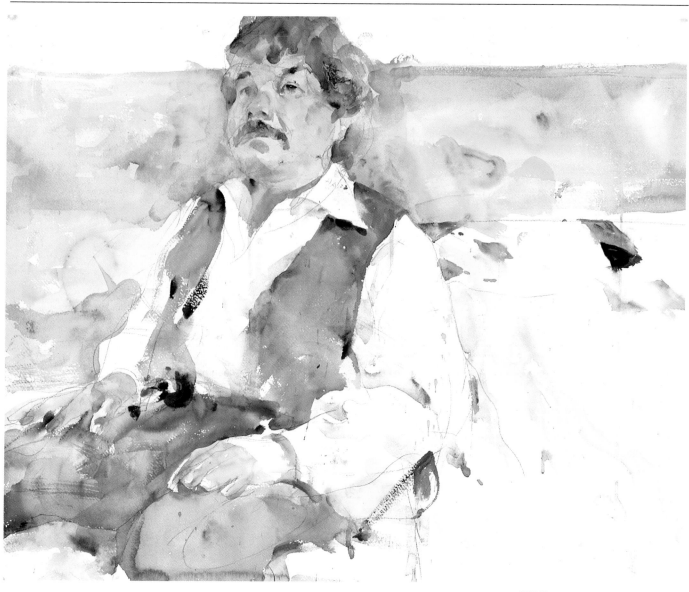

JUAN
watercolor on Fabriano
Esportazione,
21″ × 30″ (53.3 × 76.2 cm).

In *Juan*, the principle of lost and
found is used throughout the
whole painting. I wanted the
figure and surroundings to be
intertwined. Notice the painting
of the vest. I didn't want a
"cutout-and-pasted-down" look.
How did I avoid it?

NUDE

Charcoal is an excellent me-
dium in which to practice de-
veloping the lost-and-found
habit. There are no oil or water-
color techniques to worry about,
and no concerns about color. I
used soft vine charcoal, a
kneaded eraser, and hot-
pressed paper. My subject was
under a strong spotlight. I
wanted to have strong contrasts
(found) between the figure and
her surroundings in some
places, and in other places I
wanted no contrast between the
figure and the surroundings
(lost). I was trying for about 75
percent lost and 25 percent
found edges. In some cases I
started out by painting around
my lights with the charcoal. In
other places I picked out the
lights with my kneaded eraser.
(For example, the torso was
painted first, then I picked out
the arm.) I also did a lot of
softening and smudging with
my finger.

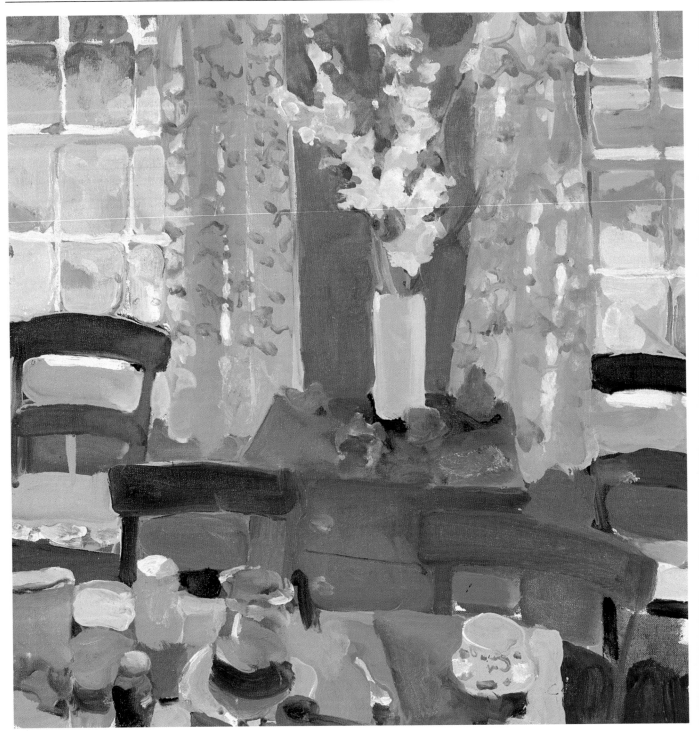

BLUE DINING ROOM
oil on canvas,
18″ × 18″ (45.7 × 45.7 cm).

In *Blue Dining Room*, I made color
and value changes to stress
contrasts and divisions in some
places, the chairs, for instance. I
emphasized the blackness in
some areas while in others I
made the chairs seem warmer,
almost brown. How did I handle
the wall behind the flowers so
they wouldn't look totally iso-
lated?

NATIVE AMERICAN
watercolor on Fabriano
Esportazione,
20″ × 27″ (50.8 × 68.5 cm).

Study this painting. Notice
where I've lost the silhouette of
various forms. In *Native American*,
we see mostly found areas
around the head, then the torso
merges with the background.
Found forms are seen again
around the arms and hands. Do
you see how emphasis has been
developed?

Deciding What's Positive and What's Negative

Sometimes it seems that art terms are intended just to confuse the unwary. Take "positive" and "negative." What's a positive and what's a negative shape can cause spirited debate. It's not enough to simplify it by saying that the positive shape is the object we're looking at and what's behind the object is negative. Let's look at my sketch of the retired Liberty Ship, *Jeremiah O'Brian*.

JEREMIAH O'BRIAN
watercolor, 12″ × 17″ (30.4 × 43.1 cm).

Literally speaking, the ship is a positive shape and the water, etc., are negative. But what happens when I start painting the clutter on the decks? It's pretty obvious that we have a problem deciding shapes to make positive. Here, in order to show a life raft or some of the funnels, I had to paint what was around those objects. In other words, I had to treat the background as a positive and the object as a negative. In a sense, all of my darker shapes are positive and all my light or white-paper shapes are negative. This finally leads me to my point: We mustn't think of objects as the necessarily important or "positive" shapes and the background as the unimportant or "negative" ones. Incidentally, the approach I used for the ship doesn't quite work with the rest of the sketch. Why? Because I was drawing shapes instead of a ship. Then, when I got around to painting the distance, the fog had started to roll in and I couldn't see specific shapes. I should have established some stronger shapes in the background early instead of concentrating only on "Jeremiah."

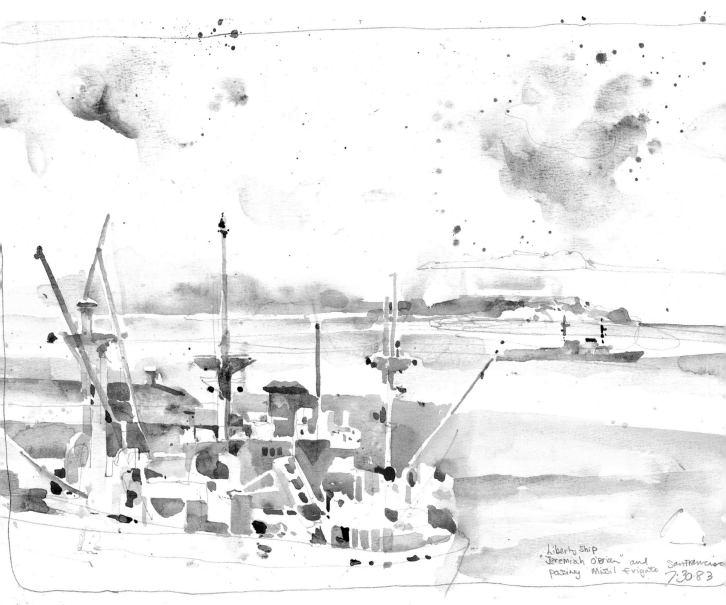

Liberty ship
"Jeremiah O'Brian" and
passing Missil frigate
San Francisco
7·30·83

SNOOZING MAN, SAN FRANCISCO
watercolor,
12½" × 17" (31.7 × 43.1 cm).

I did this sketch the afternoon after I painted *Jeremiah O'Brian*, working in the park overlooking San Francisco Bay and Alcatraz. The sky above was just darkening, but I fended off the thought of going to a delightful bar just above the park and concentrated instead on this sketch. What I did was a study of a man rather than a painting of him, a study because the man really bears no relationship to his surroundings. It looks like I painted him first, then filled in a partial background. The fact that the sketch is unfinished is not the point. I should have connected the man in the foreground to something in the middle-distance—and the light pole doesn't work well enough as a connector.

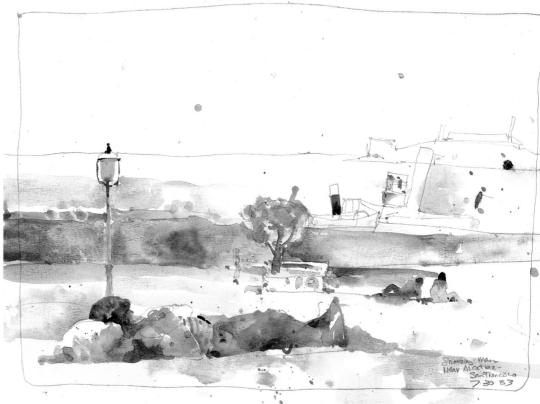

SNOOZING MAN (CORRECTED SKETCH)

Compare the study with this sketch. This sketch shows better connections at an early stage. For example, the grass, an adjoining shape, dominates the light shirt and connects the darker values on the face with the two figures in the middle distance. The figure in the first example looked isolated because all the positive darks were contained with the figure. Even though this sketch is unfinished, it gives me the bare bones of a painting. The first sketch shows me nothing.

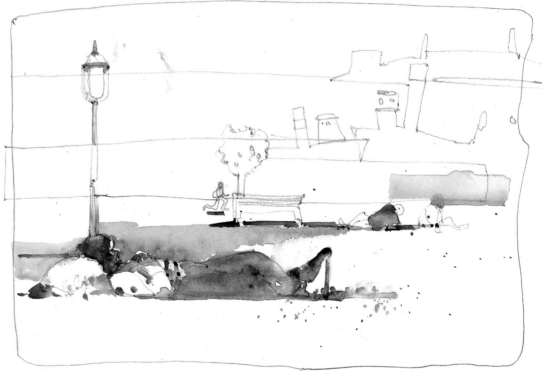

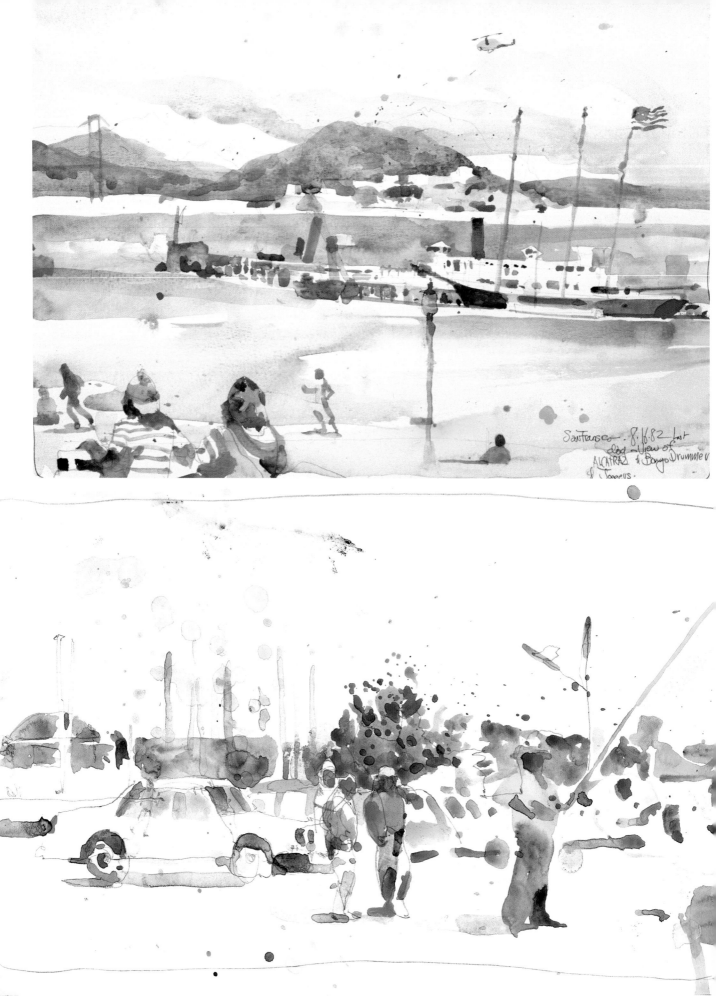

San Fransco — 8.16.82 last
dod view of
ALCATRAZ & Banyo Drummer
& Joggers.

Connecting Positive and Negative Areas

BONGO DRUMMERS, SAN FRANCISCO

watercolor,
12½″ × 17″ (31.7 × 43.1 cm).

My wife's only comment about this was that I was trying to do a Dong Kingman. This ruffled my feathers somewhat, but I had to admit privately that there was a lot of theft going on here. Folks who remember Norman Rockwell's covers for *The Saturday Evening Post* will get a kick out of trying to find all the Kingman touches I stole.

Look for the objects I painted as positive shapes, those I painted as negatives, and those painted with a combination of both positive and negative shapes. Find places where I used compatible (harmonious) values to connect adjacent areas, and where I separated areas with incompatible values.

BAY BRIDGE AND FISHERMEN, SAN FRANCISCO

Like many of my paintings, this was done on facing pages in my sketchbook. I like this wide format, though it's hard to find. Notice that the right side of the painting is painted in positive shapes, while the left-hand side is painted "negatively." Can you see the difference? You shouldn't do this, of course. Positive and negative shapes should be combined. I think I did it because I wasn't thinking, I was simply enjoying myself painting the bridge, distant hills, and water—the positive shapes. Then, as I moved to the left, I became aware of the complications of moving figures, cars, boat masts, buildings, and trees—and I got nervous. Whenever I'm fearful about capturing a mass of detail, I turn to cast shadows and negative shapes to simplify the scene. Instead of strong darks, (notice that the cast shadows and negatives aren't as dark as they could be), I go for patches of strong, intense color.

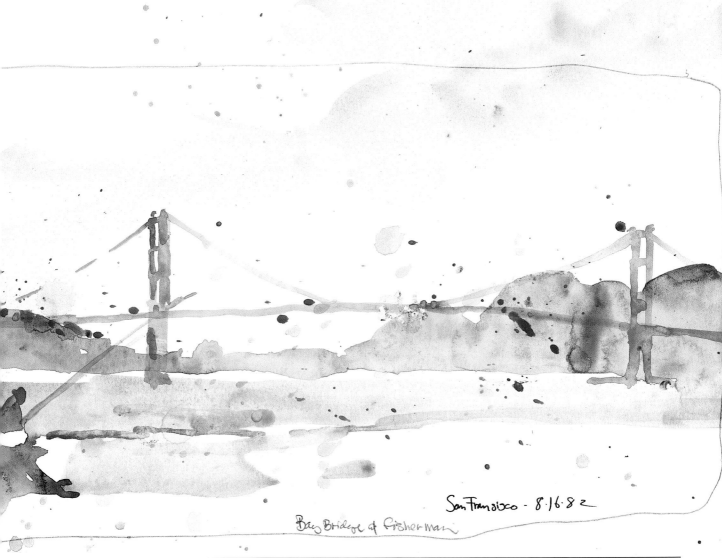

San Francisco - 8·16·82

Bay Bridge & Fisherman

I've found five drawings I did many years ago. It's interesting to look back on old sketchbooks and wonder if I wasn't better then. I think all artists fear waking up one morning and finding they've lost "it." Actually, I suspect it's not going to happen that suddenly. Instead, there will be a slow drift toward banality, when there's too much skill and technique and a fear of failure.

My sketchbook helps me stay "fresh." I can try ideas either in pen or watercolor that help my thinking when I paint. These five watercolor drawings aren't particularly adventurous. But they helped me concentrate on an idea that concerned me at the time—the massing of different values and colors into silhouette shapes.

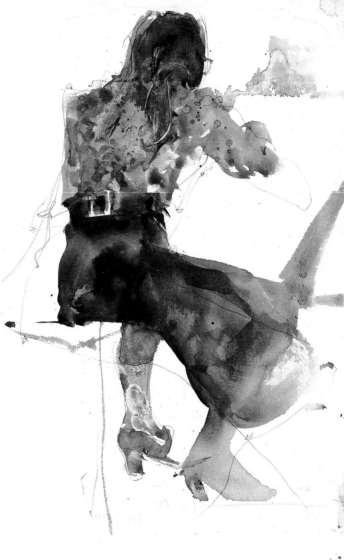

CHRISTY PAINTING, STUDIO II

Most sketchbook paper defies abuse, and that's good. You have to make direct statements. All of the washes in these sketches were put down with the final thought in mind. A second overwash would hurt the painting. For example, the pattern on Christy's blouse was spattered on because I was afraid I'd lift my first wash if I actually painted it over the first wash. Besides, my flow-throughs (linking one section to another), the point of this sketch was to capture an elegantly dressed woman painting a picture, always a marvelous sight. Notice my attention to very specific shapes. Would this sketch have any meaning without these shapes?

KATCHLYN, HOUSTON

I've been telling you all along that it's important to allow specific shapes and adjoining values to "braid" together. Yet I think that here it's the lighting that makes this difficult pose possible to paint. The strong lighting divides the painting into two areas, light and dark shapes, and without the specific light-struck shapes (on the leg, shoulder, neck, and face), the pose would be totally confusing. Furthermore, the large shadow mass helps me avoid some very difficult anatomical details. Although I can see many reflected lights and subtle value changes in the shadow across the thigh and lower leg and into the upper torso, I didn't paint the thigh alone and stop at the lower leg. I also ignored differences in color and value between the lower leg and the upper torso. Instead, I generalized the values in shadow. Remember, when you paint the shadow, pretend that you're short-sighted and can't see all the value changes there.

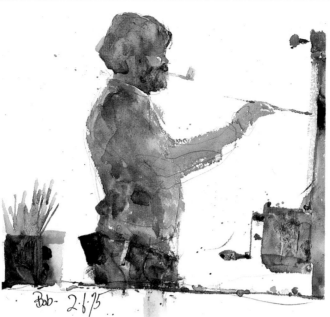

BOB

It's hard to envision the different values and color shapes I saw, when I try to separate them. But that's the point of all these sketches. I look mainly for connection and "flow through" between one color shape and its neighbor. I avoid separation except in two places, the light-struck cheek and the rim of the collar. If you look closely, you can find separations. Do you have to look hard to find all the boundaries? Perhaps you shouldn't be looking so hard!

Controlling Edges

BEVERLY IN HOUSTON

This is more finished than a sketch. It's actually a painting rather than a drawing. But I'm only including it because it illustrates a point I've been making throughout this book: We must continually find adjacent value and color masses that are harmonious.

Beverly has very dark hair, a beautiful, intense black. Yet she also has fine and delicate features. If I made the hair as dark as it really was, it would totally dominate her features. I wanted to show the hair as being black, but I also wanted to stress her features. Softening the edges is one way to decrease emphasis, but because of its dark color, soft edges wouldn't work here. The deep value would make it still dominant. Another way to de-emphasize the dark hair would be to cut the contrast by lowering the values on the face. You could do this by throwing the face into deep shadow, so the values on face and hair would merge. But I didn't want a harsh shadow on her face. So the only thing left to do was to lighten the hair on the shadow side to bring it into sympathy and harmony with the shadows on the face. Notice the one part of the hair I kept dark: It's above her left eye and helps draw attention to this important spot.

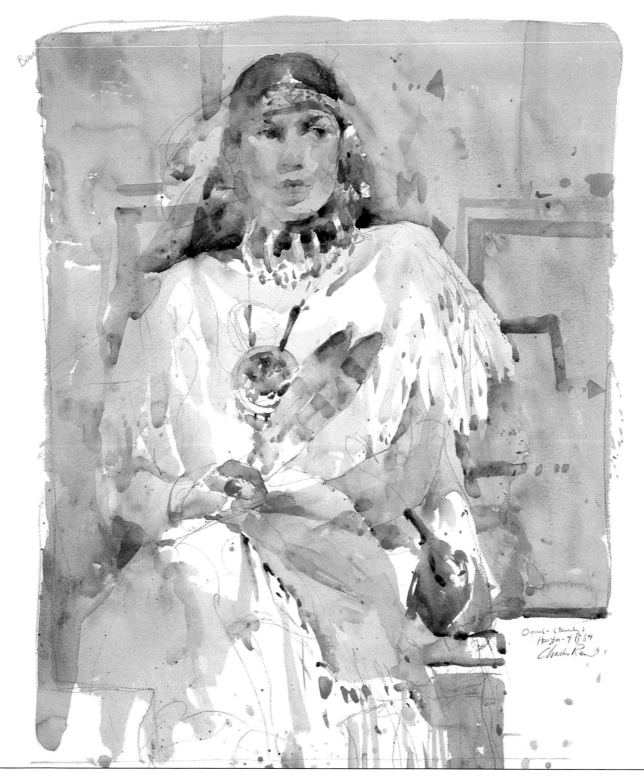

Lost-and-Found Color Edges

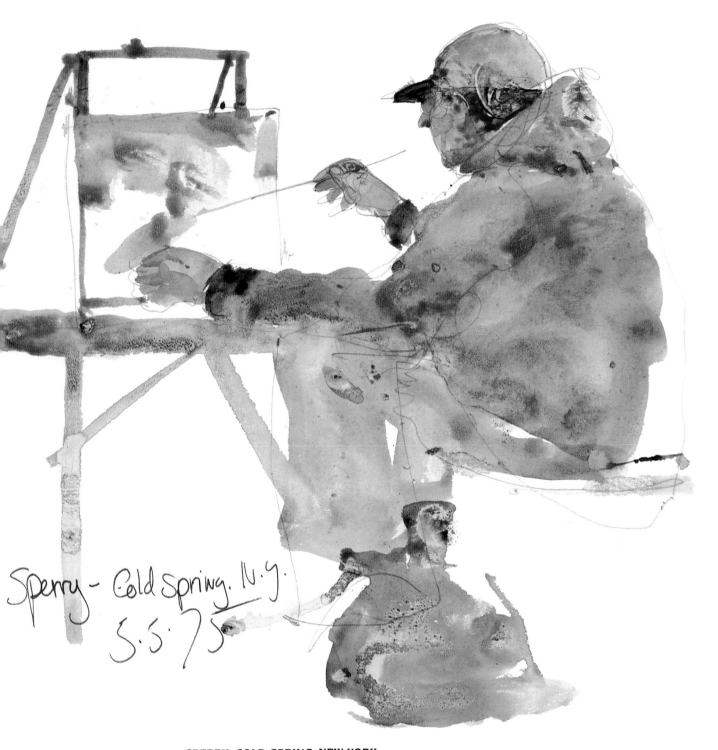

Sperry – Cold Spring. N.y.
5.5.75

SPERRY, COLD SPRING, NEW YORK

This sketch was done by painting broad areas of color. Whenever I wanted a definite edge, say, between Sperry's hair and the parka hood, I allowed the colors of the parka to dry before adding the hair. On the other hand, after painting Sperry's left arm, I immediately added the trousers so I could get a lost edge. Look for other soft-edged areas. You'll see that at least half the inside boundaries have lost edges.

I chose my favorite colors, a variation of the primaries: alizarin , yellow ochre or raw sienna, and a blue—cerulean or cobalt. Although I use cadmium red to darken and "cut" or reduce the intensity of Hooker's green dark, I rarely use it in mixtures, where I prefer alizarin crimson. I do tend to combine both blues, though; here I've mixed both cerulean and cobalt with yellow ochre for Sperry's parka. The trousers are a mixture of alizarin, cerulean, and yellow ochre. Become more alert to color and color combinations. You will often see these mixtures in my paintings.

ROSES FROM SEATTLE

Notice the color substance out in the light in both the red and yellow roses. I didn't let the detail in the roses dominate the color silhouettes.

HOLIDAY INN, ISSAQUAH, WASHINGTON

It's hard to count the number of values here precisely, but the point is that each area has a strong value identity. It's easy to see that in the distant values. Notice the cast shadows under the planes. What part do they play? And look at the pure color in the cars. Cover them up and see if you notice a difference in the painting.

WORKING WITH COLOR

WITH JUDS, GREAT ISLAND, WELLFLEET

Painting the ocean and a beach scattered with seaweed is a very complicated problem. In this sketch, I tried to simplify all the colors into three values. Notice that there are variations, es-pecially in the water. It looks very dark at first glance, but notice the middle lights. Try working on a small scale like this. It's much easier to leave out the details.

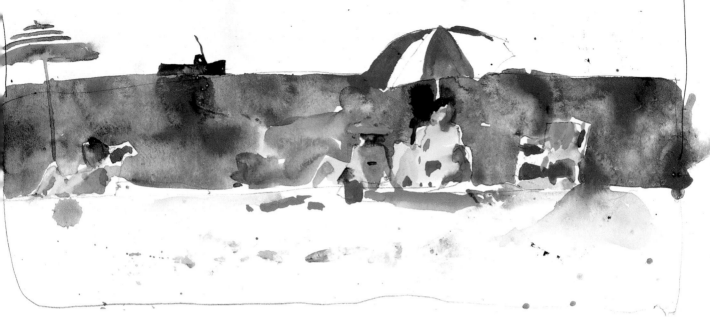

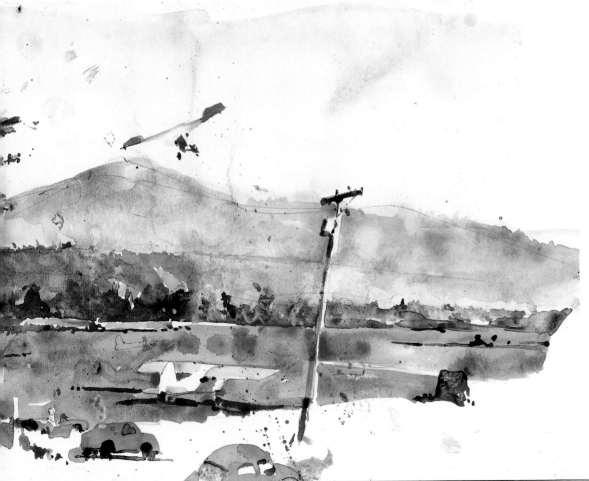

RANCHO ENCANTADO

I only had shapes to rely on. There was no line to support the painting. This forced me to be simple. There was a strong light on the guitar player (you can see the strong cast shadow by the lamp), yet I painted him with local color values. What would have happened if I had painted this sketch with light and shade instead?

Painting in Sections

STERLING HAYDEN AT STUDIO II

Even more than for his acting, which happens to be excellent, Sterling Hayden impresses me because he's an individualist who has spent his life "beating to windward," a sailing term meaning "making a difficult passage," a wanderer on a voyage. Hayden is also a fine writer and a fine seaman with a great face that deserves better than this sketch.

This sketch was done after lunch from life. Sterling is the kind of person who concentrates on what is being said and doesn't move his head constantly. Happily, he was facing into the light, which gave me obvious light and shadow shapes and planes to work with. I also had a profile, which is much easier to paint than a full face. Never attempt a color sketch like this without simple light and shade shapes on the face. I left the lights white paper. I started at the nose and tried to get the final color and value with the first try. I worked very slowly. This was no time for

flair. I worked up to the eye socket and eyebrow to a place where I could catch my breath and stop.

And I'll do it here, too. It's difficult and pointless, in a

sense, to give you a blow by blow description of how I painted, since I do each head differently. The only thing it's safe to say is that you should try to complete whole areas at

once, that form natural units, complete within themselves. The reason for this is that when you stop painting, you'll have hard edges. These edges mustn't occur in the middle of a section you're working on. For example, look at the hard edge under the nostril. A hard edge here doesn't matter. The hard edge above the eyebrow is fine, too. That's where there's supposed to be a hard edge. But you can't just paint. You have to plan your hard edges in advance.

All of this was done without thought. I wasn't intending a "statement," but it might be helpful to ask yourself a few questions. Why did I choose the view I've painted? What have I left out? What was left "white-paper" so that the eye goes where it's supposed to go? Compare the simplicity of the trousers to the details on the face. Although the face is indeed the focal point, there's a composition here; the lower part of the sketch has "weight."

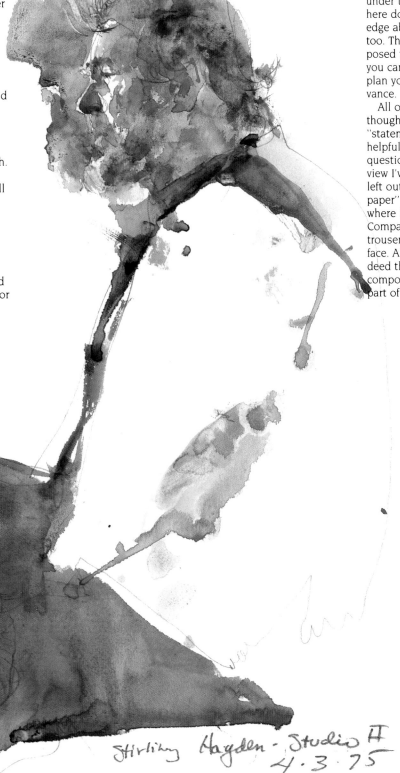

Stirling Hayden - Studio II
4·3·75

Interpreting the Light

If you look at the *American Heritage Dictionary*'s definition of *abstract* as "considered apart from concrete existence," then my sketch *Near Northport* can be viewed as an abstraction, because in it, I've changed or ignored certain facts. If I were dealing with concrete reality, I would have painted the boat lift as a very dark trestle supporting the rigid outline of the boat's hull. But I wanted a different reality; I wanted to emphasize the feeling of light as the reality I guess it comes down to a decision between painting facts, or your response to them.

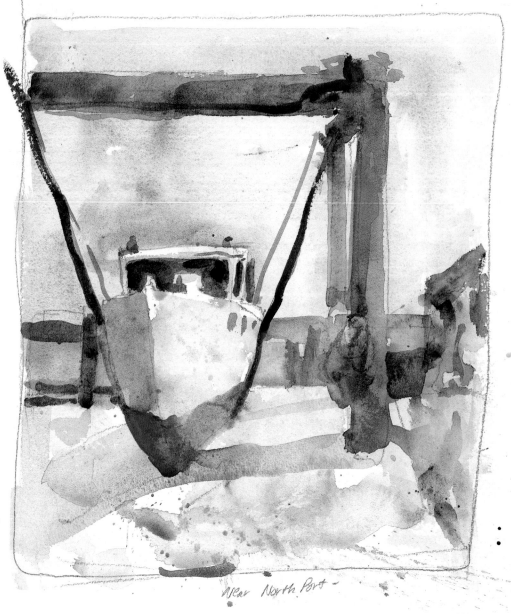

SKETCH

Here is the scene as I remember it. I haven't tried to make a bad painting to show this as a poor approach. In the right hands, facts can make a good painting.

NEAR NORTHPORT
watercolor,
12" × 14" (30.4 × 35.5 cm).

Here I reacted to what I saw. I didn't care about the architecture or the boat's classic design. I was responding to the effect of light on a white surface and to the pattern of shadows and cast shadows. Your reaction might have been different. But the point is that you must state a point of view, you must have some idea of what you want to say, even at an early stage. Compare these two paintings. What did I paint? What did I leave out? Why?

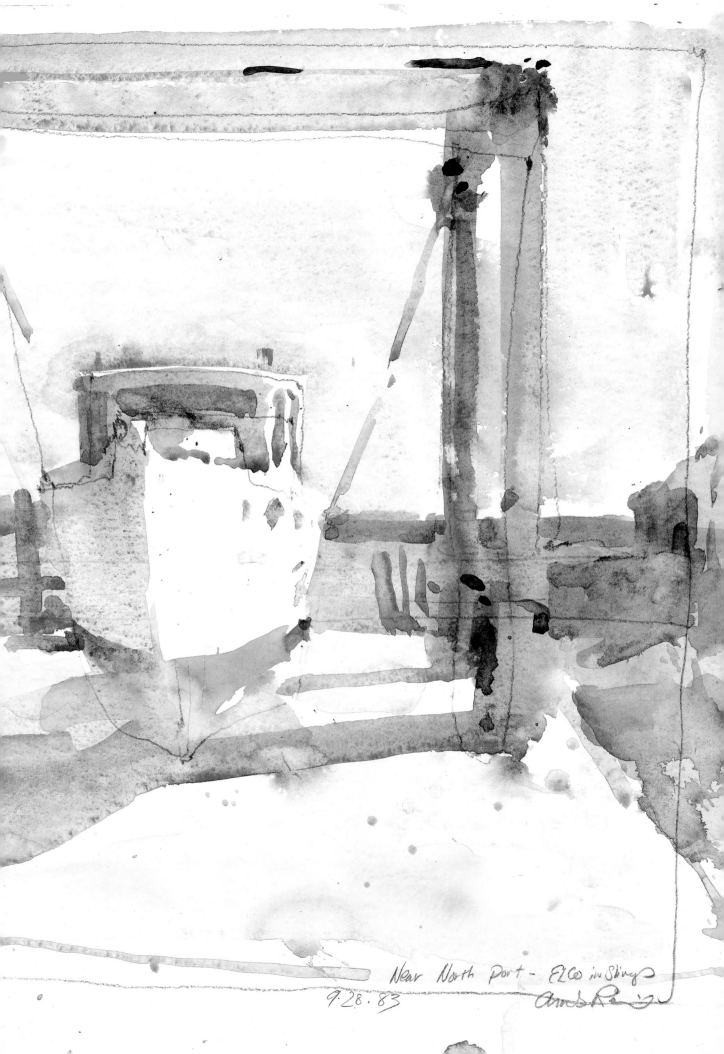

Near North Port — ELCo in slings
9.28.83

Painting in Backlight

Simplifying is a most difficult idea to put into practice. Unfortunately, many of us see too much and have trouble separating what's essential from what's merely distracting detail. It's not that detail is wrong in itself. It's just that any details and small forms you put in must be correct in value in relation to their surroundings or they will stick out and be distracting. It seems to me that less is best, especially if you're a beginner. One good way to avoid seeing too much is to use backlighting. I think this is especially helpful in figure painting where painting features can be very frightening to artists new to figure work. Under backlighting, features and other details are less prominent and shapes become more apparent.

ON THE PORCH
by Rhoda Madan-Shotkin

Here is backlight done in watercolor. Rhoda has made color changes in the shadow, but she's kept the integrity of the shadow (its overall constancy) in relation to the lights. This is important. People often change the value drastically when they try to make color changes. Remember, adding a complement will often darken a color as well as neutralize it. The lights are simply done by leaving the paper white. We see very effective negative shapes and fine descriptive shadow shapes in the face and dress.

GENE AND ALICE
oil on canvas, 60″ × 50″ (152.4 × 127 cm).

Notice that the faces and Alice's arms and legs have been painted in only two values—in a light and a shadow. You can be sure I saw many value changes in the shadows, yet I generalized them into a single shadow value. It's excellent practice to try mixing single values in a large areas, though this is especially difficult in watercolor. In this case, I probably used just cadmium red and yellow ochre in Alice's arms and legs with just a touch of titanium white in the skin shadows. Not a very exciting flesh color, but one that's charming in its simplicity. Incidentally, beginners often get muddy shadows when they add a cool color like cerulean blue or green to the warm flesh tones. So even though adding cool color in some places makes a better flesh tone, if your colors are getting muddy, try skipping the blue or green. One final note: It's critical that you see the *shapes* of light and shadow. If I hadn't got the shapes of light-struck sections correct, the figures wouldn't have made sense.

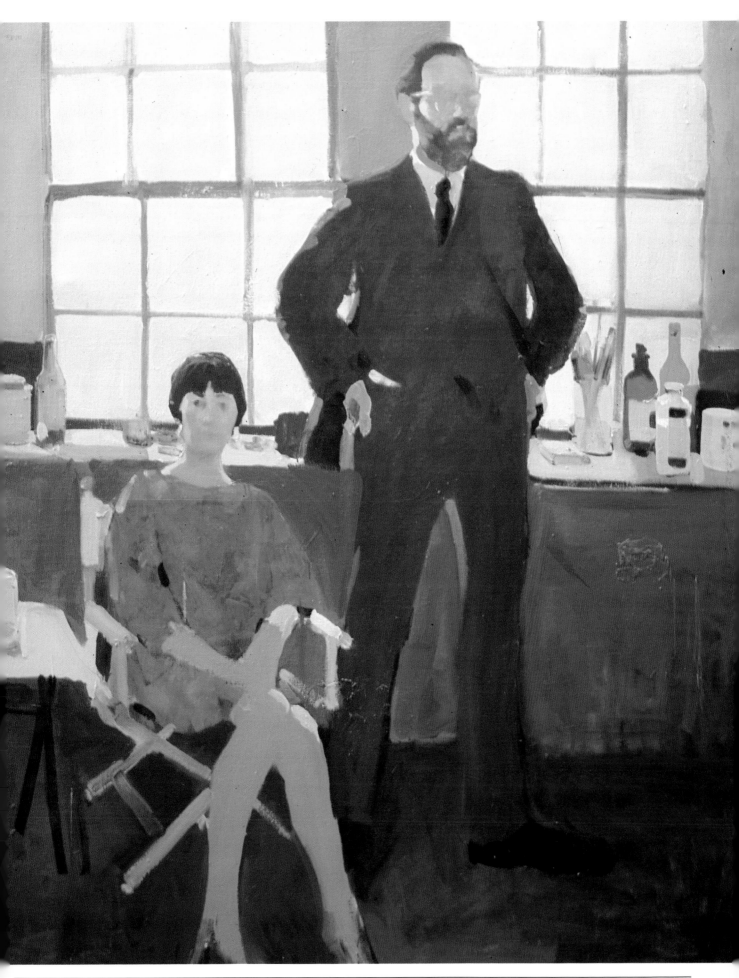

Combining Chiaroscuro and Local Color

A common fault of student painters is overdoing light and shade, forgetting to put in local color values when working with a strong light source. The result is a spotty painting. No matter how strong the light, we always need local color value to give our pictures pattern and substance.

You can see what I mean when you look at these three oil sketches, done of my family many years ago on a beach on Nantucket Island. Look at the three sketches and see if you can find where I stressed local color and where I stressed light and shade. It's pretty easy to see. Now try to envision the real scenes.

SKETCH 1

Think of how the water must have looked. Was it really as simple as I painted it?

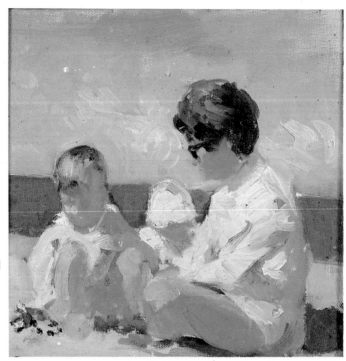

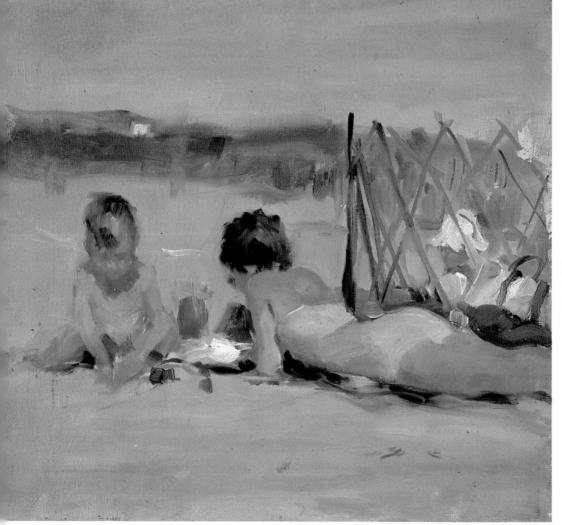

SKETCH 2

Why did I paint Judy's back more with the local color of the skin in mind, while I painted Peter's skin much lighter out in the light? Peter is painted much more in terms of light and shade. Notice the blue bag and red pail. Wasn't strong sunlight shining on them, too.

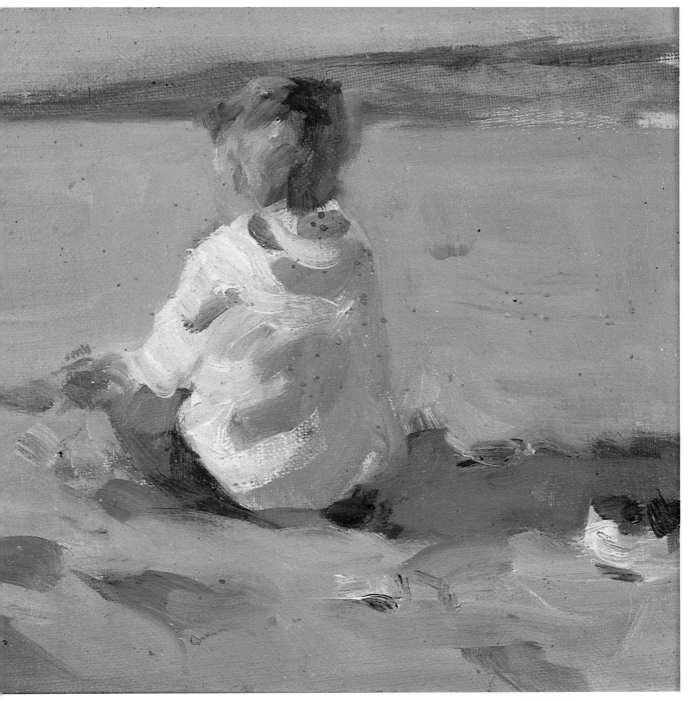

SKETCH 3

Why did I simplify the sand next to Peter's shirt (painted in local color value) but used more small forms in the foreground sand (painted in terms of light and shade)? Why are Peter's pants more of a local color idea (though there's some light and shade), while Peter's shirt is *all* light and shade?

Integrating Local Color—Values and Light and Shade

Some subjects seem to call for several painting styles—stressing chiaroscuro in one section, emphasizing local color values in another, putting pure, intense colors in some places and muted grays in others. It works as long as the areas are kept separate. Here are some examples.

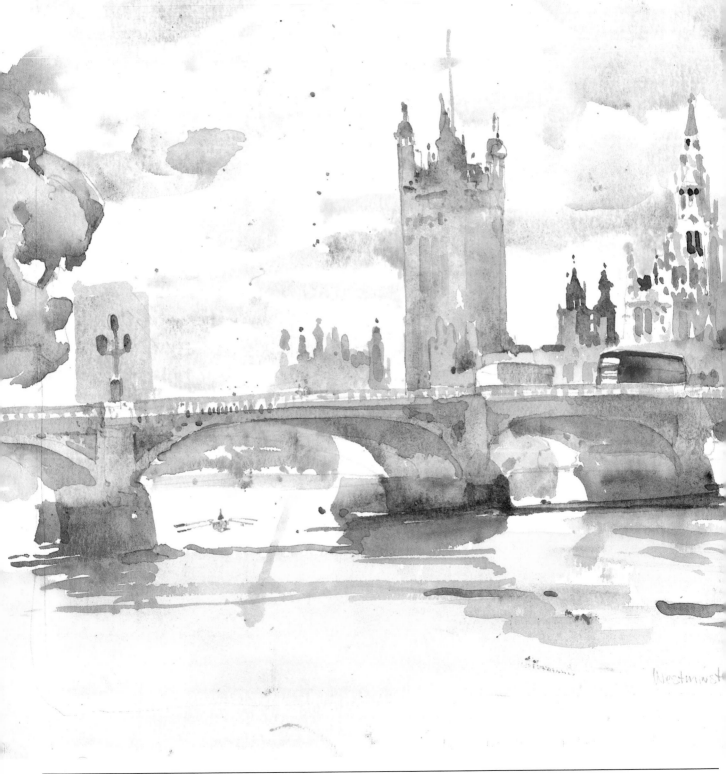

WESTMINSTER BRIDGE, LONDON
watercolor, 12″ × 16″ (30.4 × 40.6 cm).

The sun kept going in and out. Whenever it was hidden behind clouds, I saw silhouettes, and the local color became more obvious. But when it came out again, the local color-value was harder to see and I became more aware of light-and-shade contrasts. Notice the effect of this changing light in the painting. Which building stresses local color? Which depends on light and shade and negative shapes? Remember, an object must have a dark negative shadow shape to make the lighted side stand out. Which building contains both a chiaroscuro and a local color-value treatment? Where have I used negative shapes, light and shade, and local color to describe the bridge?

TERRY FRISEL
watercolor, 7″ × 10″ (17.7 × 25.4 cm).

This sketch was made many years ago to illustrate my thought for the day—to combine local color-value and light and shade in the same painting. The idea was that in some places the local color-value should dominate, and in others, light and shade should prevail. But the class had to decide where. Using this model, I asked them which areas would be most interesting painted in local color—they seemed unanimous in choosing the patterned skirt and colored socks. As for areas best suited to a light-and-shade treatment, they agreed upon the head. It's not surprising that the answer is one or the other—and your painting should reflect these decisions.

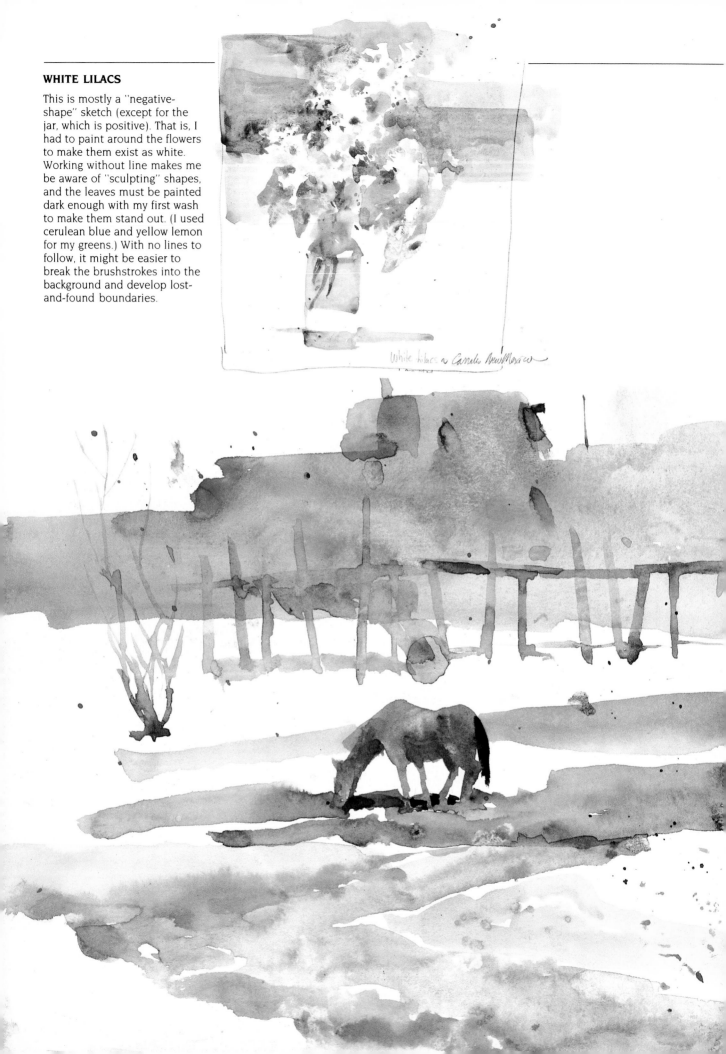

WHITE LILACS

This is mostly a "negative-shape" sketch (except for the jar, which is positive). That is, I had to paint around the flowers to make them exist as white. Working without line makes me be aware of "sculpting" shapes, and the leaves must be painted dark enough with my first wash to make them stand out. (I used cerulean blue and yellow lemon for my greens.) With no lines to follow, it might be easier to break the brushstrokes into the background and develop lost-and-found boundaries.

Switching to Local Color Shapes

Artists should go through stages. Recently I was at a show looking at pictures by an artist I admire. The person I was with remarked, "Why is she only painting cows now? I liked her still lifes much more?" I personally happened to like the cows, but that's irrelevant. The point is that artists who paint it safe don't grow. Changes don't have to be dramatic. The artist in question was merely trying out a new subject, a subject that interested and excited her. It's much better to do this than to paint something because it's in demand.

What if you don't want to change what you're painting, but want to try a new approach? There are still things to try. In my case, I wanted to get away from painting in terms of light and shade. I'd seen, Matisse, Vuillard, and Bonnard, and wanted to try painting color shapes, where local color was more important than light and shade. Nothing dramatic, just a little something to try. So on a trip to New Mexico, I decided not to take a pencil. (Pretty tame stuff!) It sounds silly, but it really helped. Somehow, painting directly on the paper, I had to think of masses right from the beginning and this helped me make stronger, richer first washes. That alone was enough of a lesson, since most artists think of the first wash as a throw away, something to get started with. Actually, when painting in watercolor, you should be looking at a "middle light" (not a highlight) when you want to know what color to paint a light area with, and you should paint the entire light area with this middle value color. In most cases, you'll lose a couple of values as the wash dries, giving you the right color-value.

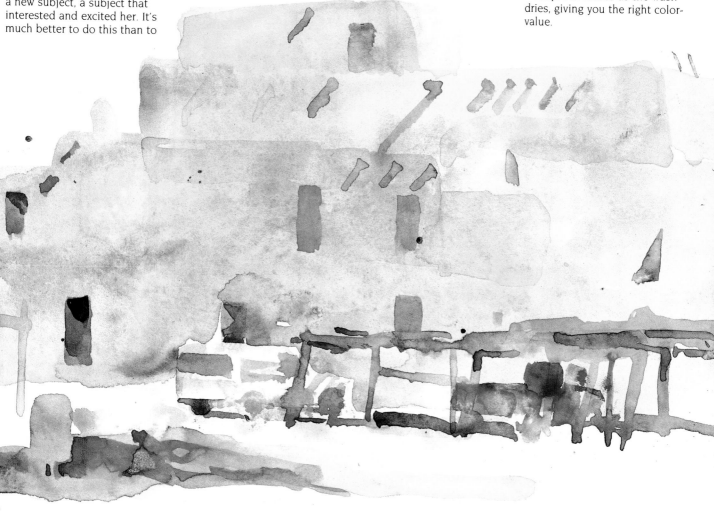

TAOS, NEW MEXICO

The sun-lit adobe looks very light so I compare it to a piece of white paper by holding a piece of paper out in the sun and glancing back and forth to compare values. By itself, the adobe looked very light, but when I compared it to the white paper, it not only looked definitely darker, but also much richer in color than the white paper.

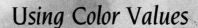

SKETCHING WITH PETER

Here I took a slightly different position and carried the picture further. (My first sketch, *Taos, New Mexico*, helped me determine the color-value of my lights.) The shadow and cast shadow shapes were added when my first silhouette was dry.

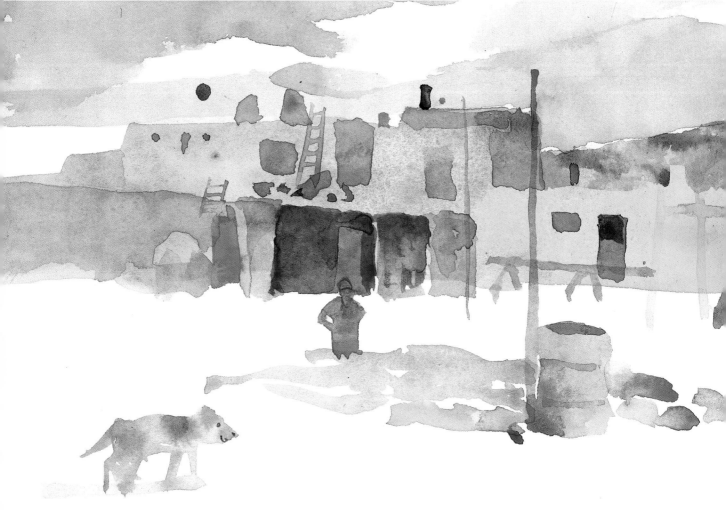

First wash. My first wash "silhouette" was made with alizarin crimson, cadmium orange, yellow ochre, cadmium yellow, and cerulean blue, though I didn't use all of these colors throughout. (Some sections had a lot of blue, for example, while other sections had none.) The paint was mixed mostly on the paper. If you're trying it yourself, don't use more than two colors in any one section.

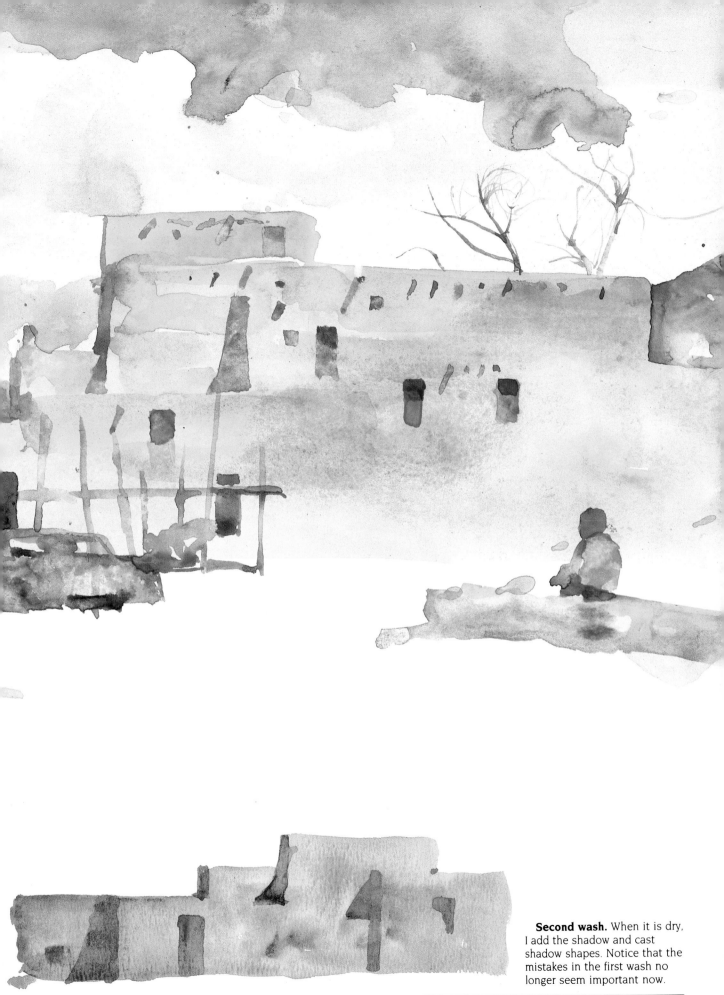

Second wash. When it is dry, I add the shadow and cast shadow shapes. Notice that the mistakes in the first wash no longer seem important now.

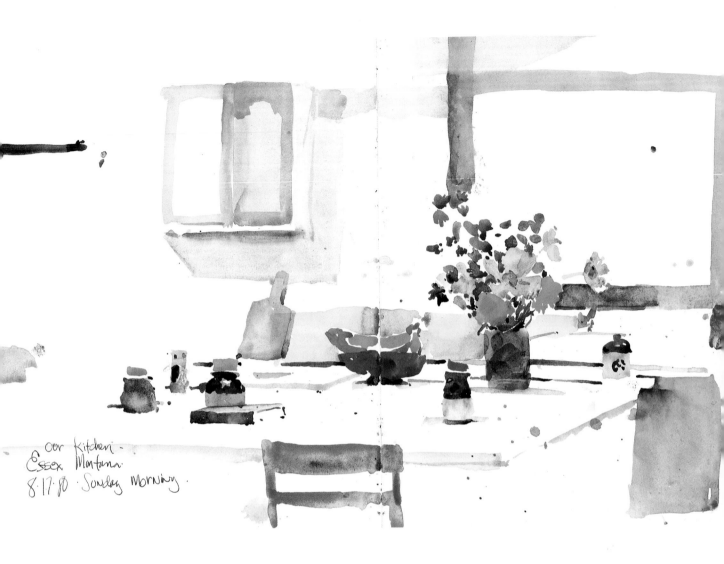

Oor Kitchen-
Essex Montana.
8.17.80 Sunday Morning.

OUR KITCHEN, ESSEX and LISBON HOTEL

These sketches show how shadow and color shapes are painted first and then become the backbone of the sketch. Artists usually think of shadow shapes when they think "shapes," and color shapes don't seem to have the same meaning and importance to them. But my attitude is just the opposite—as you can see from these examples. In all of these, the color and values have been painted premier coup—in one stroke—with no layering from light to dark. (This is handled just like an oil painting, where the darker values and colors are established before the lighter colors and values are put in.)

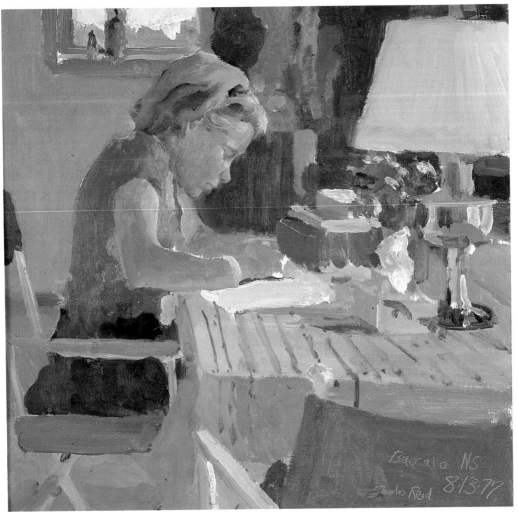

SARAH DRAWING IN BACCARO
oil on canvas, 14″ × 14″ (35.5 × 35.5 cm).

I've tried to balance my reds and blues, the main players. I then divided the painting into warmer, more neutral color on the left, and cooler, neutral color on the right. If I hadn't spread my reds and blues around the painting, I'd really have a problem. Never divide a painting in half like this, with one part cool and the other part warm. There must always be an intermixture of warm and cool throughout the picture.

The same advice holds for bright colors. Don't settle for just using one red or blue. Compare the cooler red, almost a pink in the foreground (probably mixed with alizarin and white), and the much warmer

shirt color (cadmium red light with a touch of cadmium orange). Sarah's chair back is ultramarine blue, but her trousers have some black and perhaps a touch of burnt umber in them. Cobalt and cerulean blues have been used in the table. Too often, artists get a particular blue or a red out on their palette and use only that version of the color. Incidentally, I put some red into the pants and you can see a trace of blue on the edge plane of Sarah's back. And note the "lost" edge where trousers and shirt meet. It's always a good idea to mix your major colors together in a painting to help integrate results.

PUNK ROCK
watercolor on Fabriano Esportazione, 24″ × 30″ (60.9 × 76.2 cm).

This painting was done in an attempt to get a class to use more color and paint. I was also showing them how I let colors mix together on the paper rather than pre-mix them on the palette. The blue is both ultramarine and phthalo, with alizarin crimson and raw sienna in the background.

The painting has a very "raw" look. To show the class how to avoid murky dead shadows, I used pure ultramarine blue in the folds of the jeans. This worked well as a demonstration and the class really perked up, but as a painting I dislike the intense colors here. The jeans should have been more neutral, and less alizarin crimson should have been used in the jeans and the background. I also should have used more burnt sienna, burnt umber, or raw sienna in the mixtures to balance the color. Don't use all of these colors with the blue. Instead, mix separate color swatches to test the blues and yellows. Add some alizarin, too—just don't go overboard as I did.

COLOR PATTERNS OF REDS AND BLUES

As I worked out the ratios of red areas to blue, I realize I don't actually have a balance of these two colors, just the *appearance* of a balance. Just as we shouldn't have an equal division of warm and cool colors in the surroundings, so we shouldn't have an equal division of our "major players" either. In this case, the blues have more places in terms of number, but the red actually dominates the picture visually, simply because it's more intense—though it could be argued that the red dominates because it has bigger shapes. You decide.

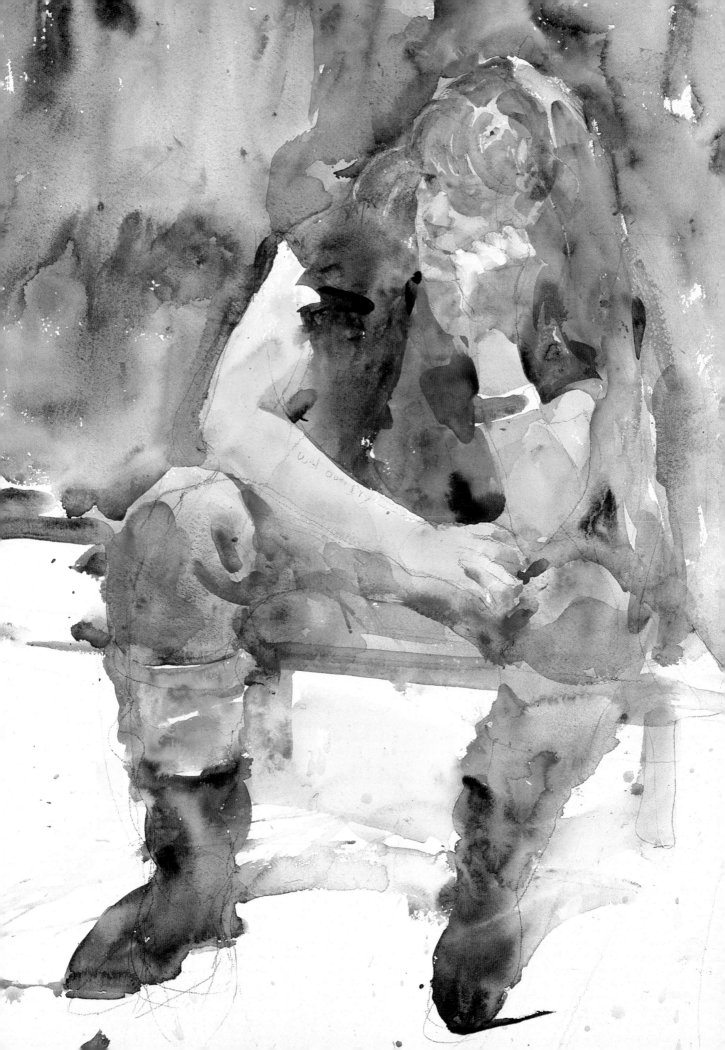

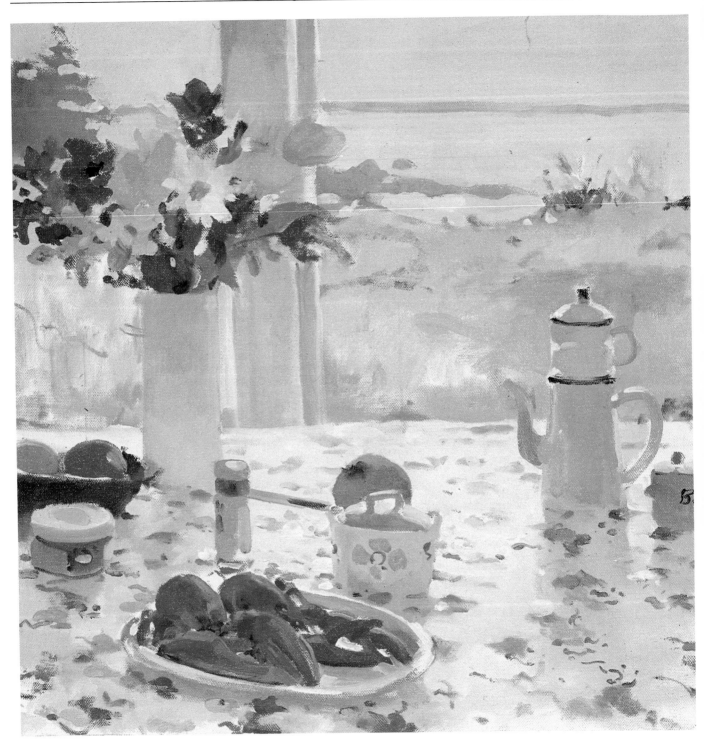

LOBSTERS AND SILK FLOWERS, BACCARO

Oil on canvas,
24″ × 24″ (60.9 × 60.9 cm).

In this painting of two lobsters we caught on opening day of the lobster season on the south shore of Nova Scotia, I've managed to present myself with several problems. First of all, I tried to paint the primary colors and their complements in my setup while the surroundings were rather misty and subtle. (The painting was done over two foggy and rather dark days in November.) This left me with the problem of balancing strong primary hues with weak background neutrals. The second problem occurred when I tried placing the weight—in value as well as color—on the left-hand side of the painting. This painting is rather like having a mischevious child. One is fond of it, but wishes it were more normal, less eccentric. I'd like you to study the painting and think of what changes you'd make. I think there are several alternatives.

ANGRY LOBSTER

I used alizarin crimson, cadmium red, and cadmium orange for my "reds" in the lobster, with Hooker's green dark, and cerulean blue as my complements. Some raw sienna *might* have been used, too, but very little.

The idea is to get more color variety into your reds. Don't mix all your reds together on the palette. And don't mix your reds and the green or blue together on the palette either. You'll just get mud. Study my sketch. I've tried to leave individual colors showing. Almost all of the mixing is done by the water and pigment on the paper. In many cases, I just put colors side by side and let them work together with a minimum of direction from my brush. Notice the cast shadows. I've only used cerulean blue, trying for color shadows rather than dark shadows. The white stripes in the lobster were left so I could work wet-in-wet and still keep some definition between forms.

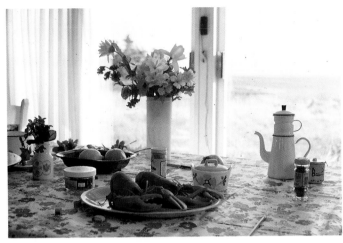

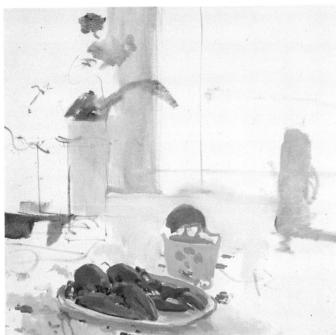

LOBSTERS AND SILK FLOWERS, BACCARO (early stage)

I took the painting out to the deck to photograph it after about an hour and a half of painting. I was filled with promises, thinking that the hardest part (the lobsters) was done and that the rest would be easy. Notice the lighter, less intense values on the purple-blue bowl in the upper left. Later I darkened the bowl and used a stronger ultramarine blue. The one darker flower in the still life is also lighter and less intense than in the final version. Finally, the colors in the expresso pot are warm. Later I made them cooler. The painting has a rather "misty and soft" look that I should have kept. It would have gone better with the feeling of the landscape beyond.

The changes I made later (for the worse) show that I failed to understand what was happening in the painting as a whole. Instead, I concentrated on the still life and copied the values and colors I saw without realizing they were out of pitch—correct in terms of the individual objects but wrong in terms of the spirit of the painting.

Characterization Through Exaggeration

Frank Reilly used to say, "Exaggerate the principle." In general, that's sound advice, but in figure drawing, it's the best advice I can give. There are no truisms in painting. Still, most of us underplay, tone down, overmix, and generalize too much. This time, let's consciously try to exaggerate, to go out on a limb. Let's make objects, features, and shapes very obvious. In overstating everything, we'll probably find that what we think of as exaggeration is really closer to the reality we're trying to express.

BLUE NUN, NEW ORLEANS

Faces aren't always the key to catching character. In *Blue Nun, New Orleans*, the shape of the coat (Connie Jones) or the bulk of a body (Glen Wilson) says about as much about these two men as a detailed portrait study.

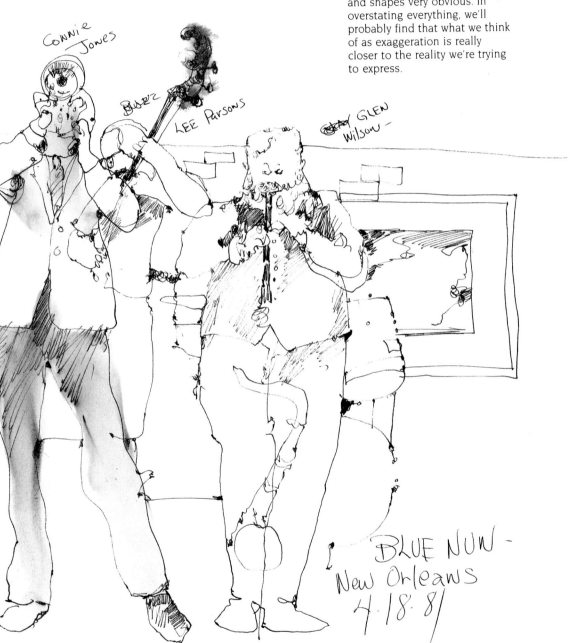

SI

These two drawings were made minutes apart, yet one seems to "say something" and the other seems to be just another drawing. Comparing them taught me something. They helped me find a direction. To me, the drawing of Si looking down captured an attitude and emotion that wasn't expressed as well by the drawing of his profile. Do you know what I'm getting at?

HACIENDA

Notice my exaggeration of the two central figures: the one on the left with the restated nose and small chin, and the man to his right, with the large chin. Notice where I've restated boundaries to get a specific nose or shoulder line. What if I had left the first shoulder lines (the inner lines) in both figures? Proportions are important, but what do you think of my "re-thinking" lines? Do you think a "hunched back" makes a more expressive figure? Should I have understated a nose? If I had, would the man have seemed as interesting?

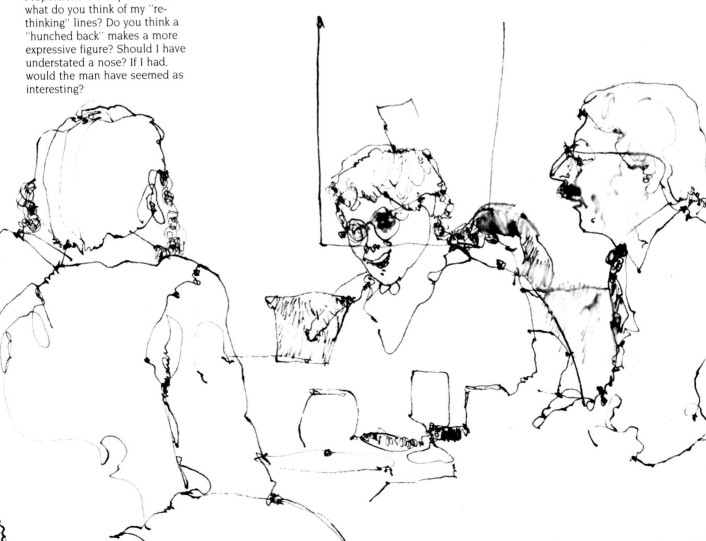

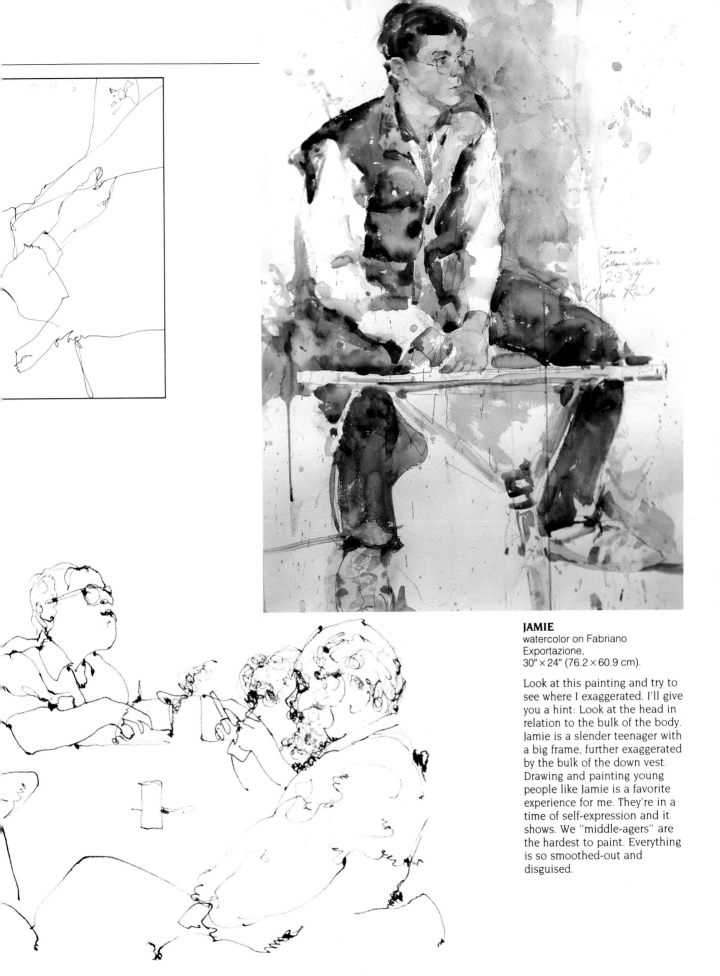

JAMIE
watercolor on Fabriano
Exportazione,
30″×24″ (76.2×60.9 cm).

Look at this painting and try to
see where I exaggerated. I'll give
you a hint: Look at the head in
relation to the bulk of the body.
Jamie is a slender teenager with
a big frame, further exaggerated
by the bulk of the down vest.
Drawing and painting young
people like Jamie is a favorite
experience for me. They're in a
time of self-expression and it
shows. We "middle-agers" are
the hardest to paint. Everything
is so smoothed-out and
disguised.

Catching the Gesture

Let's look at the action in these three sketches. I did the watercolor in a sketch class. At the time, I tried to exaggerate the model's pose and heighten the feeling of movement by exaggerating the slant of her shoulder line, though I left the head vertical and the waistline horizontal. Yet looking at it now, I find it a bit dull. The painting itself is okay, but the underlying drawing isn't very good. Nothing much is happening. There's no point of view. My attempt to get movement in the shoulders only resulted in giving a rather awkward shape to her right shoulder.

To improve the sketch, I made two drawings using the watercolor as a reference. One exaggerated the action and the other minimized it. Let's see which one was more successful.

CATHERINE AS DANCER
watercolor on Fabriano Esportazione, 24″ × 32″ (60.9 × 81.2 cm).

You must become more aware of the action of the model, the overall gesture, so you can make a conscious decision to exaggerate or minimize it, depending on the final effect. To express action, remember:

1. Create conflict by letting different parts of the body work against each other. For example slant the shoulder one way and the hips the other.

2. Avoid the vertical and horizontal. Tilt the head and slant the waistline, instead of leaving them static.

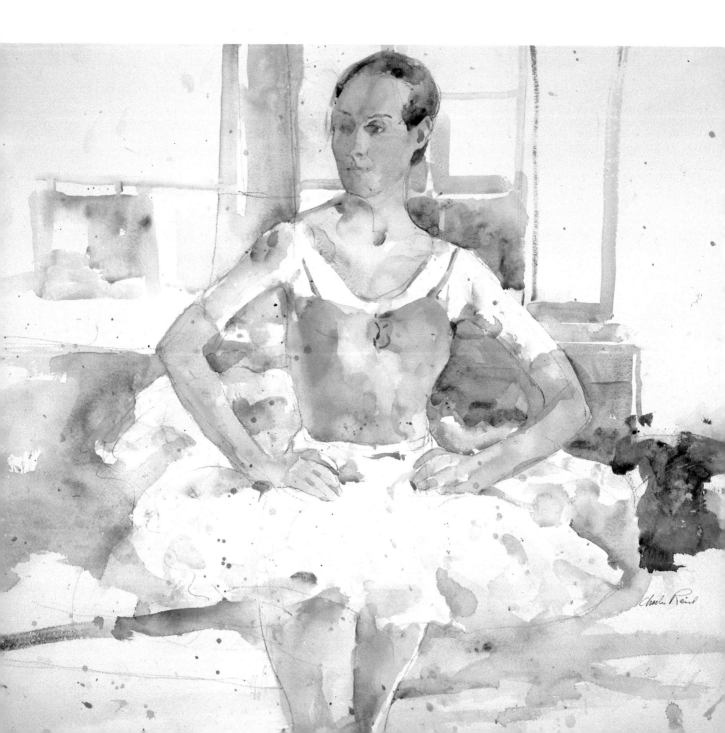

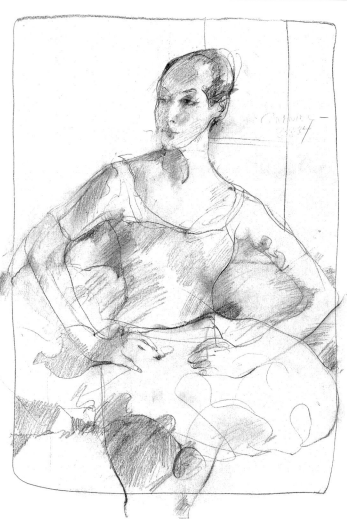

DRAWING 1

I exaggerated the action and did everything I could to get movement by tilting the shoulders and slanting the hips. I got movement, but I think the result looks commercial, like the kind of pose a fashion artist might use.

DRAWING 2

I ignored the principle of action and allowed the shoulder line to remain level and become parallel with the hips. By minimizing the action, I could lower the right shoulder and reveal the model's graceful neck shape. The rather small head and long neck take the figure out of the ordinary, and the pose seems natural and unaffected.

The lesson? Never approach a model with a preconception of what you want to do. I had assumed I wanted a certain action in the figure that really didn't suit her. I should have made these sketches *before* I did the painting.

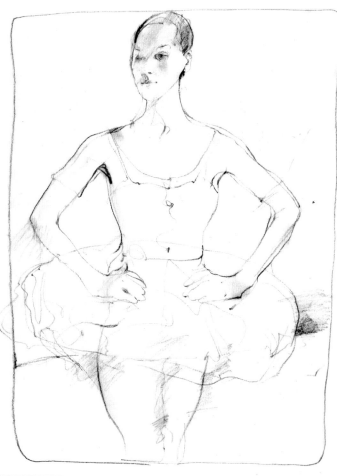

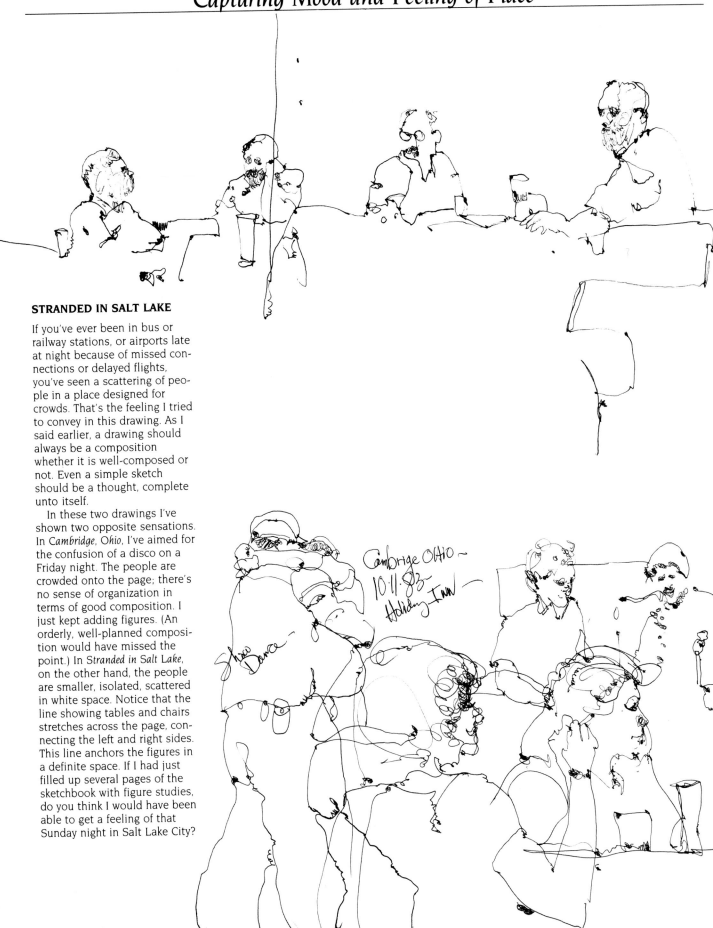

STRANDED IN SALT LAKE

If you've ever been in bus or railway stations, or airports late at night because of missed connections or delayed flights, you've seen a scattering of people in a place designed for crowds. That's the feeling I tried to convey in this drawing. As I said earlier, a drawing should always be a composition whether it is well-composed or not. Even a simple sketch should be a thought, complete unto itself.

In these two drawings I've shown two opposite sensations. In *Cambridge, Ohio,* I've aimed for the confusion of a disco on a Friday night. The people are crowded onto the page; there's no sense of organization in terms of good composition. I just kept adding figures. (An orderly, well-planned composition would have missed the point.) In *Stranded in Salt Lake,* on the other hand, the people are smaller, isolated, scattered in white space. Notice that the line showing tables and chairs stretches across the page, connecting the left and right sides. This line anchors the figures in a definite space. If I had just filled up several pages of the sketchbook with figure studies, do you think I would have been able to get a feeling of that Sunday night in Salt Lake City?

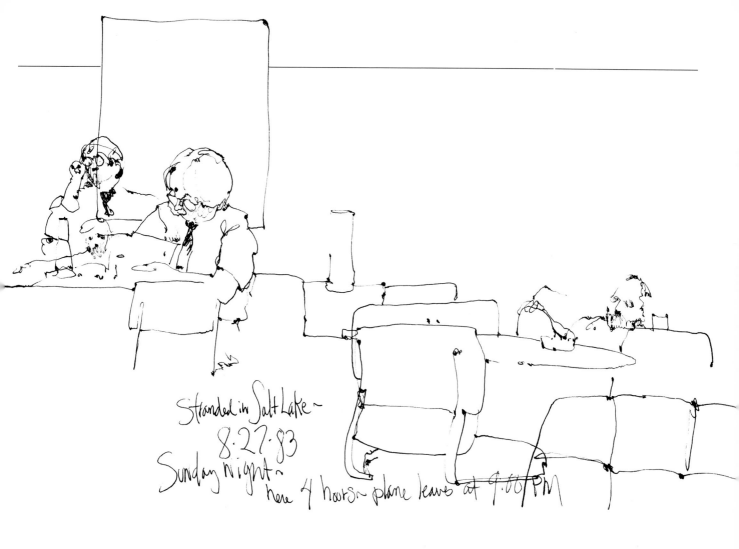

Stranded in Salt Lake ~
8·27·83
Sunday night ~
here 4 hours ~ plane leaves at 9:00 PM

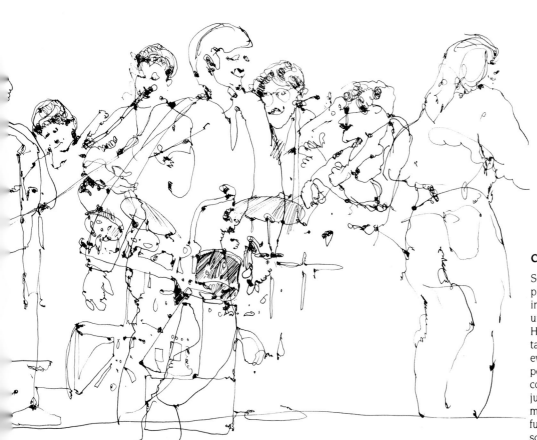

CAMBRIDGE, OHIO

Some of you who travel can picture the scene: Sound, flashing strobes, and twisting figures—a Friday night at a Holiday Inn. Usually for a solitary traveler, it calls for an early evening, but I seem to have persevered. I didn't think of composition when I drew this. I just kept filling the page with as many figures as I could. A confused picture of a confused scene.

While I believe we should make value and color changes that suit our paintings and not be a slave to what's actually in front of us, sometimes I think it's wonderful practice to catch a specific time of day or get the feeling of the weather at a particular moment. As I sketch, I think less about composition than I do of catching a specific cloud formation or getting a certain color and value relationship between the rocks, sea, and sky. In other words, I am primarily involved with what's in front of me, hoping it will look good on the paper. Here are the results of some of these study sessions, five small sketches I did in Nova Scotia. Try some quick sketches like this, too.

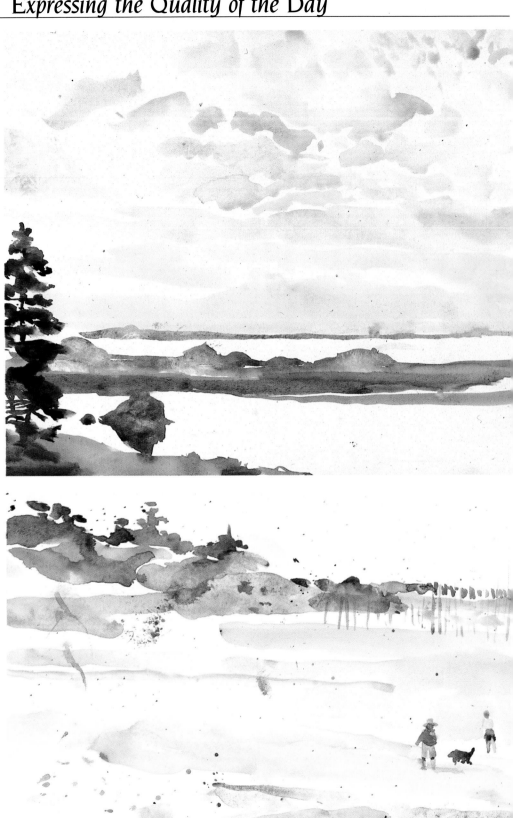

ALFRED'S BLUE BOAT

I wanted to express the freshness and purity of a sunrise scene—the soft, clean colors and the stark contrast between the colorful sky and the dark land masses. To keep the soft effect, I diluted the sky colors with water. The pinks are cadmium orange and alizarin—sometimes mixed, sometimes used separately. The pale blue is cobalt and the gray clouds are ivory black. To get a clear, definite feeling in sky and land masses, I used hard edges throughout. Even though we're told that some pictures need some soft edges, I think the hard edges helped me here. I left the water as white paper because I wanted the rocks to stand out starkly, and a light wash on the water would have decreased the contrast there.

→ t got up to get him off fishing with Gordon Hawin on Alfred's boat - 5:45 ~ July asleep So Sam & I sit on front and Watch for Alfreds blue boat - Great Sky!

SANDY COVE, NOVA SCOTIA

The day was crisp and warm, with no wind. I tried to keep my colors clean and hardly did any mixing on the palette. I didn't want grays; I wanted strong color. So I used the color right out of the tubes, using only water to cut the intensity. Note the alizarin crimson on the sandbar at the lower left. I put the slightly diluted alizarin there, then allowed some cerulean blue to flow into it. I didn't paint them together but let the water and diluted pigment mix by themselves. The blue of the water is cerulean with only some water added. I tried to give each area—the sea, sand, and people—a color identity, even in very light, high-key areas.

Left to right - Elinore, Sam, Peter, Sarah and Judith at Sandy Cove N.S. - 7.26.78 -

SPRUCE TREES, CROW NECK

The color of these trees defy me. They're a sort of dirty blue-green. Hooker's green and viridian didn't seem to work too well, and I tried cerulean, cobalt, and ultramarine blues with various yellows (yellow ochre and raw sienna), and just about every other conceivable combination.

Black is called "the prince of colors," yet it's rarely used. As an experiment, I decided to use only ivory black and yellow for the grass and trees on Crow Neck. (I tried both cadmium lemon and cadmium yellow pale.) I also used black in the cloud shadows, foreground rock, and the boat on the right (along with some cerulean blue). Try mixing black with raw sienna and yellow ochre—also with the umbers and burnt sienna. But simplicity in values and shapes is vital, and so I had to be careful not to make the details too dark. Compare the values in the tree masses on the right with the darker bluish spruce on the left. Dropping in a lot of darks would have destroyed the soft, misty look.

Spruce trees. Baccaro –
8·10·78

SCHOONER, CHESTER, NOVA SCOTIA

The sun was going down beyond the sailboat and a slight breeze was ruffling the otherwise placid inlet. To get a feeling of backlighting, I tried to keep the silhouettes simple, with a little detail. But I kept the dark masses lighter than usual to give a feeling of haze. To get the effect of the sun raking across the water, I kept the paper white except for a few painted ripples. Finally, I blotted the wash in the schooner's cabin and on the tree line beyond to suggest the sun's glare.

Seeing the "Big Picture"

CASA MARINA, KEY WEST
watercolor, 11″ × 14″ (27.9 × 35.5 cm).

This was done in two separate sessions. People on the beach tend to move at awkward times, making any modeling impossible, and so I had to depend on very simple shapes. Notice that almost all the light areas have a darker negative shape behind to "set" off the light shapes. Where I didn't have a darker negative, I stressed the local color value of the skin tones. We see this on a pair of legs in front of the central beach hut. Since I knew this was going to be a vignette, I deliberately left large areas of the sketch unfinished since I hoped to leave other parts white paper. Had I painted the beach huts completely, they might have looked cut out and pasted down on the white paper. Instead, I just painted the shadow shapes on them. Painting in less left me more flexible. Later, if I decided to paint the water, I could paint the beach huts out in the light, too.

TWO SKETCHES: SUN CASTLE, POMPANO BEACH, FLORIDA
watercolor, 11″ × 14″ (27.9 × 35.5 cm).

It's important to keep in mind one single idea you want to stress. In the case of these two sketches, I simply wanted to establish the overall value relationship between the catamarans and the sand, the sand to the sea, and the sea to the sky. A lady came by while I was painting the first sketch (two boats) and complained that I wasn't putting in the waves. My obvious inadequacy went unspoken. What if I'd added waves? First of all, waves are hard to paint; they keep moving. But had I added waves, what would have happened to the value relationship between the sand and the sky?

In the second sketch, I had a more difficult day to deal with: an overcast sky with much closer value relationships. What if I'd added some tone in the light areas on the catamaran instead of leaving them white paper? How would that have affected the relationship of boats to sand?

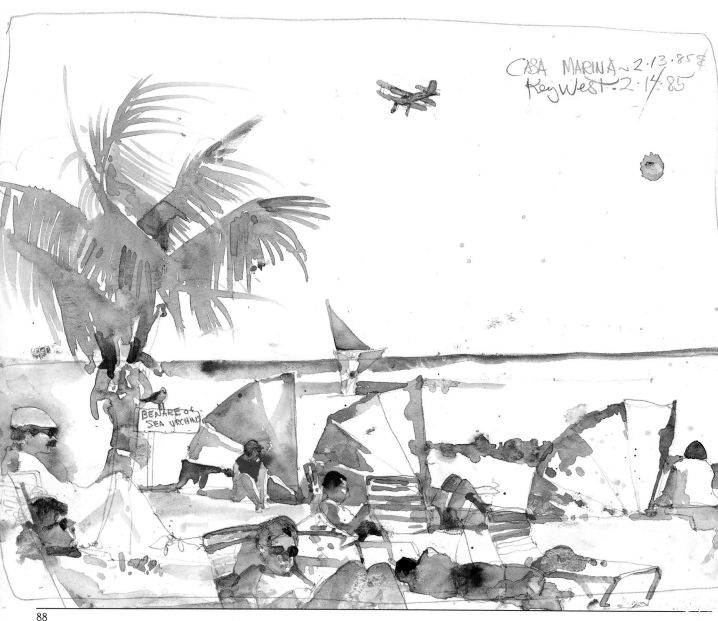

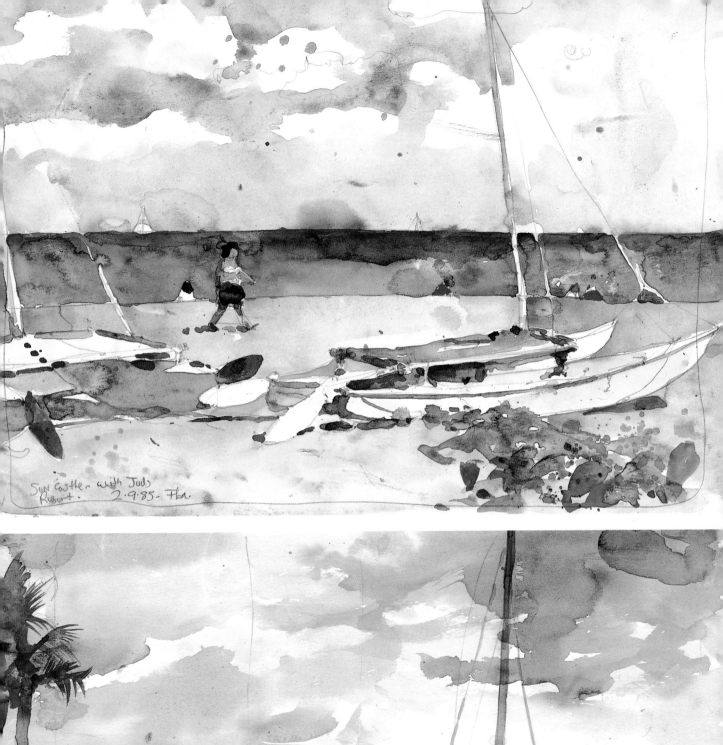

Sun Castle. With Judi
Resort. 2·9·85 - Fla.

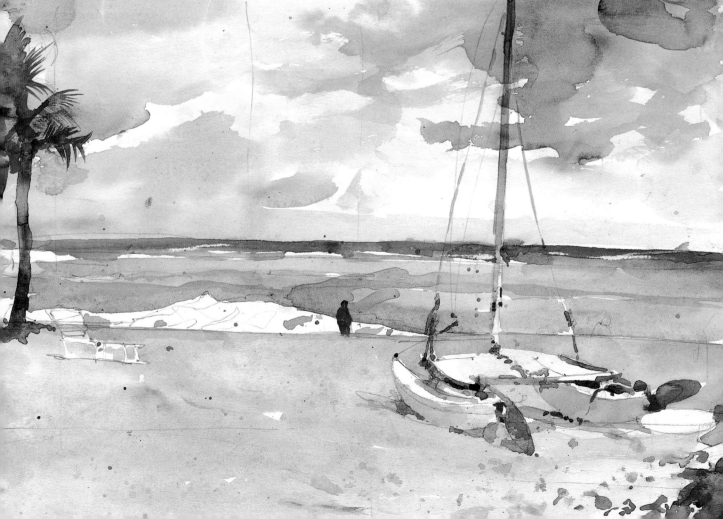

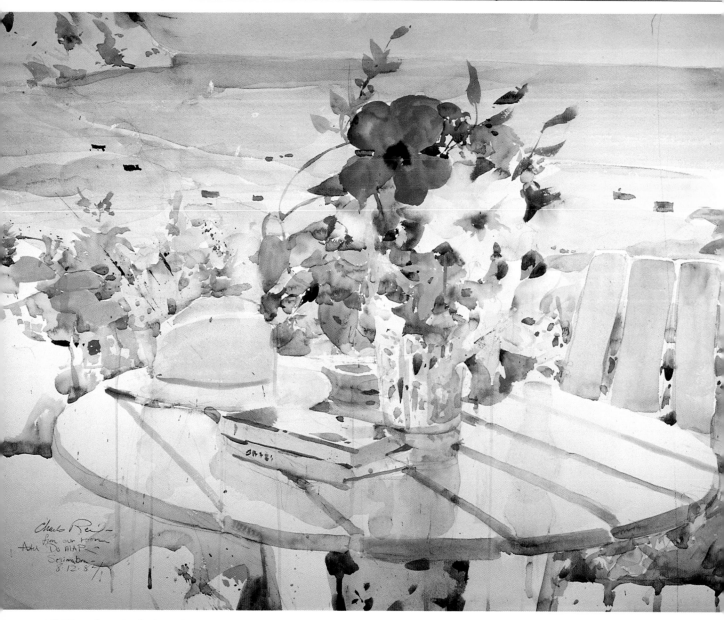

HOTEL DO MAR, SESIEMBRA
watercolor on Fabriano Esportazione
22″ × 30″ (55.8 × 76.2 cm),
collection Marge Ferguson.

Our veranda in Portugal was
filled with beguiling subject
matter—exotic flowers, lush
surroundings, and an azure sea
beyond. You have to be excited
about your subject first. But
then you have to stop seeing it
as a beautiful bouquet in a
beautiful setting and start
seeing it as masses of beautiful
color shapes. If you have trou-
ble with this, the following exer-
cise should help you.

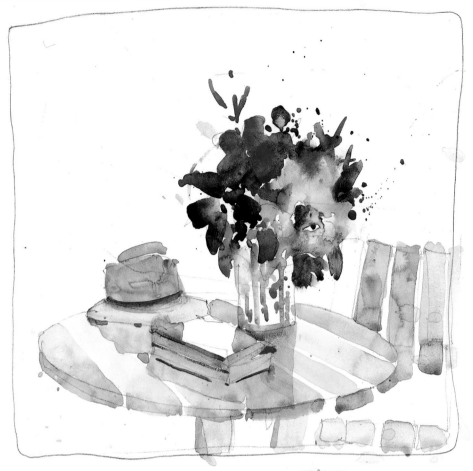

ASSIGNMENT

Positive Shapes. Choose a subject you'd like to paint: a bowl of flowers, a still life setup, a person, or even a tree. Establish your picture borders, then draw the subject with a contour line. Then paint it. Forget about the background and details. Just aim for a clear understandable silhouette of dark, middle, and light values on a white background.

Negative Shapes. Now make another drawing, this time painting only the background or negative shapes and leaving the parts painted in the first sketch.

Combining Shapes. Using the first sketch as a reference, paint in the blank areas. You should now have a complete painting containing both positive and negative shapes. It's best to work from dark to middle color-values, leaving your lightest color for the end. (I made the table and hat lighter in the final painting than in Sketch 1 because I wanted some of my positive shapes to be lighter than some of the negatives.)

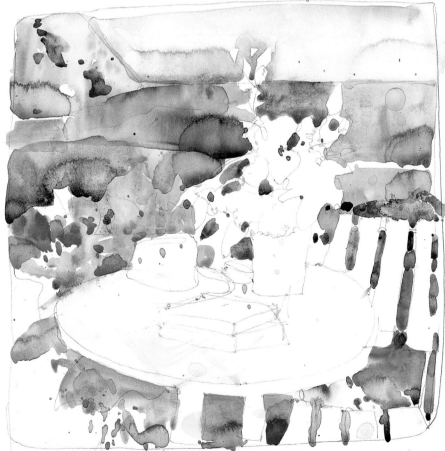

The sketches in your sketchbook don't necessarily have to serve as the basis for future paintings. They can be a valuable source of exercises to get you used to seeing painting possibilities in the material around you.

SKETCH 1

These three sketches were done over a two-hour period on a brisk autumn afternoon near Casonovia, New York. I was attracted by the geometric shapes in the fields as opposed to the soft, feathery quality of the trees and distant hills. I was also intrigued by the strong yellow-orange of the fields on such a bleak day. Now that I had decided what interested me, I was ready to begin. I made the sketch smaller than the paper itself and surrounded it with definite borders—note the pencil line I've drawn around all three sketches. (These lines define the picture frame, the borders of your composition. Be sure to include them.) Then I wandered off so I could return with a fresh and critical eye. In this case, I came back to find the oranges harsh and the greens rather dreary. I did like the rather abstract feeling in the fields, though, so all wasn't lost.

SKETCH 2

Make a second sketch, trying to retain what you liked about the first but altering the few things that displeased you. Be specific in your mind about what you'd like to change. Don't just paint, hoping your second sketch will come out better. Here, I cooled the cadmium orange down a bit with alizarin crimson and cerulean blue. I mixed my tree greens on the paper instead of the palette, hoping they'd look less tired and dull. While I was working, Tom, a student, came along and started painting, so I included him in the sketch.

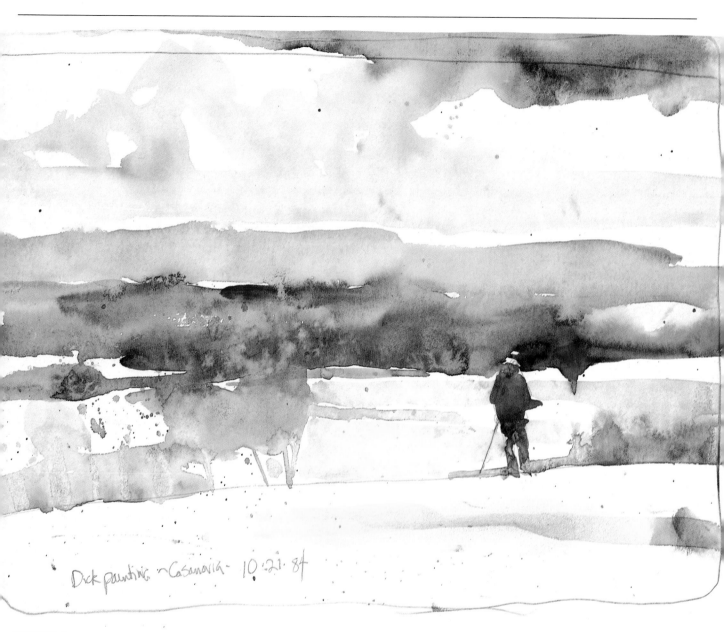

Dick painting ~Casanova~ 10·21·84

SKETCH 3

Again, I analyzed the result after a brief "break" from painting. The second sketch was an improvement over the first, particularly in its color feeling, but I still didn't have a painting. Then I looked a bit to the right where another student, Dick, was painting the same view, and I realized that he reminded me of a figure from an Ingmar Bergman film. This changed my initial painting idea, but it didn't matter. I was still painting with an idea and a purpose.

ASSIGNMENT

Choose a view that makes an initial impact on you. Next think of an objective goal, some concrete idea you'd like to express. Don't start your sketch with just a vague idea of a scene that looks interesting. If you can't think of a concrete painting idea, walk around a bit and let the place sink in. (I'm assuming you've come to a place with possibilities.) Don't just get back into your car and drive off to find the perfect spot. Analyze what attracted you to the scene in the first place.

"Shorthand" Drawings

Occasionally situations arise where we know there isn't much time to make a drawing or painting. In the case of each of these three sketches, I had different problems. In *AP, Bacarro*, I had planned to do a watercolor of my friend Alfred. He said he could pose for the entire morning, but it soon became apparent that his idea of posing and mine were very different. His idea was to have "a yarn" while staying in relatively the same spot; mine (foolishly as it turned out), was to have him keep still. In *Perry*, the second sketch, my model was a busy cowboy with plenty of work to do. Twenty minutes posing time was all I could ask of him. Finally, in *Stable*, I had a lot of territory to cover, including three horses with the fidgets. In all three cases, I would have liked more time to do more realized pictures. Just the same, I think there's a great deal to be learned from shorthand painting. Drawing quickly helps us to see the importance of large shapes and forces us to tell our stories with a minimum of detail.

AP, BACCARO, NOVA SCOTIA
watercolor,
18" × 23" (45.7 × 58.4 cm).

I put Alfred near the window so I could have a rim light with most of the face in shadow. Had his face been in the light, I would have had to deal with more halftones, and there'd be more fussing. Remember, shadows should be simple, with very little modeling.

I painted the shadow shape over a dried light-value first wash. I used only one value for the shadow and completed it in a single wash, ignoring all the small value changes I saw in the shadow. Then I went back to the cheek with a clean brush. (I rinsed it out in water and gave it a hefty shake rather than drying it with tissues, because a dry brush would act like a sponge and lift out too much color. On the other hand, too wet a brush would cause a flood. All you want is to allow the color of the shadow to move out into the light to make a soft halftone.) Note that the warmth of the shadow color, as it flows into the light, gives the cheek a slight blush.

I carefully shaped the boundary where the shadow meets the light. This boundary, with its hard and soft edges, is where I try to catch the particular quality that is Alfred. The hard edges in the form to the right of his mouth are really the key to his rather impish personality. The mouth itself is important too, but had I missed the structure next to the mouth, it wouldn't have looked like Alfred. His eyebrows are also unique—even more than his eyes. Compare the understated eyes with the brows (both painted wet-in-wet), and notice the "skips" in the glasses, (I didn't complete the rims) painted wet over dry. I also added slightly warmer and darker color to the nose, working wet-in-wet.

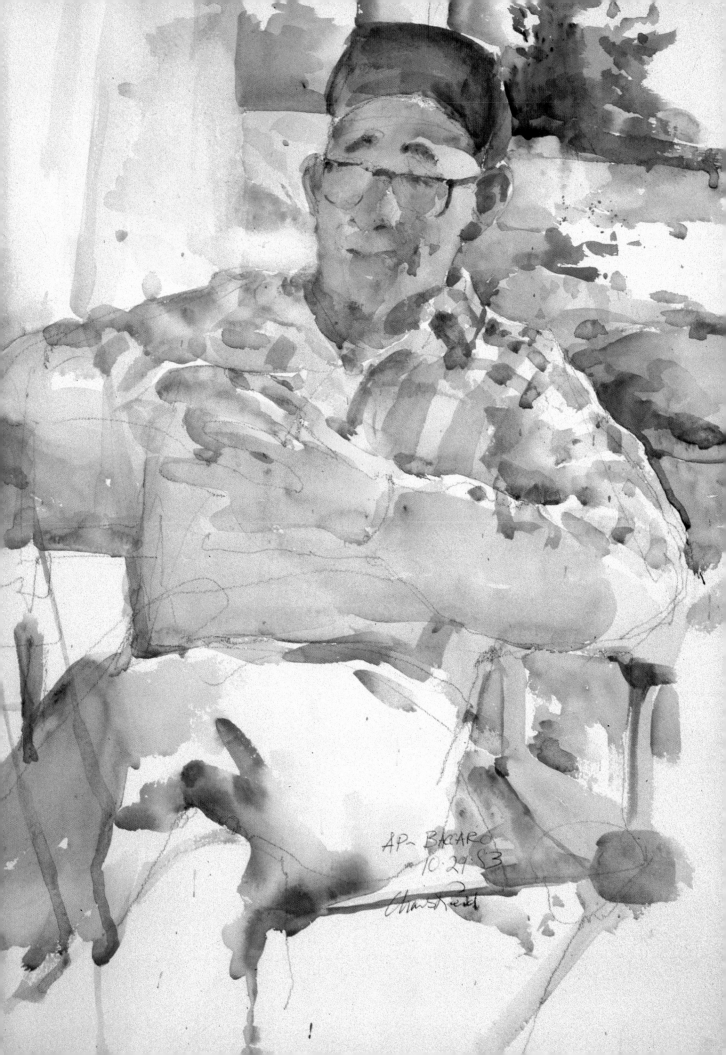

AP. BACARO
10.29.83
Chas Reid

PERRY, CRYSTAL LAKE, MONTANA

This sketch is much smaller than the one of Alfred, but the handling of the face is similar. To save time, I eliminated the light fleshtone wash and I began with the shadow shape, leaving the light-struck areas white paper. Then I painted the shadow on the hat and under it at the same time, ignoring the boundaries. (While the shadow is still wet, be sure to soften some edges where the shadow shape meets the light. I often plan where the edges need softening *before* I start to paint.)

Notice the touch of face color in the hat. I had accidentally added some fleshtone to the hat shadow in an effort to find the boundary on the left side of his face. But it looks fairly natural because the exact color you add doesn't matter as much as

getting the right value. In fact, the value changes you see on the face are actually color changes. I added more cadmium red and a touch of raw sienna to the cheek where I wanted a strong contrast with the sun-struck section, and did the same under the chin. I even added cerulean blue to Perry's right cheek. Again, you can get away with a lot as long as your values are right.

I painted the arm with one wash and added cerulean blue directly into the warm color, wet-in-wet. Since the lights were rather washed out, I gave them some form with distinct—*not dark*—negative and shadow shapes. I don't recommend washed-out lights, but if you happen to get them, this is one way to save the day.

STABLE (KEN AND PERRY'S HORSES)

This is a very rough sketch, and I only include it to show you how to get some structure into a drawing very early on. Notice the handling of the stable. Painting the shadow and negative shapes first gives me important information. I can always go back and add a light wash (with some color changes) over parts of the building that are still white paper. But if I'd worked on the areas in the light first and had to stop before I had time to add shadow shapes I would end up with some formless light washes but nothing resembling a barn. I also painted some local color into the horses, aiming for a final statement with the first wash. The horses aren't great, but it's good practice!

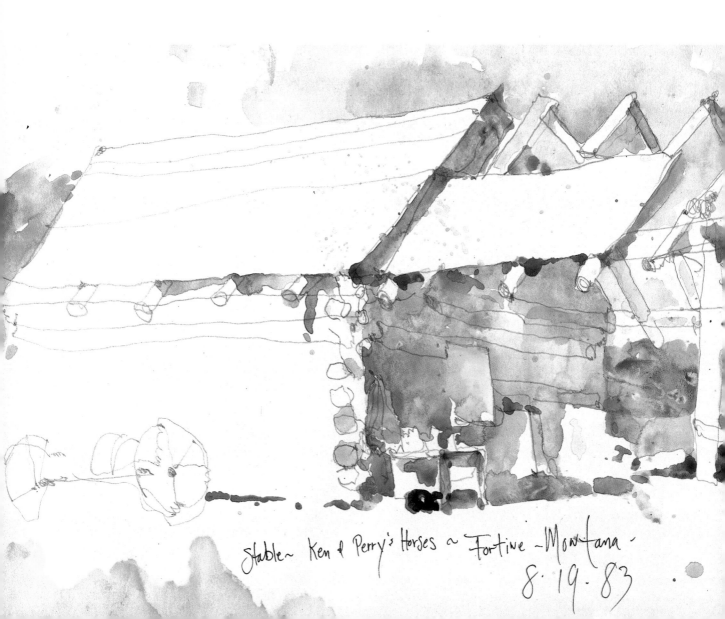

Stable~ Ken & Perry's Horses ~ Fortine ~Montana.
8·19·83

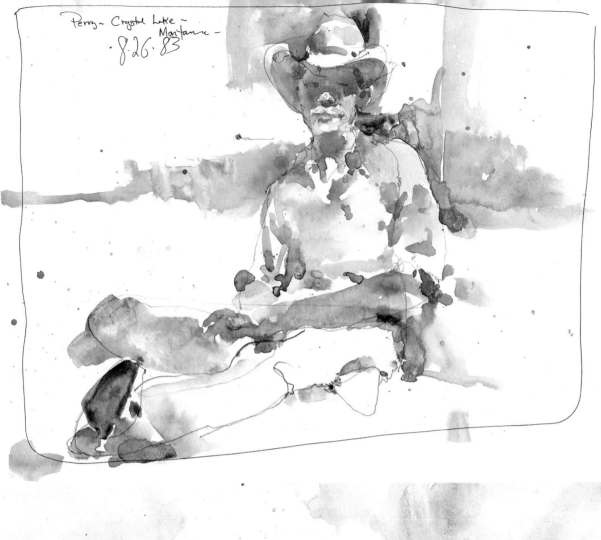

Perry ~ Crystal Lake ~
Montana ~
8·26·83

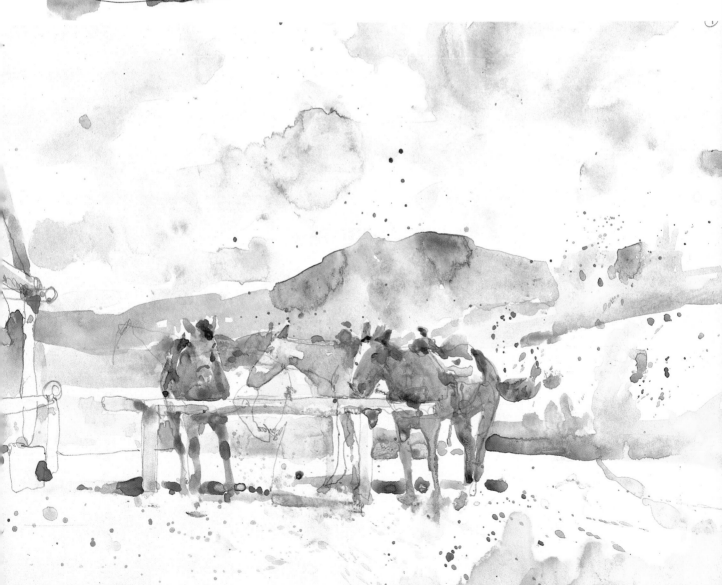

TIPS ON TECHNIQUE

I did two paintings on a recent trip to Portugal. Both were done on the spot, both took about two hours to paint, and both were unfinished. I made some quick decisions knowing I had a limited time to paint, but I feel that in the case of these two paintings my decisions were poor and so the paintings weren't in good enough shape to finish later in my studio. By examining my mistakes, seeing how I made them and how I tried to fix them will help you in your painting.

ANTONIO
watercolor on Fabriano Esportazione,
22″ × 28″ (55.8 × 71.1 cm), private collection.

I worked rapidly because I was painting in sunlight. (In direct sunlight the light changes rapidly, and so the shadows and cast shadows seen at 9 AM will look very different at 11 AM.) But I shouldn't have finished the face so completely. Instead, I should have gotten the color feeling of the face by running an initial wash over the entire face, and come back later to establish the planes and shadow and cast shadow shapes (assuming the sun were to stay out). I also should have massed in more foliage, along with some sky and water, so I had some background information to work with back in the studio. And I should have indicated the chair and have done more work on the hands.

FINISH
(completed in my studio)

I decided against trying to paint the foliage out of my head, but instead, because the face is basically a light shape, I chose a dark, nebulous background. Study the boundaries on the shadow side of the figure. The background actually gets slightly lighter as it nears the figure so the figure would "flow into the background in the shadow. This is why you shouldn't stress boundaries on the shadow side of an object. On the other hand, to separate the figure from the background, the boundaries on the light side should be made clearer and crisper. To see what I mean, compare the edge of the hat in the light with the edge of the shadow section behind the ear. Of course, there are always exceptions to every rule. Notice the edges on the light side of the figure. The hat and shoulder are both technically in the light yet the edges on the hat are less distinct. Do you know why I did this?

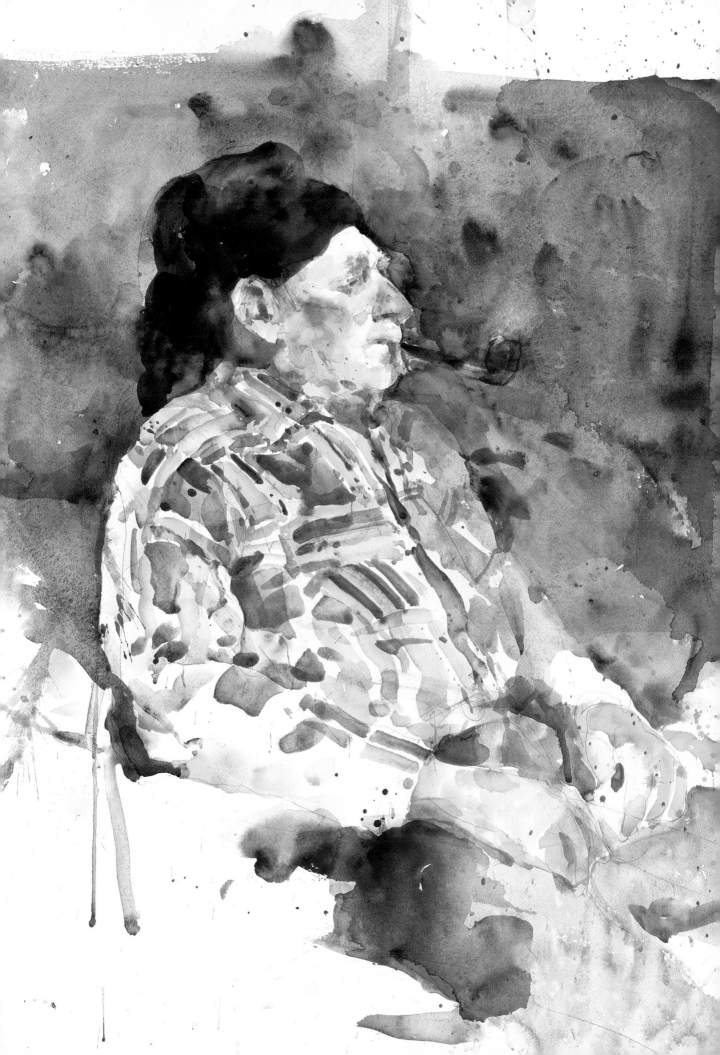

REPAINTING ANTONIO

Looking back over my on-the-spot sketch, I now see what I should have done:

1. I should have put a first wash on the face using a color note that would relate it to the background.

2. I should have worked a wash into the background, resolving the leaves and water.

3. I should have established the major shadow shapes on the shirt.

4. I should have worked more in the light areas, on sections of the shirt where the pattern is most important. (Note that the pattern in the shadow is played down.)

In other words, I should have had the painting far enough along with enough information to enable me to finish it in the studio if I ran out of time on the spot.

Although this will be just a sketch, I'm going to outline the procedure I should have followed on the spot. (Incidentally, this is not a preliminary sketch. I rarely do preliminary sketches because the scale of a painting and a sketch are so different that I find little relationship between the two.) You might find it helpful to follow along with me as I paint, making a similar sketch for yourself.

First washes. Start with the fleshtones in the face and hands. Since you will be adding the hat and background while the fleshtones are still wet, paint the flesh beyond the boundaries everywhere except for places you want to keep white or very light. Working beyond the boundaries will give you a relationship between the flesh and the surroundings. I don't want a hard, cut-out edge between the two. If you were to add the darker background or hat, without a buffer, the darker color would invade the flesh areas and ruin the flesh color and values I want to keep clean and light. If you study the sketch, you'll see a halo of fleshtones outside the face and hand boundaries.

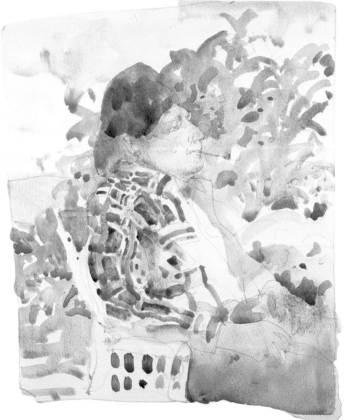

Plaid shirt. Add the plaid pattern, trying to get a feeling of the body underneath. Then do work in the negative areas. Notice that there is as much work in the negatives as there is in the positive areas. Try to keep the surroundings at an equal pace with the subject.

Final touches. Add a few more negatives and work the plane and shadow shapes into the face and hands. Also put in a little more pattern on the shirt leading the eye into the shadow side of the shirt. I carried the shirt too far here, but that's because I wasn't working from the model. That's why it's so important to paint the difficult things (like this shirt) while the model is still posing and not put it off.

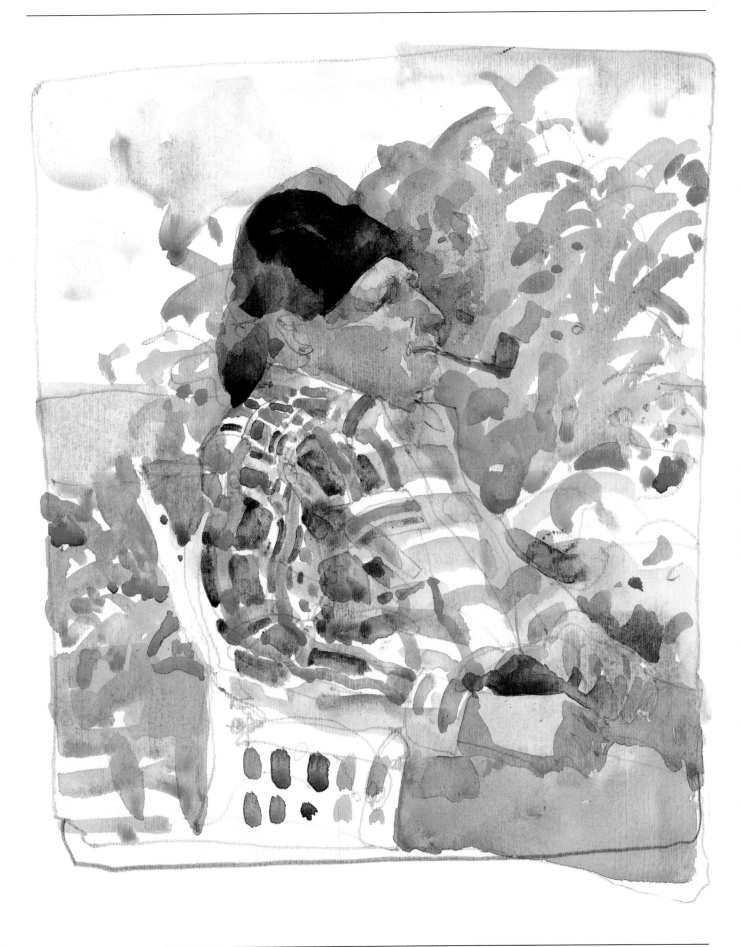

CHURCH, SESIEMBRA
watercolor on Fabriano
Esportazione,
22″ × 30″ (55.8 × 76.2 cm).

Again I'm sitting in my studio staring at this painting I did in two hours on the spot in Portugal, trying to finish it. Yet I feel none of the joy and excitement I felt as I stood painting in the square. There are no dogs barking, no people watching or walking by, no screeching motorbikes, no delivery trucks blocking the view.

Again, my problem was that I did too little on the spot. I should never have finished only one section, leaving the rest to be finished in the studio. Why? Because my loss of excitement will cause the studio portion to be overfinished in too many places. Besides, I've forgotten the original colors I used, which means the colors of the studio-finished portion may not relate to the on-the-spot section. And finally, since I accidentally left my Polaroids behind in Lisbon, I must now work without references. Fortunately one Polaroid survived, so I could see the shape of the shadows on the church wall and steps. But the color in the photo was too cool to use for reference. That's why I usually work from black-and-white photos, using the colors I've already painted to suggest colors of other areas.

The wall. Hoping that a small success would get my stagnant mind stirring, I began with an area that was fairly easy. I knew I wanted to work on the white wall behind the woman in the green blouse. But what color would I make it, and how far should it extend? The first thing I noticed before I started painting was that the sky on the upper left fades into the white paper. If I were to finish the wall on the right out to the right-hand border, I'd have to add more sky there to balance the painting. So I knew I wouldn't want to carry the wall too far to the right. Since the Polaroid colors were too cold, I looked at the painting for information. I had used both warm and cool colors in the shadows on the steeple and knew I wanted to do the same on the wall. Color areas throughout a painting must relate to each other. This is even more important than using the colors actually seen in nature. Studying the painting, I could see my favorite combination of blue, alizarin, and yellow—a combination that allows me to get the appearance of variety with control. I choose colors in the same family: a darker blue for the wall (cobalt or ultramarine), a raw sienna for my yellow, and alizarin crimson plus another red, burnt sienna. In choosing colors, you must also keep the *value* of the color you choose in mind. A very light cadmium lemon might not be the right yellow to choose for a fairly dark area like the wall. A darker yellow like yellow ochre or raw sienna would be better.

Looking at the finished painting, the wall turned out okay, but it has been over-finished. It looks too much of a piece, with too many definite edges and possibly too dark a value. Working in the studio has caused me to tighten it up too much.

The foreground. Even though there are things I still don't like about the wall, I can no longer put off painting the foreground. If I keep avoiding it, I'll overwork the rest of the painting. It's like painting a figure without a face because you're afraid to tackle it. You just keep fussing around and overworking everything else hoping that if you work long and hard enough your figure will look fine without a face—but instead all you get is a weary and bedraggled-looking figure.

Since I've lost all my reference pictures, I search my memory for something to put there. All I can remember are many little short-haired dogs scratching and barking at one another, motorbikes bleeting past, and many mature women in black. I look at a book on Portugal, and one of the photographs seems quite right for this painting, so I decide to use a seated woman in black, placing her close to the viewer and cutting off the lower half of her body.

I like Degas's practice of butting figures against borders; it has a slightly unconventional flavor. So something offbeat like this refreshes me, and the woman in black interests me the most. The black I mixed— ivory black, ultramarine blue, alizarin crimson, and burnt sienna—relates to the wall colors. I thought the wall was too dark until I added the woman in an even darker value and made the wall seem less important.

I don't like the figure in front of the church, so I dampen the paper and lift it out with a wet (not too wet) tissue. Then I draw in a figure on the left, add some figures above it, and put in the woman in black in the lower right. I erase the group above her because I find them distracting, though I leave the rather conventional-looking figure on the left.

Notice that the darks in the painting direct the eye from the

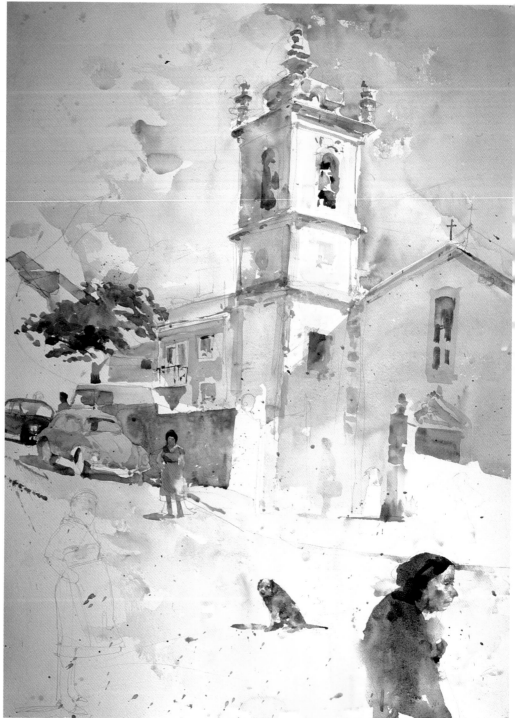

upper right to the middle left to the lower right. A painting should be in balance at this midpoint in progress, with the major eye directors in place. Getting a center of interest is not yet a concern.

I invented the woman's features, using cadmium red, raw sienna, and a touch of Hooker's green deep in the warmer middle and lower areas with cerulean or cobalt blue added around the eyes and forehead. I use the cadmium red-raw sienna-Hooker's green mixture for the shadow shape above the eyes, too—the Hooker's green helps keep this important shadow shape warm and dark enough. Cerulean blue would make the shadow area too cool.

Finishing up. It's important not to isolate the foreground figure. If the clothing is too dark and the edges too hard, she'll look cut out and pasted down. So I first paint a light wash of alizarin, phthalo blue, and cadmium yellow. (The alizarin and phthalo are dark and strong and must be diluted.) I don't often mix colors on the palette, so it's helpful to wet the paper first to soften the colors. Then I splash individual hues on the paper and let them mix. This takes practice. You'll have to experiment with the ratio of water to pigment. Just remember not to do much brushwork. Let the paper, water, and pigment do all the work.

Since the paper is still damp, I get some blurred edges on the figure. I'd get too much blur if the paper is too wet. If you splash some clear water where you're going to put the figure, you'll get hard edges on the dry areas and blurs in the spots that are wet.

I also add a dog. It connects with the background where the values are the same. Then I add a figure on the left, the gate, steps, and wall on the right and call it quits.

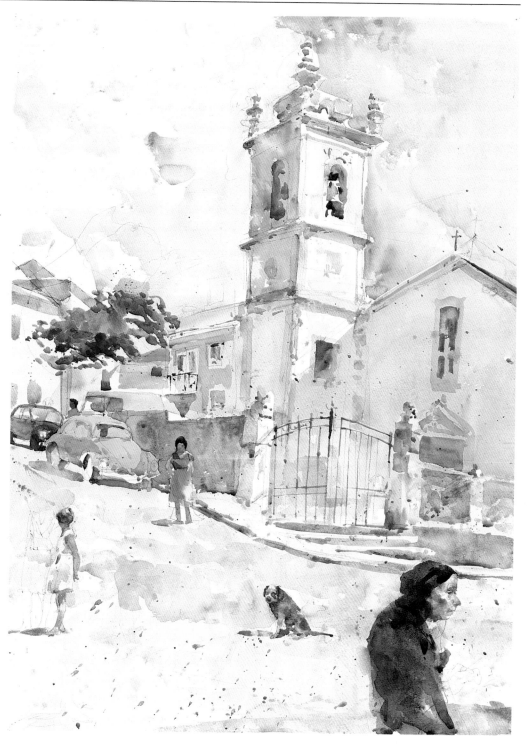

WHITE TABLECLOTH
Oil on canvas,
50″ × 50″ (127 × 127 cm),
courtesy of Griffin-Haller Gallery.

I don't think there's time when we ever feel content with our work. We all worry about going stale, getting into a rut. I often wonder if I'm better or worse than I was a year ago. But this doesn't discourage me. It keeps painting interesting.

One way to keep fresh is to try something different. We all have certain safety nets, painting clichés and techniques we've come to rely on to make us a decent painting. Now, I don't believe you should dump these safety nets, particularly if your painting is an important source of income. And you shouldn't necessarily change the look of your paintings or your subject matter either. Instead, I suggest that you try to change your *method* of painting, your approach, so that your paintings will still look like they're yours, but you'll have an adventure painting them.

Many students think that the big difference between oil and watercolor is that you can't rework a watercolor but you can rework an oil to your heart's content. This just isn't so. An experienced watercolorist like Homer could overpaint and scrub out and still have a fine picture. On the other hand, an inexperienced oil painter will come up with a greasy-looking painting with a clogged, slippery surface and dull, muddy colors, particularly when working on cotton duck or canvas board. Using oil is not an excuse to be careless in your color and value choices. You can't think, "I can always overpaint later; now I'm just trying to get the general idea." You can't just let the

paint build up. Just as in watercolor, you must make every decision count. Oil paintings can go sour, too. That's what gave me the idea for this new approach. In fact, I often change the colors and values I see in order to improve the painting and you should do the same. Get into the habit of referring to your painting for answers instead of trying to copy your subject.

Sketch and initial colors. I sketch in the general idea with charcoal. Remember, nothing is set in stone. Since the positions of objects are not as important as the placement of colors and values, making a complicated line drawing on the canvas won't help. I just want a starting point. I begin with the bowl from Portugal, paint a yellow shape inside it, then put in a green pepper and work them to a finish. These objects now act as a reference for everything else I'll be adding. This is the same advice I recommend in contour drawing: Establish something you know and work from it, using it as your reference for proportions, values, and, in this case, color.

Adding and relating additional colors. I add some tomatoes, onions, and scallions; work a little on the windowsill; and add a gray jar in the foreground. Do you think the gray and blue jar works with the gray behind the bowl with the peppers? I worry about this jar. At this point it's the part of the painting I don't like. Instead of taking it out, I work on some other areas. A single color or value isn't wrong in itself. It's only right or wrong in relation to other parts of the painting.

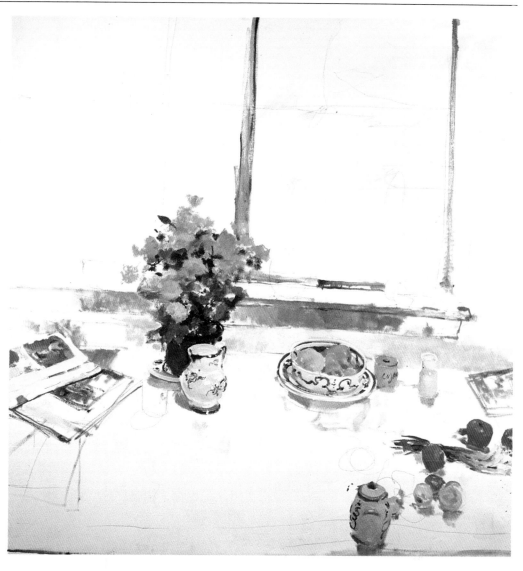

Working on a cloudy day.
Sometimes there's a strong light coming in the window and other times it's cloudy and my table looks dark. Today is one of those dark days. The white tablecloth has become a gray with no color suggestions. Yet I want to paint, even if only for a short time. Nonetheless, I am careful not to touch any colors in the painting that will be changed when the sun is shining. I work on some color-values below the windowsill using rather dry paint. Then I work a bit on the books, then try the black window casing. The window is indeed black, but do I want to paint it as black as it seems? I check the values and colors on the canvas rather than trying to match the setup in front of me. Then I add some cast shadows under the postcards on the wall and put in the predominant colors on the cards. I want to see if these spots of color will go with the color spots already on the canvas. I like to have things working together nicely at whatever stage I stop for the day. If for some reason I can't get back to the picture, I'd want people to be able to say, "So far, it looks okay."

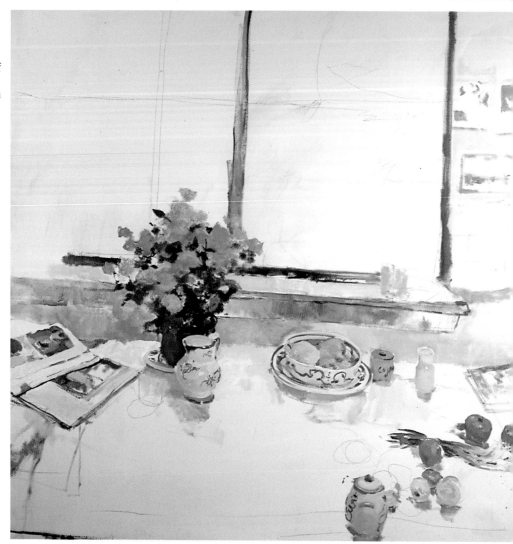

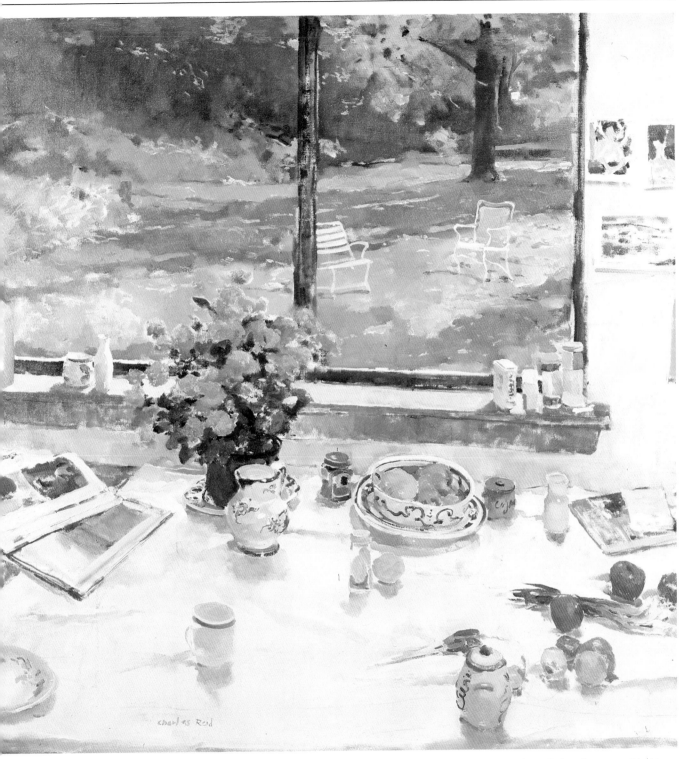

Adding the outdoor scene and final adjustments. A lot has happened in this last stage. I painted the scene through the window in one three-hour sitting. Technically, I should have worked back and forth between the outside scene and the tabletop. But because of the changing light and my fear of cloudy days, I decided it would be safest to do the scene through the window immediately. On the other hand, I wanted the background to relate to the still life, so I constantly looked at the tabletop in my painting as I painted the scene outside. (Remember, your painting has as much information as your setup.)

I tried to simplify my values by choosing just one for the light area and one for the shadows. Of course the tree shadow value was darker than the grass shadows, and you can let some minor variations like this creep in. But you can't start out by seeing a dozen value changes in your shadows, trying to paint them all.

When I finished the outdoor scene, I turned to the still life, added a few objects, and painted the tablecloth. Notice that all the objects I added in the final stage were light in value. I wanted to get rid of the empty feeling on the table without adding clutter. I also added warm and cool tones to the tablecloth—a touch of cadmium orange and cadmium yellow medium to the titanium white cloth. But only a bit. It must still look like a white tablecloth.

During my first week in the Reilly Class at the Art Students League, I watched "older" students swirling what seemed like thick paint in a magical way. When I tried, I made a formless, murky mess. I remember asking one of them what I was doing wrong and I'll always remember him saying: "It's for me to know and for you to find out." I spent a year struggling, trying to paint like the class God—John Singer Sargent. No one bothered to mention that I was using too much paint. Instead, they suggested a big brush and robust strokes. "Get more paint on, you idiot," they whispered as they passed. The class was crowded and I suspect they hoped I'd become suicidal and disappear.

Painting is filled with myths devised by people who, like the older student in the Reilly class, want to make the process as difficult and complicated as possible. One myth is to use a big brush and plenty of paint. Now a big brush and gobs of paint are fine for a virtuoso like Sargent or Sorolla (A Spanish artist of the late nineteenth century), but it just isn't good advice for a beginner. Instead of using thick paint, I'm going to suggest just the opposite: Paint as thinly as possible. I'd like you to follow my procedure as I paint a portrait of Caroline.

WORKING FROM PHOTOS

These are two photos of Caroline, my model, one shot in the natural overhead skylight of my study and the other taken with a flash. I use them here to give you a chance to compare what I saw with how I painted it, but I *never* work with photographs. I only work from life.

I find working from photographs difficult because I tend to copy rather than interpret. I

also find it difficult to work partially from photos mixed with some sessions with a live model. Even if the pose and the lighting are the same, the person always looks different. If you must use photographs, it would seem best to take slides and project the image on the canvas or paper. This sounds dreadful but I suspect many professional portrait painters d this. Most clients don't like thinking you've worked solely from pictures, yet many like the results. So do some color sketches from life. They'll give you color ideas, but more important perhaps you'll be able to get some of the "spirit" of the color sketch into the portrait.

I've deliberately used black-and-white photographs in this section because I wanted you to stop worrying about color for the time being. But since I hate painting in black and white, we'll try this with a very simplified group of colors (though you can stick with black and white if you're new at this).

Most beginners worry too much about color. The question I'm often asked is, "What colors did you use there?" Yet students who don't understand values and draw poorly are consumed with selecting just the right colors, assuming that if they use the colors I'm using all will be well. But it just ain't so. Just look at these two heads I've used the same colors, but notice the difference. The point is that you can mix any colors you choose, but if you get the value right, it will look good.

SELECTING THE BEST LIGHTING

It's important to recognize the difference between the two photos. For the moment try not to think in terms of a nicer likeness. Look beyond the subject and compare the two pictures solely in terms of light and shadow.

NATURAL LIGHTING

The photo with the natural overhead lighting (facing page, top) is indeed harsh, but it has a very obvious shadow pattern. In other words, it's easy to see what parts of the face are out in the light and which parts are in shadow.

USING A FLASH

The second photo (facing page, bottom), taken with a flash, has a more appealing lighting but can you see that the shadow pattern is harder to see? Of course, an experienced artist *would* be able to "see" the shadow shapes, but a less experienced artist might be confused. The problem with the second photo lies with the middle values which are called halftones (tones too light to be shadow and too dark to be called lights.) Painting halftones requires subtle modeling that can result in overworking. It also requires a knowledge of values. You must have "perfect pitch" because if the middle value is too dark in what should be a lighter area, the light area becomes confused. Study the photograph. Would you paint the value under the eyebrows the same as the value along the left side of the nose. They look to be about the same value in the photo.

SHADOW SHAPES

Here are the major shadow shapes. For the top sketch, I've decided that although some of the darker values on the left side of the nose and cheek are fairly dark, they are actually halftones.

For the bottom sketch I've been more literal in reproducing the darks as I see them. Which overlay do you find most appealing? Squint very hard and perhaps you'll see why I decided to group some of those darker values as part of the light area. Both sketches could work but you must become aware of what's really an important shadow shape that's necessary and what other areas that seem dark actually might hurt the picture if you insist on painting everything as it seems regardless of the effect on the painting.

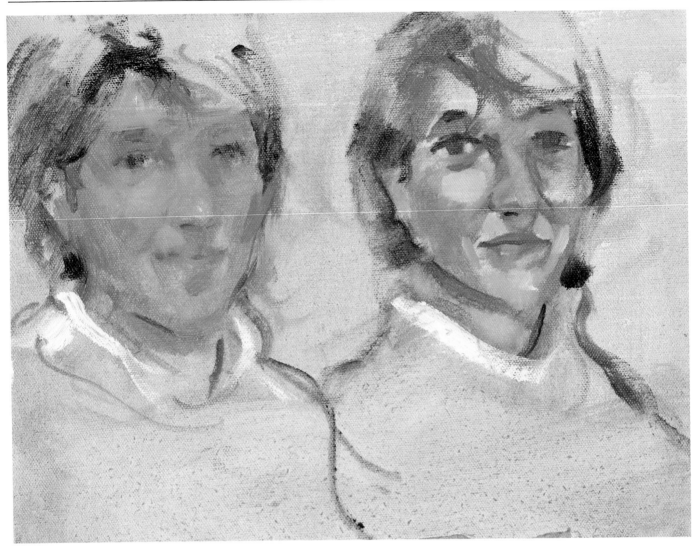

SKETCHES

I've done two sketches of the photo of Caroline in overhead light. Simply stated one looks "clean," while the other looks like Caroline's face could use a scrubbing. I deliberately overdid the mistakes in the right-hand sketch so you could tell which one is better.

Notice that I've simplified my light values. I've tried to bring all my lights and halftones in the light, close together in value. The left side of the nose in sketch 1 is an example. I squinted at the photo and decided that the left side of the face was essentially lighter in value than the right side. Once I determined which was "the lighter side of the face," I knew that the halftone on the left (light) side of the nose would have to be compatible with my light values. A halftone that is too light in what should be a shadow area confuses the shadow and tends to destroy the sense of form or bulk in the face.

As I write this I realize the terms "halftone" or "middle values" are misleading and confusing. Halftone suggests being halfway between light and shade, yet I just said that halftones must choose sides. They can't stay in the middle. Instead of using the term "halftone," we could use the more cumbersome but more accurate term "transitional values." We see this illustrated in the second sketch. There are no transitional values here. Instead we have middle values that don't relate and feel comfortable with either light or shadow.

COLOR VERSUS VALUE IN MAKING "FORM"

Even though I want to simplify my lights, I still have to show some form out in the light. One way to do this is to make the values similar and show a *color* change. Here, instead of having a darker value running down the left side of the nose, I made it cooler by adding a little blue (cerulean and some titanium white mixed with cadmium red and cadmium yellow light or pale.) The trick was to make a color change while keeping the adjacent values about the same.

CAROLINE
oil on canvas
18" × 24" (45.7 × 60.9 cm).

I got the idea for this sketch from watching artists on the street do quick pastel portraits of tourists. I'm using the photo of Caroline in natural overhead light. Unfortunately my "likeness" isn't good because it is important to take the time (which I didn't) to get the particular characteristics of the person or object we're painting and not to paint "generally" out of the imagination.

The point of this example is to show you how to establish simple but accurate shadow shapes that describe the head. These shadow shapes are painted with thin darks using turpentine as the medium. No opaque white is used. These shadow shapes are the foundation for the portrait, and it is hoped that once they're done, they won't be touched again. Shadow shape pictures are good practice, especially if you're new at oils. The approach I'm using is almost identical to the handling of watercolor and you'll see that if you add too much medium (turpentine), you'll have the same trouble a watercolor painter would have when too much water is used.

MEDIUMS

I have two containers, one filled with about one-third rectified turpentine to two-thirds Winton painting medium for thick passages, and the other with rectified turpentine for thinner sections. These mediums are for painting only. I rinse my brushes as I paint in a third container filled with mineral spirits, available in paint and hardware stores. You can also mix a medium with one-third rectified turps, one-third damar varnish, and one-third linseed oil.

I've often been bothered by the fact that some sections of my finished paintings look glossy while other sections look matte. I know that the glossy sections were painted with a lot of medium mixed into the pigments, while the matte areas just had pure pigment or turpentine alone as the medium. I suppose this problem could be solved by brushing a final varnish over the entire painting surface. But since I don't like this glossy surface, I've never tried it. Instead, I always use as little medium as possible. The thicker passages here are almost pure paint, with just enough medium or turps to make it workable. (If it's mostly pigment, a little bit of turps is perfectly safe to use as a medium.)

PREPARATION AND PROCEDURE

Put some rectified turpentine into a palette cup. On the palette squeeze out some burnt sienna, and cerulean or cobalt blue. (I also used cadmium green but it's unnecessary.) You might also experiment with some raw or burnt umber. With a large bristle brush, alternate one of the earth colors and a blue using plenty of turpentine and let the colors work together on their own. Don't try to mix them together on the palette, apply them to the canvas separately. If they're diluted enough they'll mix by themselves. Then let it dry. Don't use any oil or other medium. It will take too long to dry.

When it's dry, block in the shadow shapes using a little cadmium red, raw sienna, and *very* little cerulean or cobalt. *Don't* pre-mix these colors on the palette. Instead use your brush (no. 6 or 8) to pick up each individual color from the globs of color on the palette and bring it out to the mixing area. Be sure to rinse the brush carefully in brush cleaner and wipe it with a tissue, toilet paper, or paper towel. (*Don't* use a paint rag. Paint, turpentine, etc., can be toxic, and I've known artists who have developed allergies. I wash my hands frequently and have hand cleaner handy.)

SUMMARY OF OIL TECHNIQUES

1. Paint one section at a time and finish it before going on to another.

2. Use the full range of values on each section. Don't spot darks throughout first.

3. Keep all darks thin and transparent and the lights thick and opaque, as before.

4. Mix your colors on the palette or directly on the canvas with a brush. (I never pre-mix color with a palette knife.)

OBSERVATIONS

Notice that my drawing is done, not so much with line, but more with very thinly painted shapes. I combine the shadow areas in the face and the hair all at the same time. I don't worry much about color. I'm much more interested in getting the shapes correct in size and position, literally in getting the shapes correctly "shaped." Make sure you don't let the paint build up. Your shadows should be the consistency of watercolor.

In terms of color, I've used mostly raw sienna and just a little red on the cheek. Under the nose I exaggerated the red. I like to get a *color* in my shadows, so that I don't have to make the shadows too dark to get strength. Note that I'm using mostly warm color in the flesh shadows. I find that when students stress cool color in flesh, it often results in harsh, brittle shadows. The same colors are used in the hair, but I used little or no red and added more blue, either cerulean or cobalt. I also used some raw umber for the darkest value in the hair. (I did use some cerulean in the shadows around the eyes and in the eyes themselves.) Again don't worry about color. Just make sure you get the shape and value right because these shadow shapes won't be re-painted or corrected. Remember *not* to use any white pigment in the shadows. You're supposed to control the value with the amount of turpentine you're using.

Notice that I've held onto my shadow shapes, being careful not to invade their territory. (Once you paint lights in the shadow areas you lose the form of the face. Notice how much of the canvas shows through and hasn't been covered with opaque paint. Although indeed opaque, my lights are still relatively thin. Speaking of lights, compare the "lights" in the flesh tones with the lights in the sweater. If I'd painted the lights as light as they appeared in the photo, the fleshtones would have appeared washed-out and dead. (The colors in the lights are titanium white, cadmium red light, yellow ochre, and cerulean blue.)

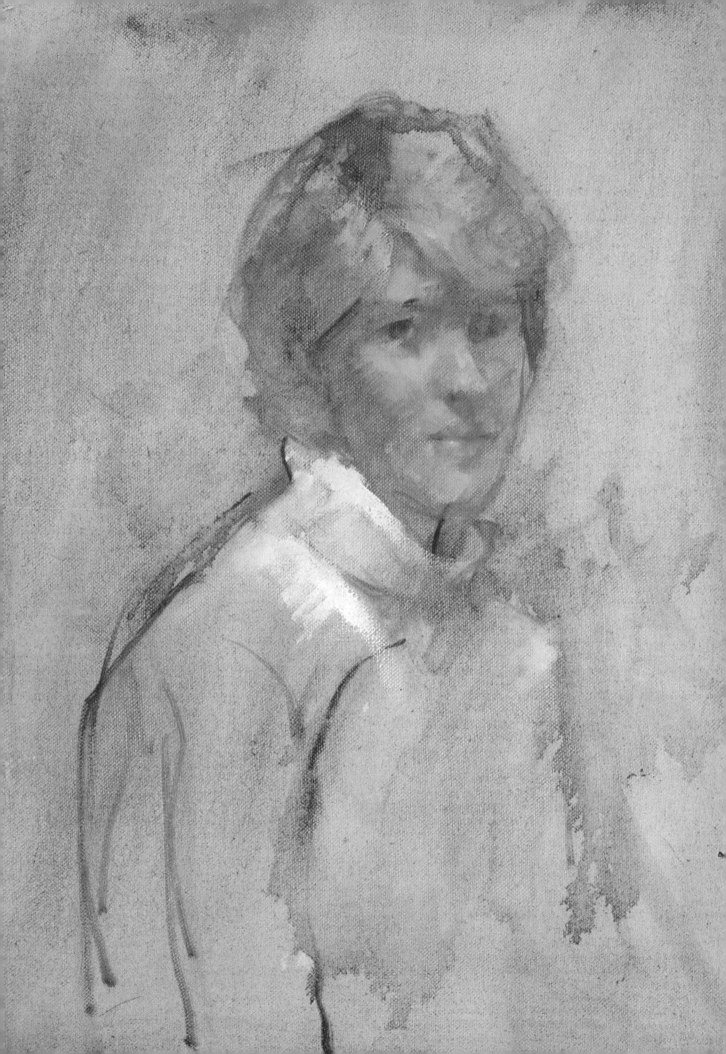

Lessons in Picture-Making

ERNO
oil on canvas,
24″ × 48″ (60.9 × 121.9 cm).

I've used the thin oil paint procedure here that I outlined in painting *Caroline* (see pages 110–113). The big difference is that there's no strong light and shade on Erno's face. Instead, I've relied on strong darks around the eyes and beard. I've also used more line (sketched with black and part of the original drawing). Normally I'd cover this linework, but I was experimenting, trying a technique Toulouse-Lautrec and Degas used. Notice the simplification of value in the face. I'm relying on warm and cool color to make form. For warms I used cadmium red, yellow ochre, and cadmium yellow light; and for cools, I used either cerulean or cobalt when the overall feeling of the picture was "cool," though in a warmer color scheme I might use a green. Again, the specific color isn't the point. You could try any number of different tubes. The point is that you want a controlled close value relationship with obvious warm nose, cheek, and ear areas, and cooler color in the forehead, side planes, and around the mouth and chin. Note the warm tones of burnt sienna and cool ivory black in the background. Much of this shows through the figure. The only really opaque parts are the touches of white in the cuffs and scarf.

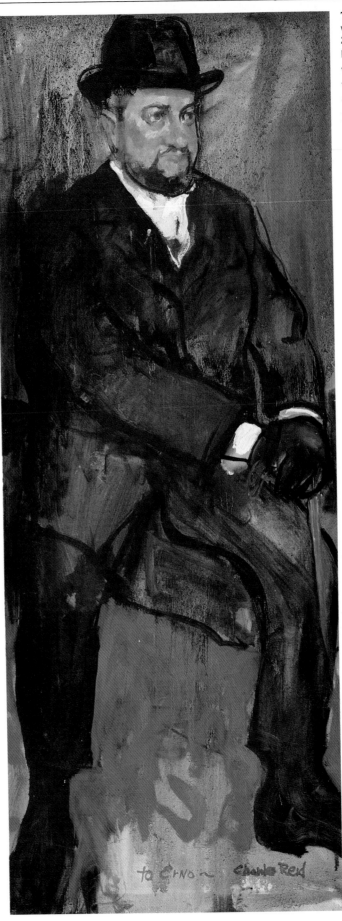

TOP HAT
watercolor,
24″ × 30″ (60.9 × 76.2),
private collection.

When we're looking at a subject, we think of its boundaries and are concerned with getting them all correct. But what if some boundaries are more important than others? Should we show them all? Must we make them all equally clear and defined? I made a choice in this painting. I made some boundaries clear with lots of contrast, while disguising or losing other boundaries. Look closely at the painting. What is the important stress area here? How did I make sure you see it?

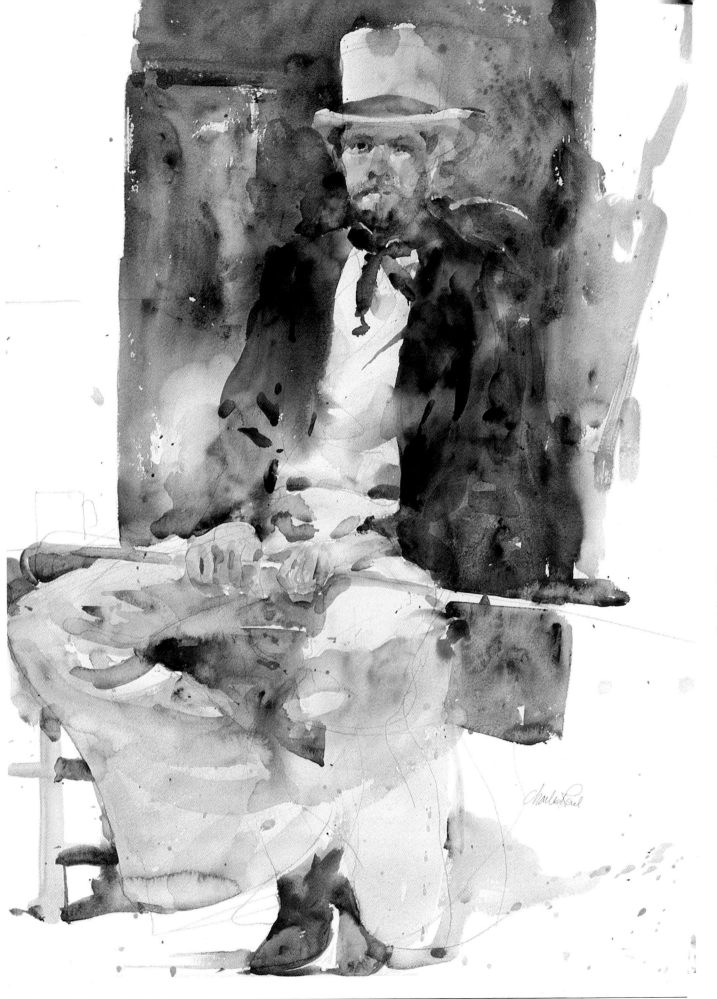

Integrating a Double Portrait

PETER AND SARAH
oil on canvas, 40″ × 44″ (101.6 × 121.7 cm).

Painting one's family is ulcer territory, if you know what I mean. Peter and Sarah are good friends and when I said "This will be the last time you'll ever have to pose," they did their very best. I sketched them both in together, then had them pose alone when I painted. Of course, it would be better to have them pose together the whole time so I could work back and forth, keeping a good color and value relationship and not overworking one person more than the other, but that's really dreaming. Peter came along swimmingly and was out free as a bird after two 2-hour sessions. But painting Sarah was more difficult. There was more subtlety in the face.

It's hard to free yourself of these practical woes and, like Matisse, to think only of picture-making but we'll try it anyway. Let's look at the picture in terms of picture-making quality and note some points made earlier in this book. For example, think about contrasts and differences. I've stressed Peter's silhouette, but Sarah's silhouette is lost and her white shirt, cuffs, and hands stand out. This wasn't intentional just as the differences in poses wasn't intentional, yet the poses do reflect different attitudes.

Now, look again. How have I drawn attention to some places and made other places less interesting? Where do you see the warm red in Sarah's sweater picked up on the right side of the picture? Notice the values in Peter's chair seat. Where are they darkest? Where have I lightened them? Why? How have I disguised Sarah's "leggy look" so I could stress Peter's?

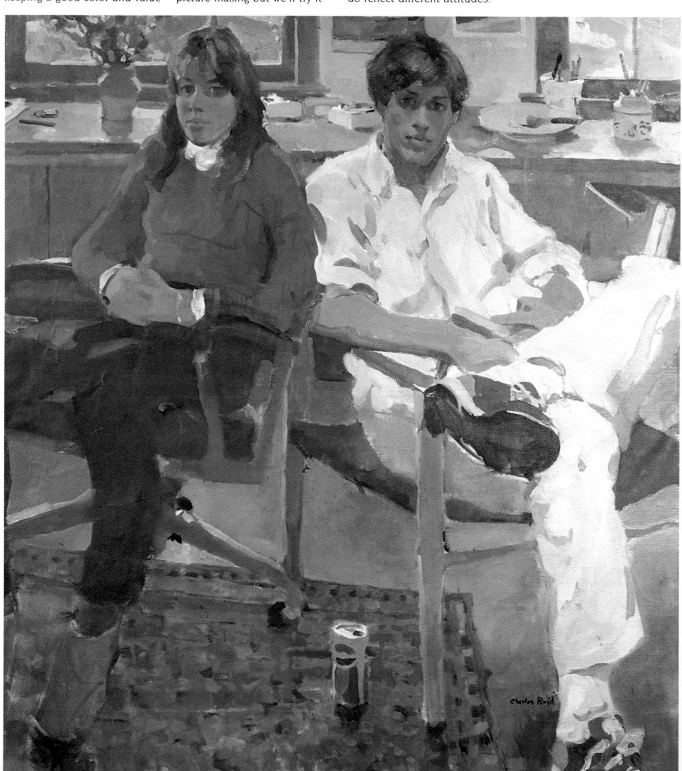

DETAIL OF SARAH

You can "mold and model" a face in paint just as a sculptor models in clay. To show you how this works, I'm using a detail of Sarah from *Peter and Sarah* for my reference. Study my sketch. Notice how the darker values and warmer colors seem to project while the lighter cooler colors seem to recede. Look at the left side of the head. It has light and shade, but don't you think that the colors—the warm nose and cheeks with cooler colors on the side of the nose and cooler side planes on the face—are more important than the chiaroscuro in giving the face a form? I think the point is even clearer on the shadow side where values are very close and we really only see color changes.

ASSIGNMENT

Try to find a backlit or sidelit subject with enough reflected or bounced light to give the shadows luminosity. You've got to be able to see into the shadows, even though they may be dark and murky. A good colored photo would be a starter. Forget about features. (Notice the mouth is only a spot of warm color.) Remember to keep your values close. Certainly there will be value changes, but you're supposed to be relying on color changes to make the face go around.

Palette. Use warm color in the light such as cadmium red light and cadmium yellow pale or cadmium red light and yellow ochre (try both). For cool colors in the light, a touch of cerulean blue mixed on the palette with a little of one of the warm combinations will serve. For the shadows, use cadmium red, raw sienna, or yellow ochre for warm areas and a touch of viridian or cerulean for cooler areas. (Adding green will tend to make the shadows a bit darker than adding blue, but any complementary color will darken a value as well as changing a color.)

Hair. I usually rely on raw sienna with a touch of raw umber, burnt umber, or burnt sienna. Cadmium red and Hooker's green dark also make a nice warm dark.

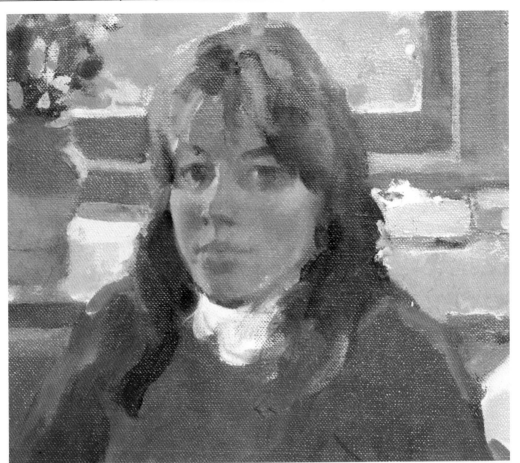

JON AND SARAH
(unfinished)
oil on canvas,
60″ × 64″ (152.4 × 162.5).

Every painter has a different approach in starting a painting. I begin with a brush drawing using turpentine alone as my medium. The drawing is very sketchy and loose. I try not to think of my lines as areas to "fill in" but rather as broad indications for my massing-in of color areas. I treat the oil paint almost like a watercolor in the beginning. I avoid white paint and use only turpentine. Many beginners put on too much paint much too soon. I like to keep the texture of the canvas showing for as long as possible. Once the grain of the canvas is lost the surface can become clogged and slippery.

This painting was started during a short vacation. Both Jon and my daughter Sarah had just a few days to pose. I started by posing both together to get a very general layout of the picture (not shown). This took about an hour. The next day I did Jon's face and washed in the shirt. I did add some painting medium to my turpentine (about two-thirds Winton painting medium with one-third rectified turpentine for the face). Notice that I rely heavily on shadow shapes in the eyes, under the nose, upper lip, under lower lip, and under the chin. I painted the area under the chin and neck in one value. I wanted simplicity and so I ignored any small, subtle value changes. Notice that I painted the shadows very thinly. I always squint when painting shadow shapes so I can't see minor color value variations within the shadow. It is only out in the light that I place spots of color. I left can-

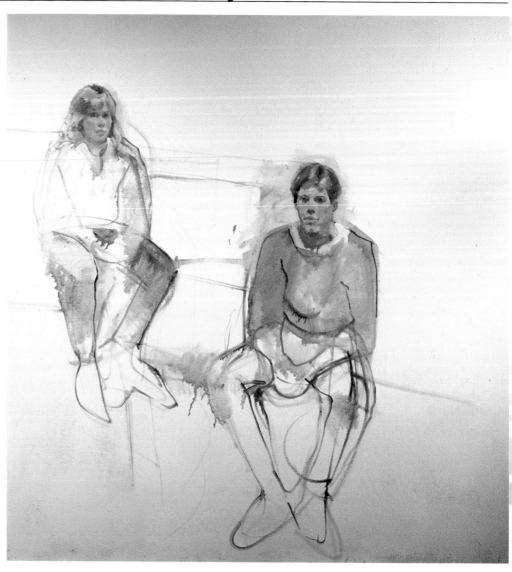

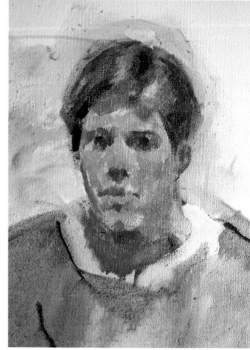

vas showing through between these pieces of paint so you can see how I place these spots of color. Overblending and painting thicker lights into the thinner shadow shapes causes a mess. It's excellent practice to learn to mix the correct color and value with the brush on the palette, then try to place the piece of paint on the canvas in the right place. It'll look a bit patchy, but if the values are right it will be okay. On the other hand, if the values are wrong when you apply them, no amount of blending on the canvas will help. I've used the same approach with Sarah's face but here I have worked the pieces of paint together.

My skintones are always painted with the same colors: cadmium red light, raw sienna, and/or yellow ochre. To cool it, I use viridian and/or a blue, either cerulean or cobalt. Remember, adding green and/or blue will darken the warmer colors. Try not to use white in the thin shadow shapes. A little might be necessary, but it's better to control the shadow value with the correct ratio of warm and cool. You'll be using very little green and/or blue. The ratio should probably be two-thirds warm to one-third cool color.

As you study the remaining stages, notice how thin I've kept the paint. Also notice how I've stressed local value in the clothing. (We're more aware of the light and shade on the faces.) I used no white in Jon's sweatshirt; I used cadmium red. To darken the red I might have added a little viridian, or alizarin. I wanted a rich red (second stage), so avoided adding white. (White tends to make cadmium red look pasty.) If I

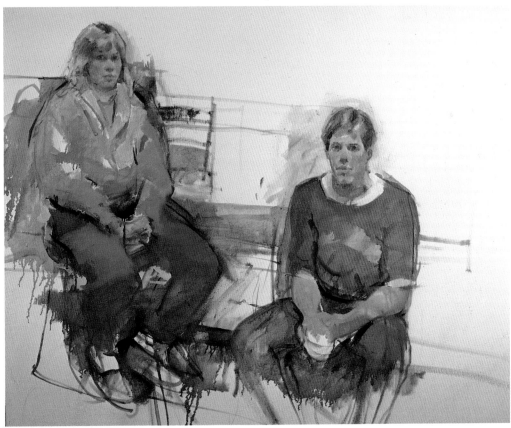

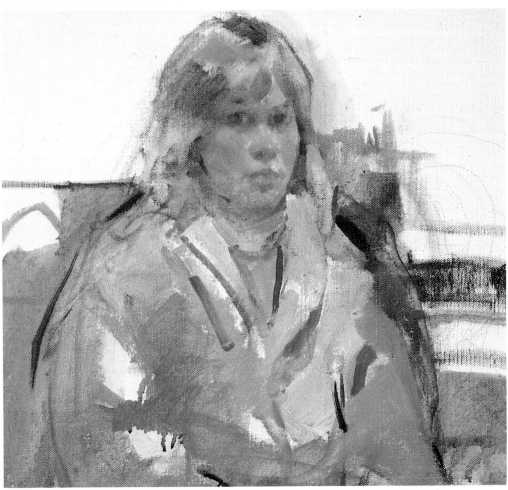

wanted a lighter value, I might add cadmium orange and/or a little yellow ochre. The jeans were painted with cobalt and ultramarine with a touch of burnt sienna in the lower legs. I did use a little white out in the light on the jeans, but when you do this be sure to add just a touch of white to the blue on the palette first, combining it completely with the blue on the palette. Never add pure white directly to the canvas when you're painting middle or dark values.

Sarah's jacket is cerulean blue, a little cobalt, and very little alizarin. To cut the intensity I might add just a touch of cadmium orange. When you read a list of colors that I mixed, I don't mean for you to mix them all together in one big "schmear." Instead, experiment on your palette, always mixing small amounts using a brush, not a palette knife. Remember, always rinse the brush in mineral spirits or turpentine, and wipe it with a tissue before going to a new color.

Generally, I mix only two or three colors at one time, plus white if needed. In Sarah's jacket I did use more white. (Jon's T-shirt is also white.) It's okay to use white in your lighter local color areas and in the skin out in the light. Sometimes you need it in middle value areas, too, but try lightening with another color of the same family. (I'd try cerulean to lighten ultramarine, for example, before turning to white.) Almost all of the darker areas around the figures are painted transparently, almost like watercolor. Remember, it's critical to keep your darks thin.

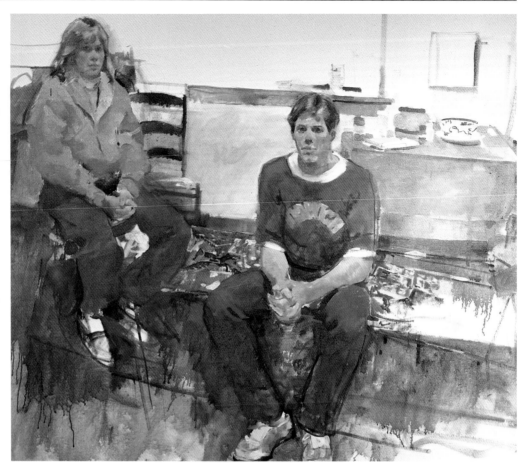

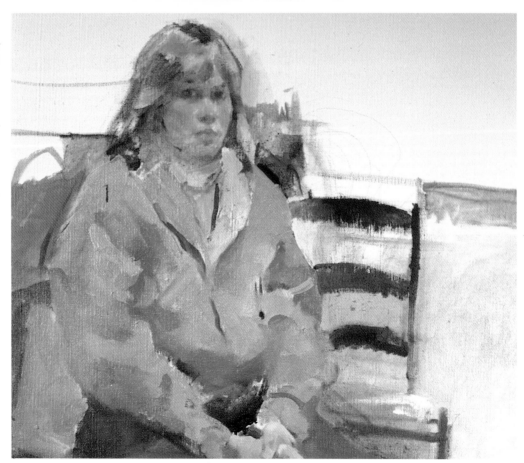

The painting is rather large—60″ × 64″—at least larger than I usually work, and as I look it over, it seems somehow empty. Sarah and Jon appear isolated from each other, and it bothers me. I tried to link them through the horizontal lines of the chair back and the bar near Jon's head, but it's not enough. So when my son Peter happened by, I decided to add him to the composition. He fell automatically into a casual pose that fitted right in with Sarah and Peter's relaxed posture, yet his standing figure created a pyramidal effect. When I realized that I'd placed him too far to the right, I just redrew him again closer to Sarah. His arms and legs link the other two figures and complete the grouping. I painted his legs right over the chair (you can still see part of it in his dungarees). The painting is still incomplete, but it's beginning to work now as a composition and I've put in enough information to complete it someday when the mood strikes me.

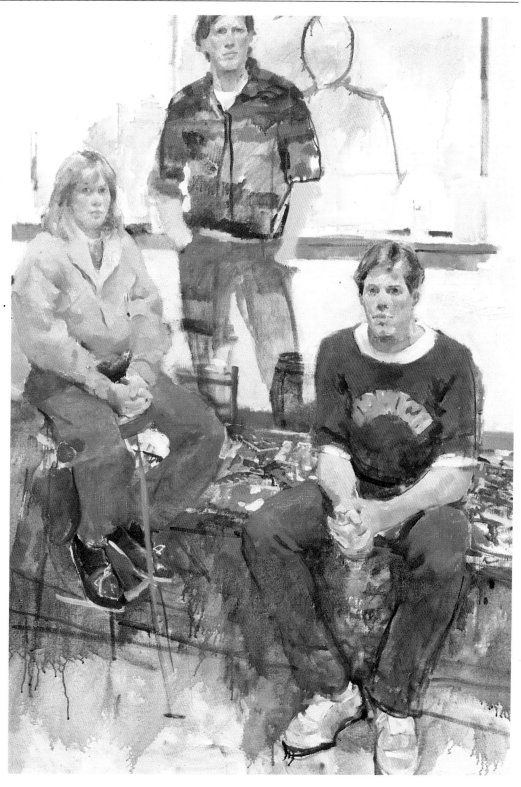

LESSONS PAST AND PRESENT

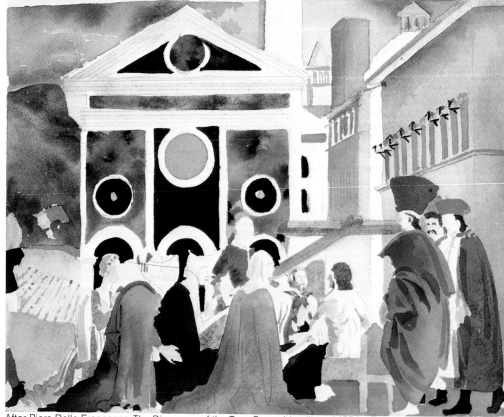

After Piero Dello Francesca, *The Discovery of the True Cross (detail)*, c. 1455 by Tufts Welihan.

I've often given my classes assignments to copy the Masters. To avoid problems of details and paint handling, I suggest a small format: 4″ × 6″ or 8″ × 10″. Too often we marvel at how beautifully a painting has been painted rather than seeing the picture's construction in terms of value and color relationships. These two facsimiles are the result of a fifteenth-century assignment.

IDEAS TO LOOK FOR:

1. Local value and color are more important than light and shade.

2. See how the entire picture space has been dealt with. (Border areas and focal areas are handled equally in both color, value, and edges.)

3. Show how the artist used compatible values in some adjoining areas to keep the connection and relationship. (No edges were "lost" by softening in the fifteenth century.)

After Bartollo Di Fredi,
The Adoration of the Magi,
c. 1400 by Tufts Welihan.

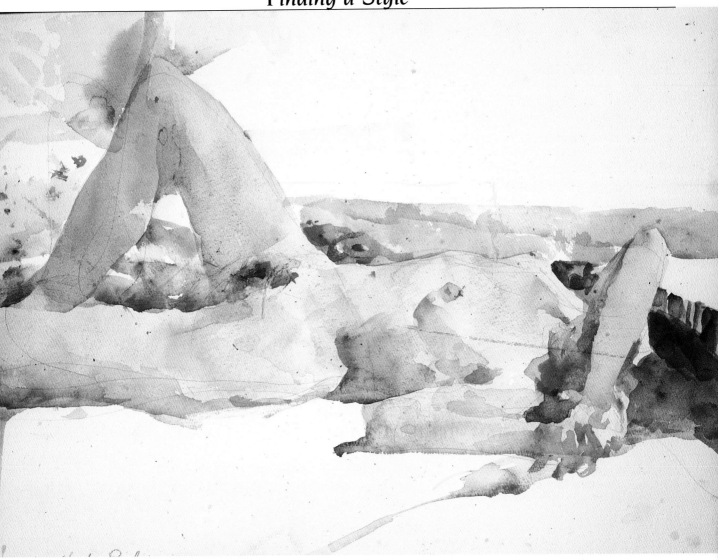

I think style, the way we want to paint, consumes us as artists. I've spent much of my painting life looking at other artists and trying to paint like them. At some point I've tried to imitate Charles Russell, Frederic Remington, Edgar Degas, Leonard Baskin, Winslow Homer, Richard Diebenkorn, Robert Andrew Parker, Larry Rivers, Edouard Vuillard, and Fairfield Porter, among others. Right now I'm trying to paint like Pierre Bonnard. At first I just mimicked them. Then I began to be interested in what they were saying. I can't (nor can anyone else) paint like Bonnard, yet I enjoy trying out his ideas. My painting *White Tablecloth* (page 00) is dependent upon Bonnard. Not in style or quality, but in color and in the placement of objects near borders.

NUDE

In this watercolor, done long ago, I was trying a Diebenkorn approach. I was crowding and cutting off part of the figure, avoiding a classic pose, trying for an abstracted view of the figure—abstracted in the sense of shapes. Notice that negative and positive shapes in the figure form this painting. You can't see a face, and the hair is no longer hair but a dark shape.

BLUE COAT
by Susan Guy

This painting is very difficult to criticize. Susan draws beautifully and uses exaggeration very effectively. Without seeing the model we know exactly what she looked like. There's a certain harshness here. Yet I hesitate to suggest losing edges, trying for more negative shapes and "background involvement," and enriched color? These ideas would all be valid, but they seem general and rather vague when we're talking about a painting that does what it's supposed to: It makes a statement. It's not equivocal. Saying this, and knowing Susan wants more than praise, I'd suggest looking at some other painters—painters who've made strong statements, often defying the rules of good painting and have still come up with important pictures. (It's interesting that these painters could never have painted good pictures had they followed the rules. Some contemporary painters in this category would be Alice Neel and Elaine de Kooning; past painters would be Egon Schiele and Toulouse-Lautrec, though of course there are others.

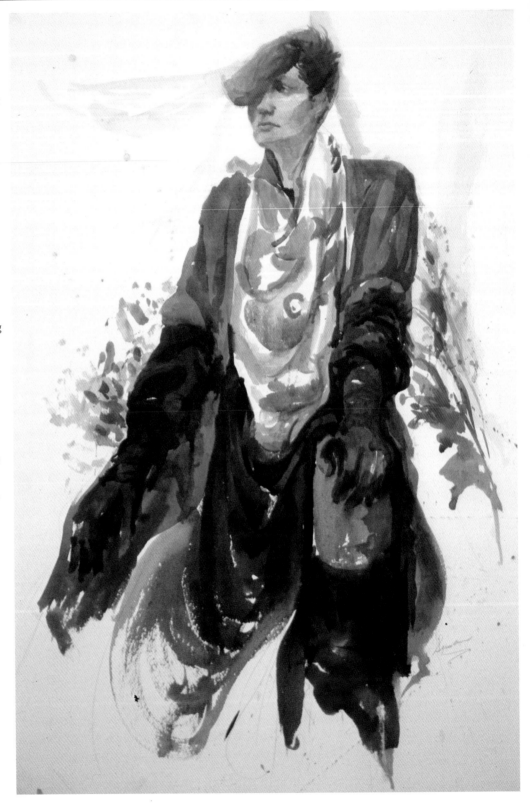

Spirit versus Likeness

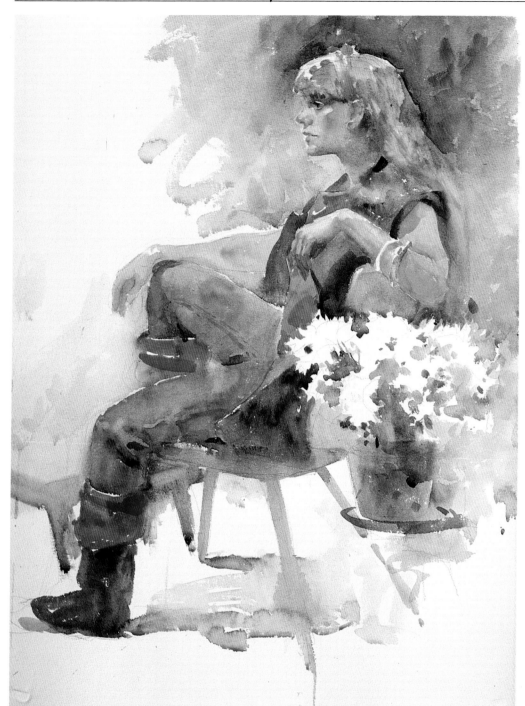

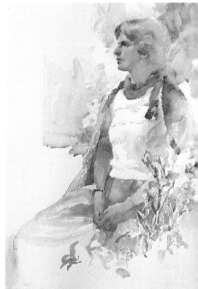

DEBBIE and JENNIE
by Roberta Carter Clark

These two pictures were done during a class at Pat Braun's workshop in Pocano Pines, Pennsylvania—one on Wednesday and the other on Friday. The subjects are different and so Roberta has treated them differently. Jenny certainly has an etheral quality which wouldn't suit Debbie in her punk rock outfit. But one of the paintings looks more like a portrait than a painting. I'm sure you can tell which one I'm talking about. The difference in the paintings (beyond subject matter) is probably obvious, but spend some time comparing the pictures. Remember, the paintings show equal skill. Yet one seems to be a nicely done portrait while the other is a painting of a person.

CATHY
by Al Krnc

Al's done a fine job and so my suggestions aren't about technique. Look at the corrected sketch below. Can you find the changes I've made to simplify the design and make the figure more important?

The Importance of Abstract Shapes

**READY FOR WORK and
EARLY PUSH OFF**
by Lois Elder

These two paintings by the same artist are very different. One is merely well painted in a technical sense, but the other is an exciting painting. The difference between the two is obvious as we compare them now, yet what happens when we're out looking for something to paint? Do we look for interesting subjects or do we look for an interesting shape that also happens to be a painting we'd like to paint. One way to tell is by making a color value sketch that stresses the abstract quality of the scene you want to paint. A pencil "doodle" won't help you here.

PORTRAITS OF DEBBIE
by Doree Loschiavo and Caroline Mangan

There are times when it's difficult to disguise poor or awkward shapes. We see this in these two paintings. Both are exciting pieces with excellent color and paint handling, yet I feel that in both examples the legs are too isolated and dominant. The rule is: If you have an impossible form, don't stress it—disguise it. Carolyn had the right idea but I wish she'd gone further.

Look at my corrected sketch below. I stress the horizontal shapes around the vertical leg forms. Even if the boots were black I might lighten their value in places. If I'm using a lot of white paper I might leave part of the boot white also. And if there were a cast shadow, I'd lighten the value of the boot where it meets the cast shadow and lose the edge there. (You'll find another portrait of Debbie on page 127.)

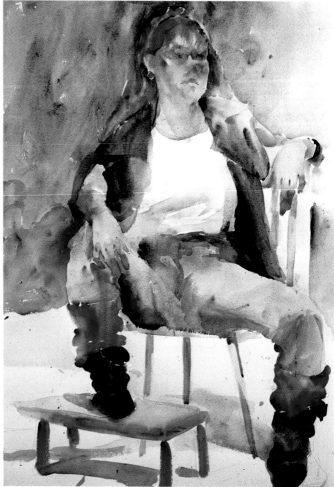

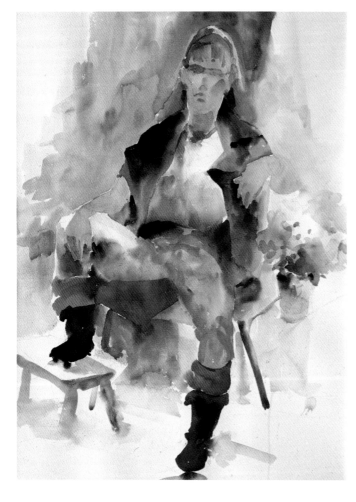

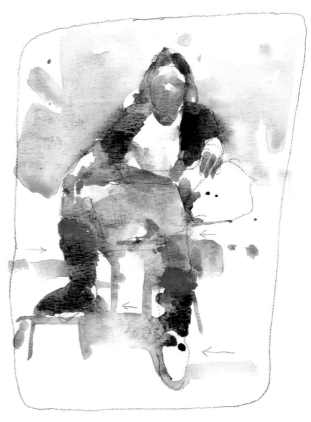

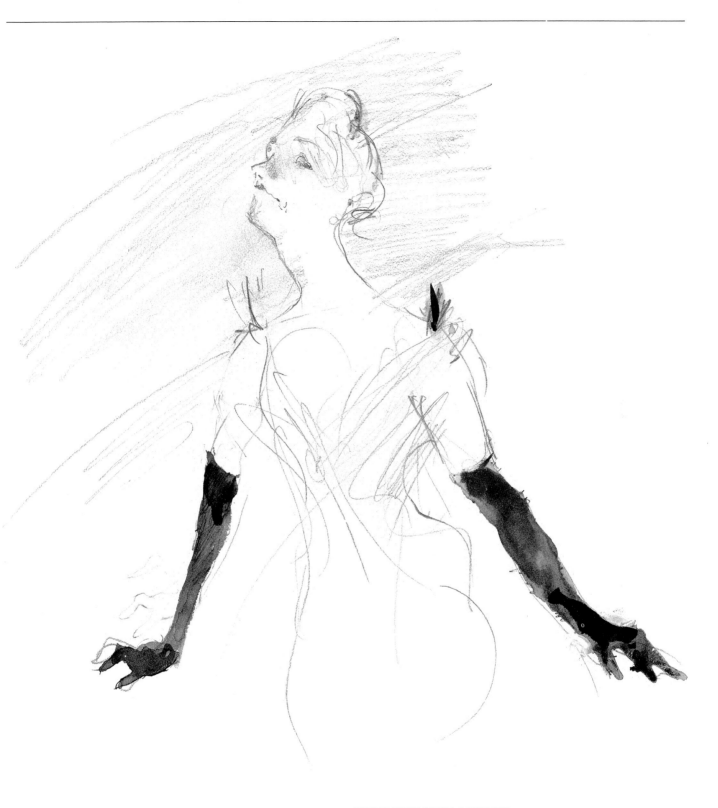

AFTER TOULOUSE-LAUTREC
by Yvette Guilbert

It's a humbling experience to copy a master draftsman like Lautrec. It really makes you understand the nuance of shape and placement. I only wanted to show how an artist can stress a shape that, in lesser hands, could have been awkward. Artists like Lautrec work beyond the rules. Here he took two elongated isolated shapes and made them the core idea of his drawing. Why does it work for Toulouse-Lautrec and not for Doree and Caroline? How does he *make* it work?

GREENS FARMS HOUSE
watercolor,
24″ × 30″ (60.9 × 76.2 cm),
collection Judith Reid.

Pictures with snow in them are
easier to paint because we see
shapes of darks against large
light areas of white, areas we
haven't been able to mess up
with unnecessary detail. There
are good, simple contrasts in
snow paintings. Think: How can
we apply these ideas to our
other paintings?

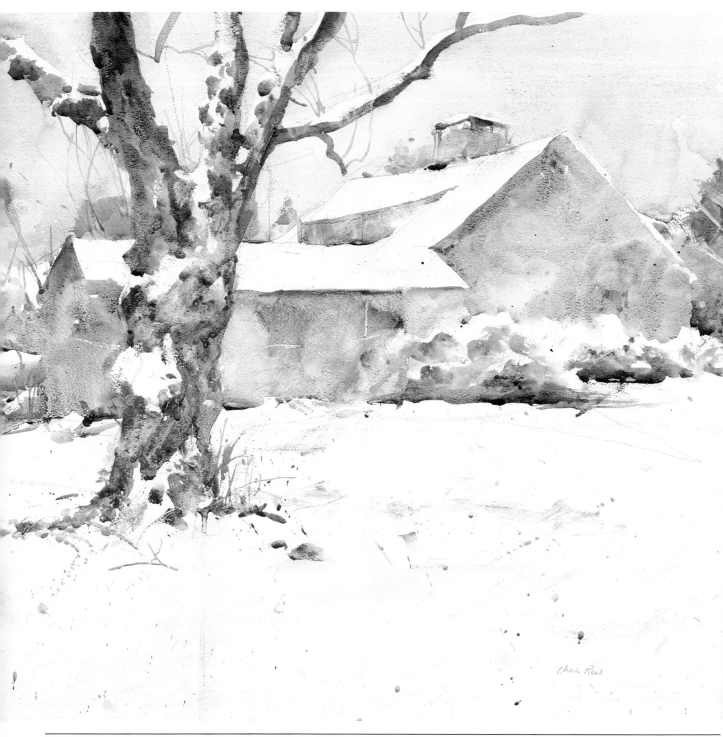

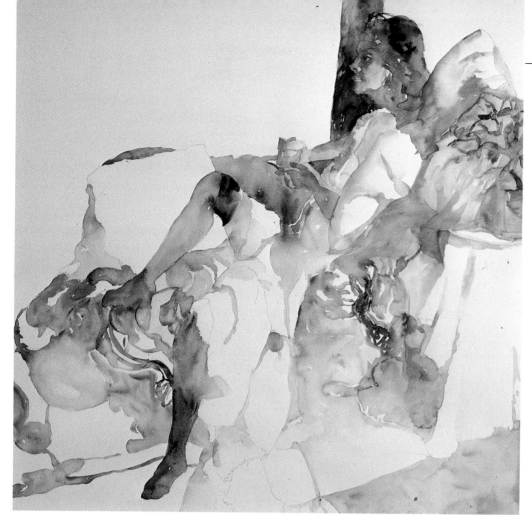

BLACK STOCKINGS
by Rena Scarfetti

This is a wonderful example of negative shape painting. Actually more of the work is done *around* the figure than within it. Notice the "bridges" between the figure and her surroundings. Some connections were made by softening edges and others done by using compatible values in adjoining figure-background values and colors. Notice how Rena handled the black stocking so it wouldn't look cut out and pasted down.

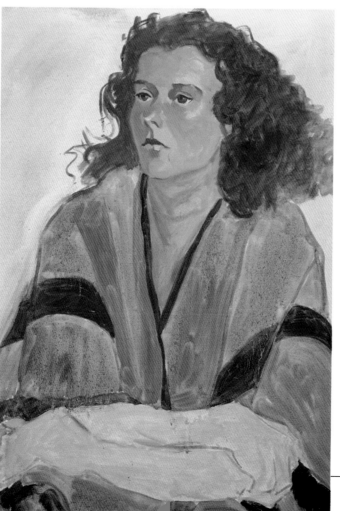

REDHEAD
by Peggy Calvert

This painting is "finished" in the most important sense: It has good drawing and shapes and it's well composed. We get the feeling Peggy's caught the essence of the model. If I had to make a suggestion, I'd say that Peggy lapses into some "non-colors" (neutrals) in the flesh-tones in the face. The color in the clothing isn't strong, but I like the thin treatment in which she's established the drawing and only needs to make a more positive color statement. (For example, has she used a red or an earthtone here?) In terms of the fleshtones, some areas look like they've been painted with flesh color out of the tube. Don't mix your colors together so thoroughly that their identity is lost. Always try to show the viewers the colors you've used.

ASSIGNMENT

Paint a small but completely committed painting (no sketches) containing distinct cast shadow and shadow shapes and strong shapes of local color values. Where local color values are hard to see, you will be totally dependent on shadow shapes to bring them out. On the other hand, where no light and shade (cast shadow and shadow shapes) can be seen, you should treat these sections wholly in terms of their local color values.

MY DEMONSTRATION SKETCH: BOATYARD, SISIEMBRA

This is a pretty shoddy demonstration—though I find crude demonstrations are often the best teachers, perhaps because students say, "I can surely do better than that!" Notice that the foreground skiff on the right is totally formed by the cast shadow and shadow shapes. There's no local color value here at all. But look at the rest of the painting. Where have I depended on local color-value with no cast shadow or shadow shapes?

KALLIE PAINTING, SISIEMBRA
by Elinor Bachman

Elinor forgot about shadow shapes but came up with a beautifully structured painting using only local color. It doesn't matter if you forget some things while painting. The important thing is that Elinor has a point of view. She's not just fussing with nothing more specific than "trying to get it right." You'll never get it right if you have no specific idea as a goal.

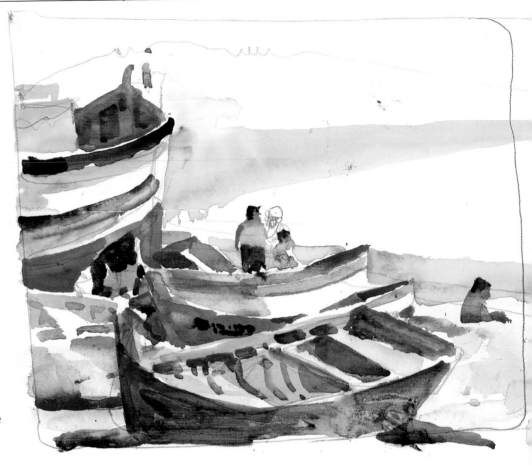

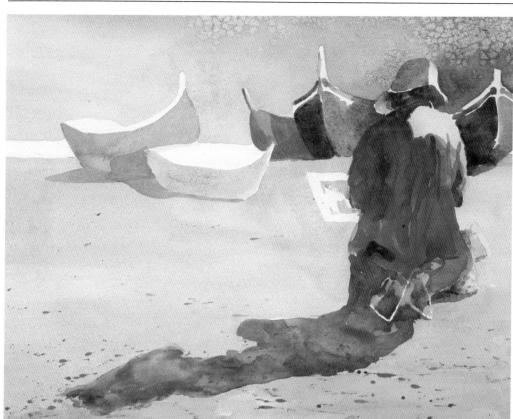

PAINTER, NAZARÉ, PORTUGAL
by Barbara Hyman

Barbara stresses shadow and cast shadow shapes but still uses local color value in a small section. Notice the marvelous use of cast shadow by the figure. Notice also the luminous shadow on the painter. It's shadow but it's more of a color idea than a shadow idea. Finally note the contours of the shadow shape where it meets the light on the right shoulder.

FISHING BOATS, WEST BACCARO
watercolor,
10″ × 14″ (25.4 × 35.5 cm).

This was a painting I did in Nova Scotia to plan my workshop in Portugal. Which sections are described with shadow shapes? Where do I use local color values?

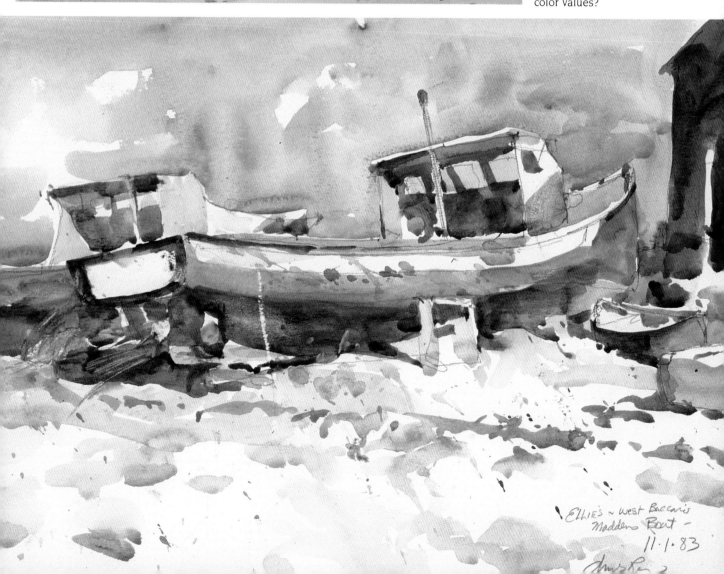

Ellie's ~ West Baccaro's
Madden's Boat –
11·1·83

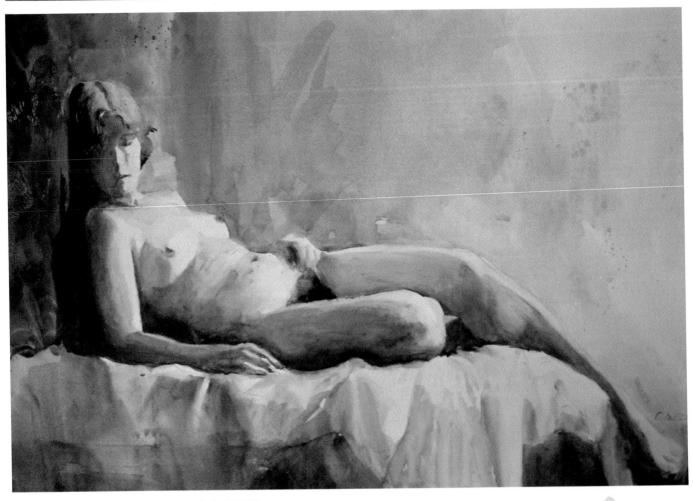

RECLINING NUDE
by Cathy Welner

This figure is extremely well drawn, with good gesture. The composition is fine, too. Although I feel there could be more edge variety, I don't think this is a problem. The only area I'd fault Cathy on is thinking mainly in terms of light and shade. The color here isn't bad, it's just not a factor. Without color strength, Cathy has relied too heavily on shadows to give her figure substance.

ASSIGNMENT

Color sketches. Before starting a large painting, do some small color sketches. Be sure to make the sketch border the same ratio of vertical and horizontal borders as the intended final painting. (In other words, don't make a square sketch for a rectangular painting.)

Initial drawing. When you make your drawing on the watercolor paper, be sure to lose some figure boundaries. Notice that I've lost the left side of the face and left boundary of the right arm.

Color mixing. I used cadmium red and cadmium yellow light for the warmer sections and cerulean blue and cobalt blue for cooler sections. *Don't* mix the warm and cool colors together on the palette. Instead mix the yellow and red on the palette but don't blend them completely. The swatch shows what it should look like. You should be able to see remains

of both the red and yellow. If you look at my sketch, you can see where I used my warm colors. Next mix either of your blues with some water. Remember to shake the brush after dipping it in water before going to the palette or paper. This is the hard part and takes practice. Often you may have too much water or too much pigment. Be prepared to spend hours practicing swatches of wet-in-wet warm and cool combinations.

Remember the first wash has a lot of water, so it will dry several values lighter. The colors will also look much less intense when dry. Practice by painting the first wash richer and darker than you really want. In watercolor, never judge a color while it's still wet.

First wash. Paint in stronger and darker color than you think you'll need. It might be helpful to draw several figures, so you don't get to too precious about making your effort perfect. Notice that I've painted out my borders in many places. I kept the boundary line firm because the model is on a white cloth, and I didn't want fleshtones destroying the whiteness.

Adding shadow shapes. I've stressed the importance of color in the lights because our lights must have color substance, so we don't despair at a washed-out first wash and try to make our shadows too dark to make up for it. Let your first wash dry *completely* before adding shadow shapes.

Mixing shadows. Since we don't want heavy murky shadows, we're going to do them in one shadow wash. This wash can have some color changes but don't get "hung up" with getting color changes if they're hard for you. You'll just end up reworking them too much. Also don't worry about soft edges between light and shade. If you can soften as you go, fine, but if you forget you'll only ruin the painting by trying to soften an edge that's already dry. The colors in shadow here are cadmium red, raw sienna, cadmium yellow light for warms, and cerulean blue and cobalt blue for the cools. If you have trouble adding the blues, forget them. Just use the warm colors, using very little of the cadmium yellow.

Notice that I've painted my negative background areas at the same time I do my shadow shapes. Remember the first "light" wash is dry so that my background running along the front of the figure makes a firm edge. (I've varied the values in the background so there's a feeling of lost and found.) We usually want soft edges on the shadow side, and painting the shadow shapes and the background while both are wet or damp gives us the soft, lost edges we want.

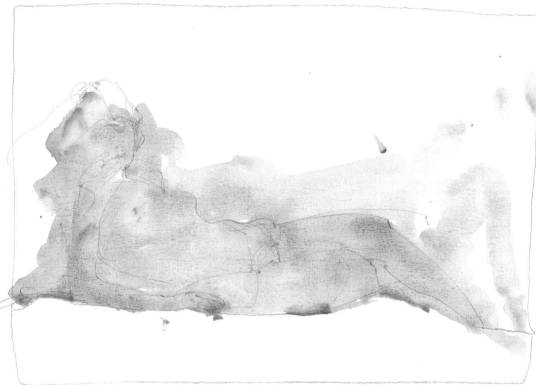

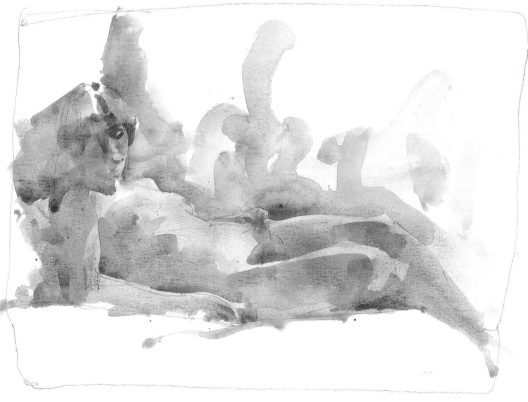

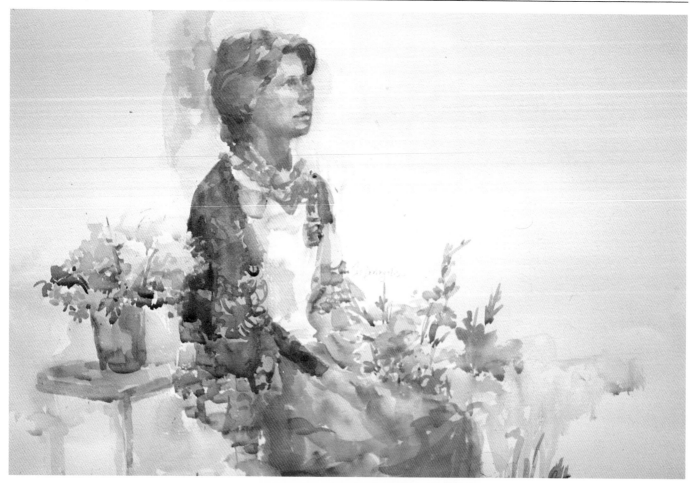

JENNY
by Pat Devirgilis

This has a more delicate and sensitive approach that fits the difference in subject. Still we have a definite local color feeling in the sweater and skirt and white blouse. The face is subtly described with just the right amount of light and shade.

MAN IN A BLUE HAT
by Abby Warman

Abby isn't worried about small forms and petty details that often dominate a student's thinking. This head, probably done in one sitting, has fine, rich local color values. It also has very descriptive shadow shapes under the cap's visor.

BEARD AND TOP HAT
by Doree Loschiavo

This painting has lush color and fine spontaneous paint handling. My only problem is with several of the shapes. Do you see forms that seem too symmetrical? Can you find an area that she's over-identified, making boundaries that are too definite on all four sides? How has she used light and shade as opposed to local color? Where has Doree stressed one over the other?

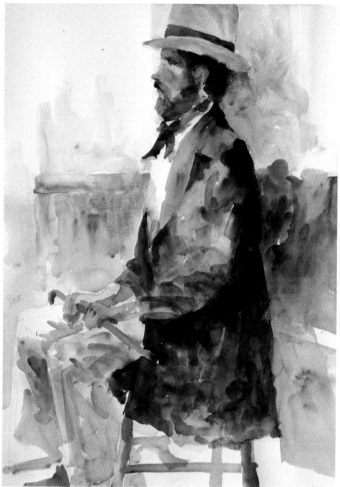

WAITING
By Kris Nugent

This painting was done over a two-hour period in class. It's a full sheet watercolor, 22″ × 30″. It would be impossible to do a finished painting this large in such a short time. (When I say "finished," I'm thinking of a picture with everything resolved.) On the other hand, I think this painting is finished in terms of painting ideas. The figures are connected to all four boundaries. They take up two-thirds of the picture space. (If Kris had wanted to add more background forms, she doesn't have much to worry about.) The shapes in the figures are good with the man's head and face very nicely resolved. The shadows are luminous, not murky or overworked. Negative and positive shapes are about equal. There are very nice connections and paths between the figures and surroundings.

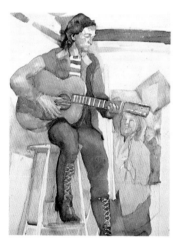

SLOW RHYTHM
by Wendy Shalen

Some painters believe in having a center of interest and others think that the whole painting should be of equal interest. But this is a question of philosophy, not right or wrong. Wendy is a very intense, thoughtful, and talented painter. What she's done has been done by design not ignorance. She's painted a figure, dominant in color and "finish." Her boundaries around her subject are firm, yet she has two definite tie-in's or places of compatible value. One is the hair and diagonal post, the other the guitarist's left boot and Rhoda's trousers. The figure isn't isolated; he's part of the design. Yet in a sense he's alone, he stands as the most important part. The obvious focal point.

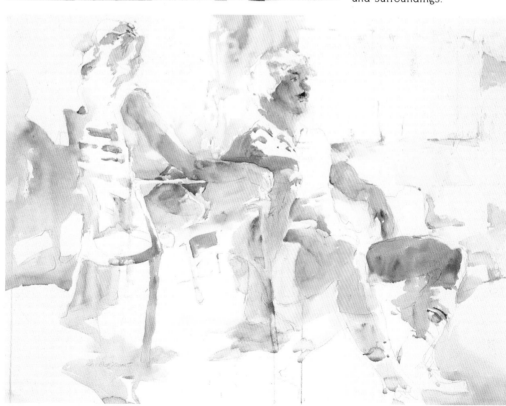

SUN HAT
by Elinor Bachman

This painting has good values and the shadows on the shirt are nicely stated. There's a feeling of "edginess," especially in the shirt, but I stressed to the class that it was more important to get the shadow shapes in simply and accurately than to try and soften edges. I'd rather see hard-edged forms correctly placed than soft fuzzy forms incorrectly placed. The real problem here is the placement of the figure. Elinor is now faced with a lot of difficult space to account for.

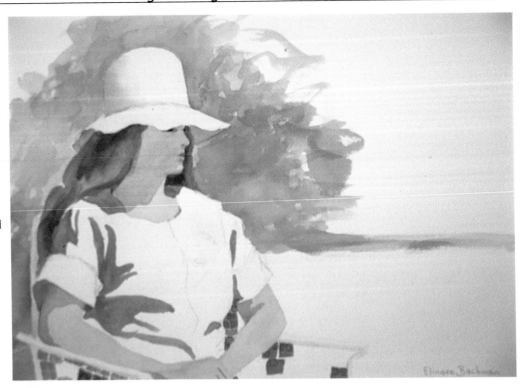

SUN HAT
by Barbara Hyman

This is a really good painting. Here the figure dominates the page, as it should. Unlike Elinor, Barbara didn't have to worry about filling in the background after the deed was done. Backgrounds should be considered first if the foreground or figure is supposed to dominate. My only criticism would be in the rather isolated torso and arms. I'm too aware of a silhouette here.

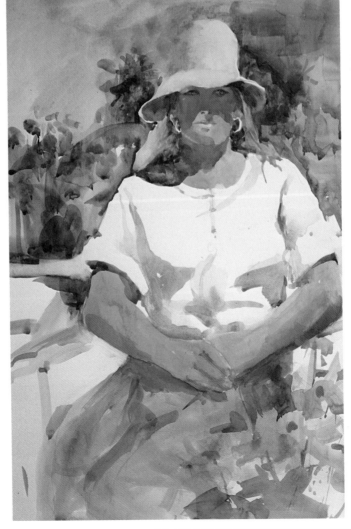

SARAH
watercolor on Fabriano Esportazione,
22″ × 30″ (55.8 × 76.2 cm).

This was a demonstration painting. Sarah faced me with her back to the audience. The background was a sea of bodies and faces. I hate to invent background colors that aren't there, though there's nothing wrong in doing it. It's just hard for me to do well. It was tempting to leave the paper white, and not deal with the colors of the background, but I knew if I left white at the top, I'd have to leave white paper in the bottom, too. Besides, it's awkward to have half of the picture finished right out to the boundaries and try to leave the other half as a lot of white paper. It looks like you haven't finished the white part. To solve that dilemma and integrate the painting better, I left one foot as partially white paper, put rather soft edges on the right side of the skirt, and left a path of white leading into the skirt on the left. More important, I made the figure as big as I could crowding the available space. For a pose like this I'd choose a vertical format. Why?

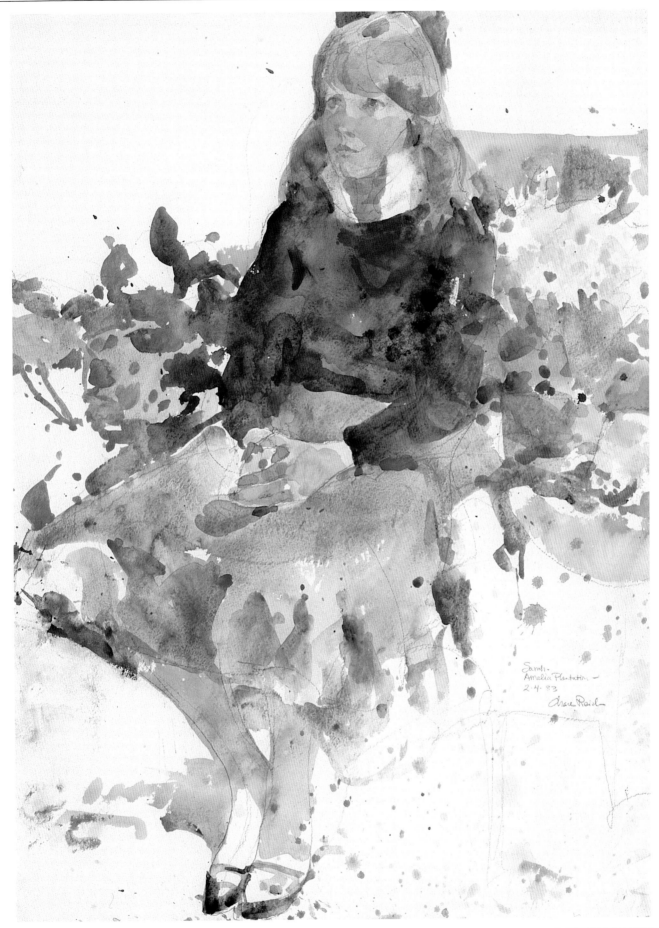

Sarah –
Amalia Plantation –
2·4·83

Charles Reid

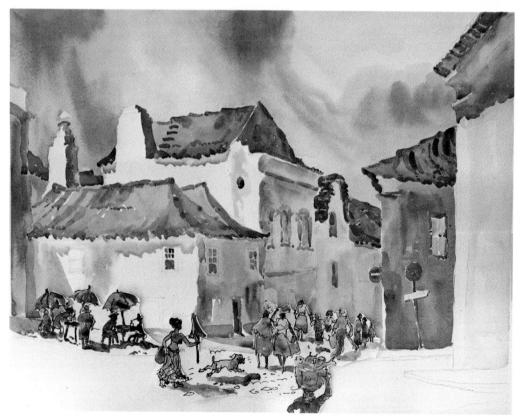

SISIEMBRA
by Lois Elder

In the first example, we see Lois's painting, done on the spot. It has a lovely feeling of light and place. But Lois knew what my comment would be in the critique and had stuck an overlay with marvelous figures on the painting (slide 2). The difference between the paintings is obvious. My comment ("If the foreground is to dominate, the background should be thought of first") works in reverse here. Lois was so concerned with the buildings that she'd made the foreground secondary. She realized too late that she should have thought of the foreground first. The moral: We can't only be concerned with what we're painting. We must also think of what we're *not* painting.

These two pictures are also remarkably different in feeling. And there's a lesson here for all of us. When she looked at her painting critically with that question we all ask as our heart sinks and depression is setting in, "What's wrong with this painting that I loved so much when I was painting it?" She did the intelligent thing by using an overlay rather than attacking the painting. Try bits of paper (construction paper can be very helpful, cut up into small shapes) or try covering up sections with your hand. Lois might have covered the white foreground with her hand and seen that the buildings looked good. This would mean that there was something wrong in the foreground. Lois's mistake is the same as Elinor's (in *Sun Hat*): We must always think about what we're *not* painting before we think about what we are painting.

MARILYN

This is a perfect example of my thinking only of my subject and painting it first, before considering the secondary or background area. I thought of adding a background to it now, but I'm afraid it would look "added" rather than appear to be an integral part of the painting.

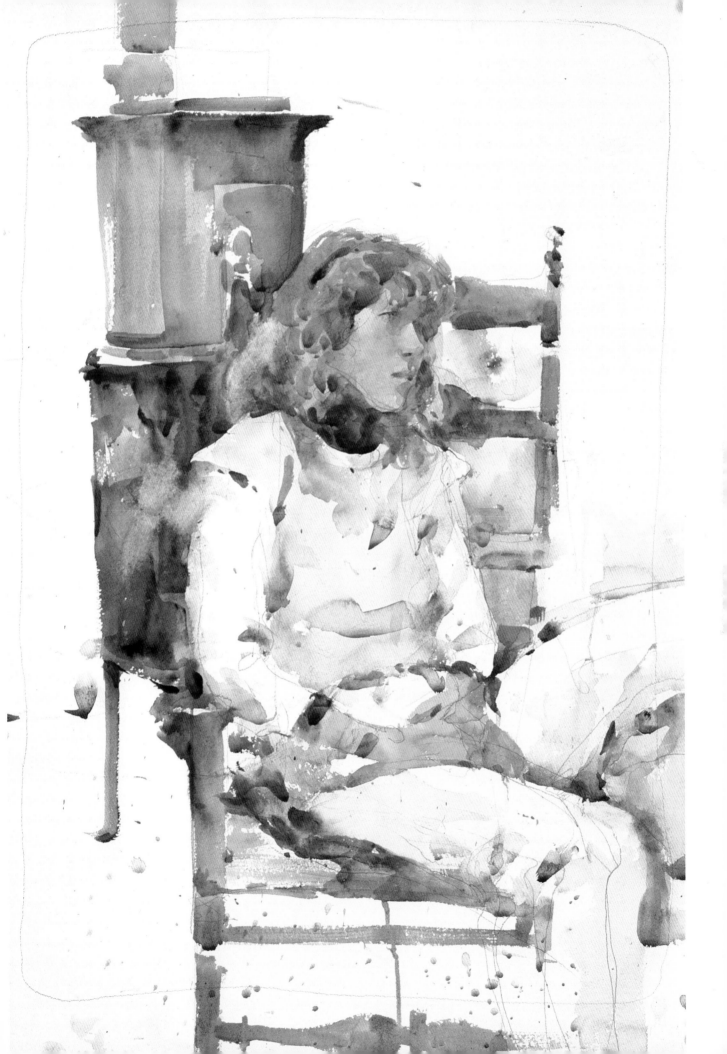

REVIEWING THE BASICS

ATLANTA AIRPORT

Follow the pen line. Can you see that almost all the forms are connected? Many students think in terms of individual features separate unto themselves, but notice how the pen travels here, connecting each feature to its neighbor.

BLUE NOSE TO BAR HARBOR

Look for directional changes in my pen line. Notice the amount of "bumps" in my line. Look for angles, curves, and straight lines within any area of the drawing. Can you see where my pen left an outside boundary to work inside the form, to find a fold in the clothing? Look closely. There is an important lesson here, a lesson on how to make your drawings expressive.

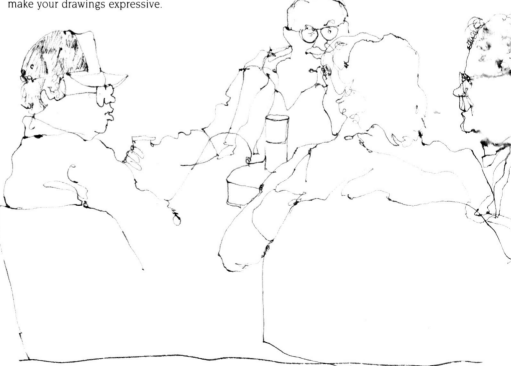

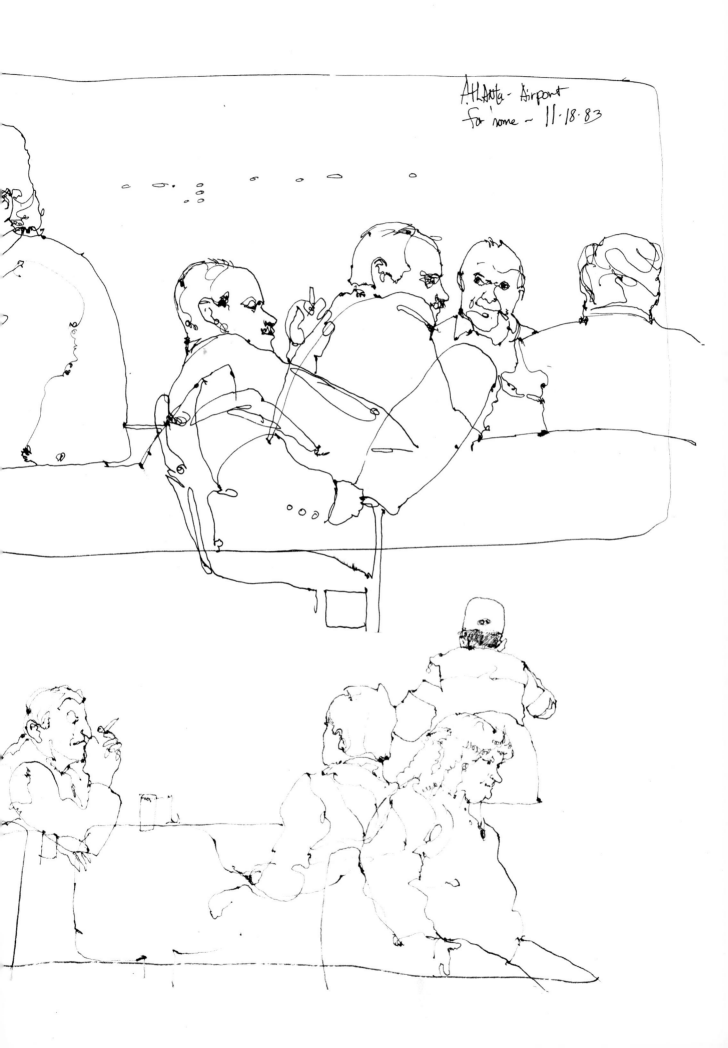

ATLANTA - Airport
for 'some - 11·18·83

Stroke Direction

BOB WATERMAN

Bob, a co-author of In Search of Excellence, is my friend. I enjoyed drawing Bob looking in one direction while his neighbor looked the opposite way. In fact she's looking outside the drawing and is bisected by the picture border. Notice the direction of the pen lines in the shaded sections. They don't all go in the same direction, rarely running parallel with the boundaries. Often they are perpendicular to the boundaries. Try to find a book of master drawings. Van Gogh, Rembrandt, and Matisse are good since they used pen and ink and you can see the directions of their strokes. Notice how in some cases they shade "with the form" (parallel with a boundary) and sometimes against it (at an angle with the boundary.) Just as these artists use opposing strokes in their drawings, they probably used them in their brushstrokes, too. This is an important lesson since many students make the mistake of always painting with the form. This is monotonous and boring. More than half your strokes should be against the form.

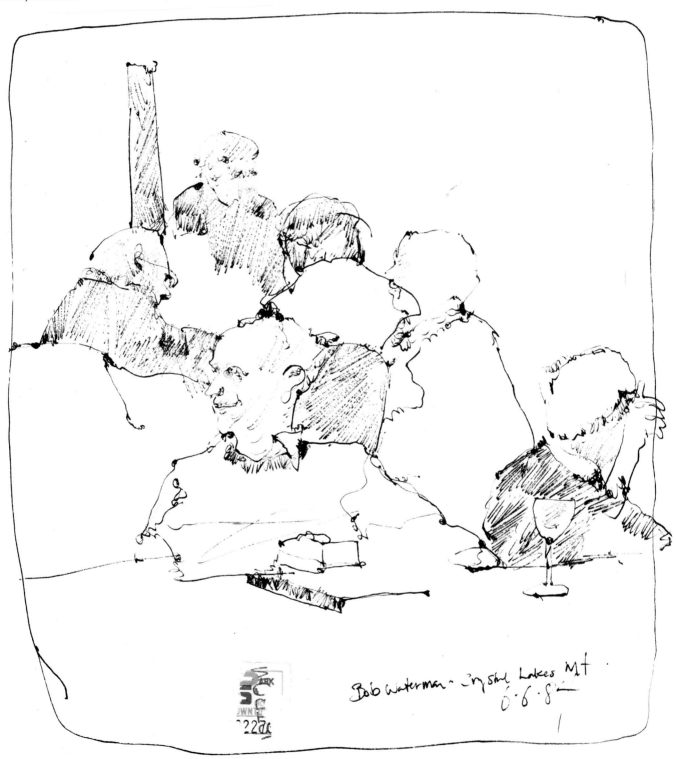

Bob Waterman ~ Crystal Lakes Mt
8·6·8

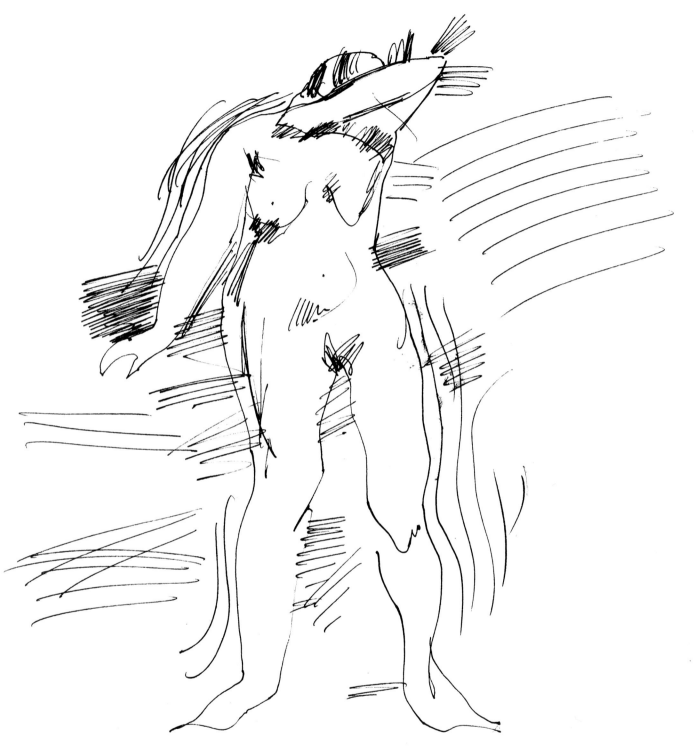

**AFTER MATISSE:
NUDE FIGURE STUDY**

This is a crude facsimile of a
Matisse drawing. You can see
how important the strokes
around the figure are. They set
up a storm of movement. Notice
which lines go with the form
and which oppose it. It's this
kind of conflict that makes for
an action-packed figure.

A sketchbook is a very personal thing, sort of a visual diary. For me, sketchbooks not only provide a practice ground where I try to draw better, but they are also a place where I can work out painting ideas. I don't think of myself as a line-oriented artist. Rather, I think in terms of masses and shapes, so that even when I'm using line I'm thinking of how I'd paint what I'm drawing. This is an important point. If you're working in pencil and trying to work out painting problems, you must be thinking of painting, not drawing. Too often I see students thinking in line and trying to solve pattern problems that their random, sketchy lines can't possibly define.

I've chosen some sketches from a friend's sketchbook with the idea of showing how one artist confronts her problems. It isn't easy to say that you must always paint your sketches, but I think there's a lot to be said for this approach.

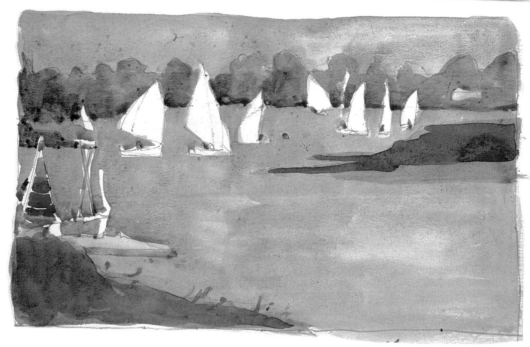

THREE PAINTINGS
by Adele Hustis

The two seascapes here deal with color mood and value. Adele's dealt with two specific types of days. And in her sketch of the basket of flowers, we see a subject placed smack in the middle of the page. Working this out with line couldn't have helped her because the solution is in the variation of the value on the table to the right of the pears as compared to the darker value on the left. (Cover up this light value and you'll see what I mean.) Notice also the "lost" upper table boundary on the left and the "found" table boundary on the right.

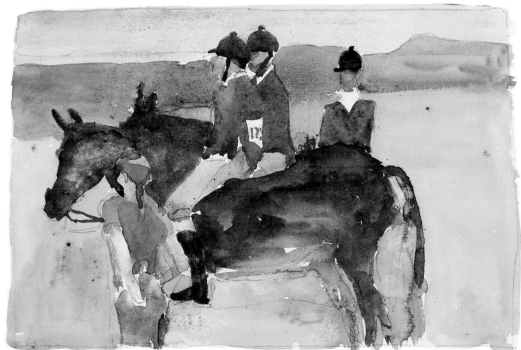

HUNT CLUB
by Adele Hustis

Hunt Club is treated almost completely as a local color value problem. She has developed her pattern. (Some students try to develop pattern or design with light and shade but this often results in fragmented and "spotty" design.) Adele has also dealt with specific and descriptive shapes. Finally she's solved her composition within definite picture borders. (Too often sketchbooks are involved with the subject alone and not with how the subject is going to relate to the picture space. But this is one of the most important considerations if you're planning a painting.)

PETER WATCHING THE TUBE

Where have I changed a local color because I wanted to paint "negatively"? Where did I lose boundaries? What role do shadows and cast shadows play in this composition?

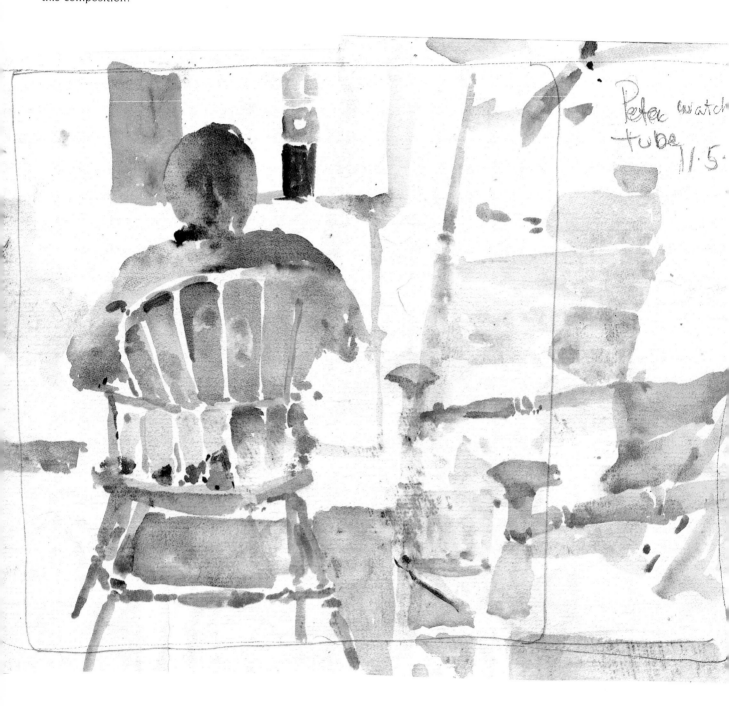

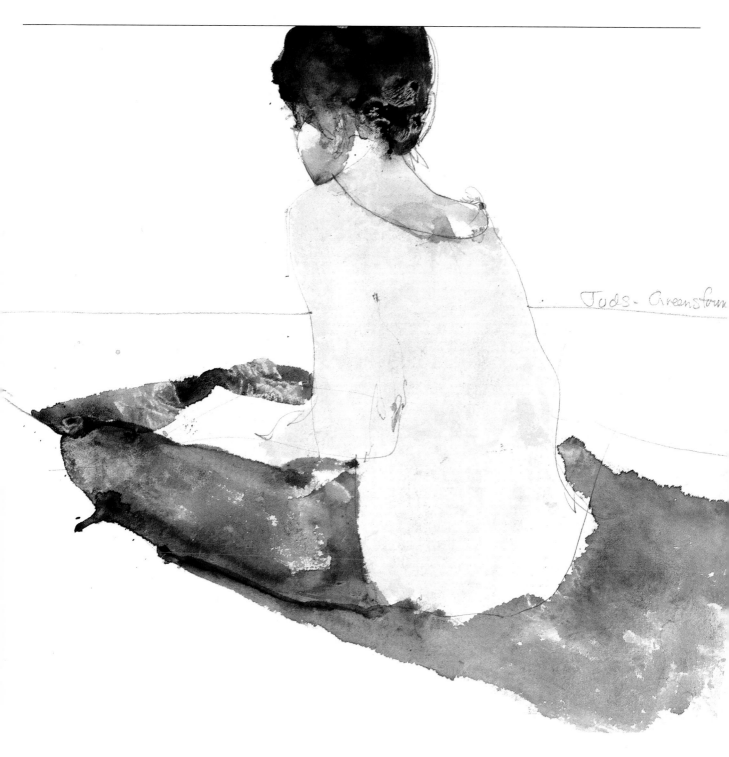

Juds- Greensform

JUDS, GREENS FARMS

There's no light and shade here,
except in the face. Look again.
How does local color value work
here? Is "shape" important?

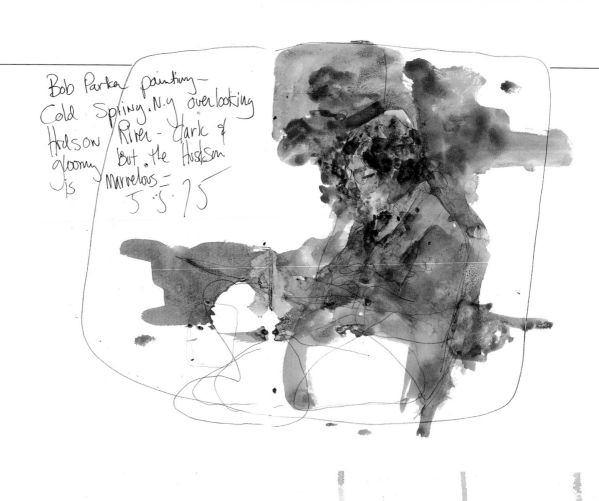

Bob Parker painting—
Cold Spring. N.y overlooking
Hudson River—dark &
gloomy but the Hudson
is marvelous—
5·5·75

Studio II~ after lunch
of Irish Stew Sperry & Bob—
With Guinness Extra Stout—
2·27·75

GUINNESS EXTRA STOUT
BREWED IN IRELAND BY
ArthGuinnessSon&Co
(DUBLIN) LTD
485 1212
BOTTLED BY
GUINNESS
ST JAMES'S GATE DUBLIN

NET CONTENTS 11·39 U.S. FLUID OZS.
IMPORTED BY
THE GUINNESS-HARP CORPORATION
NEW YORK N.Y

BOB PARKER

Robert Andrew Parker is an artist I've long admired. What details in Bob's face have been lost so that I could stress other features?

STUDIO 2 (AFTER LUNCH)

Here was a cluttered table with lot's of things happening—in fact, there was too much to paint. Then I squinted the "magic squint" that clears away details we shouldn't see and helps us see only the essentials. Notice the details I found "out in the light." But what has happened to the details in the shadow?

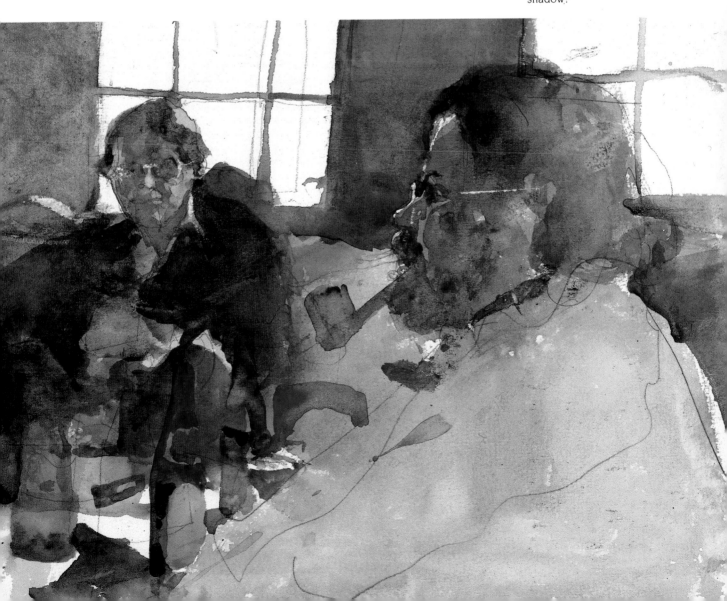

The question of finish bothers even experienced painters. We always wonder: Am I finished? Was I finished a while back but kept working and now have I gone over the edge and ruined it? I don't think there's any one answer to when a painting is finished, just as there's no really good answer to how to finish a painting. For me, I'm finished when I can't think of anything more to do. I usually get a wave of weariness with the picture and then I know it's time to stop. The best advice I can give is, if you can't think of any more major statements to make and you find yourself merely reworking areas you've already painted, then you're finished. You might not be happy with the picture, but you'll probably be a lot unhappier if you keep punishing it.

**VIEW OF THE ALFAMA
AND THE TAGUS, LISBON**
watercolor,
11" × 15" (27.9 × 38.1 cm).

I like to leave paintings, especially those done on the spot, with potential for more work. If after a second look, I should feel that more is needed, there should be places on it still left to be painted.

Let's look at *View from the Alfama*. There's quite a bit of white paper left untouched. Should I fill it in? Certainly that's open for judgment. Now let's look at other things in the picture. Did I catch a feeling of the rising sun, off to the right, silhouetting the buildings and ships? That's the major question. Have I achieved my "picture idea"—showing the way the Alfama and the river looks at 10:00 AM? If you think I did, the picture is finished. If you think I failed, no amount of small darks or details will save it.

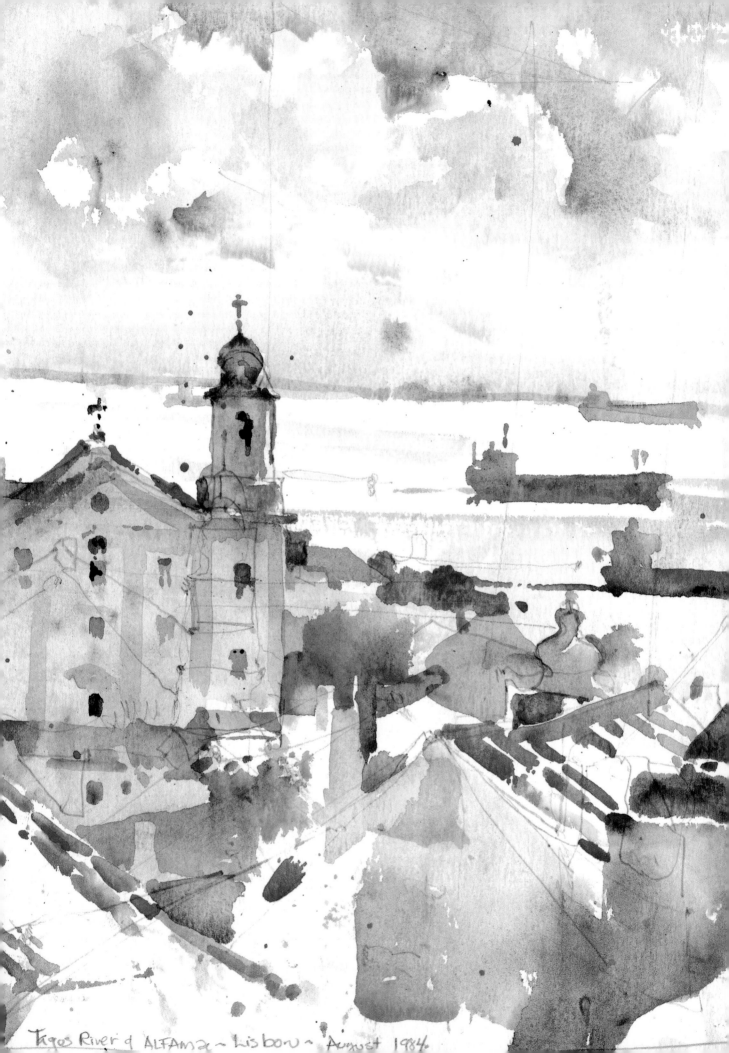

Tagus River & ALFAMA ~ Lisbon ~ August 1984.

Have you ever liked your sketch better than the finished picture? Mr. Reilly used to say, "Starts are more important than finishes." Like most axioms, this sounds better than it is. Many painters have a studio filled only with wonderful starts. Still I believe much more important painting is done in the beginning and middle stages of a picture than at the finish. "Finish" simply means finding focus and emphasis. "Finish" means complete ideas in one place and vague ideas in another. It's a kind of lost and found. One artist's idea of a finished painting is another's crude sketch. Whatever finish is, it must say all the artist can say—and gloriously. A painting is finished when we have no more ideas and we start going back to fix edges and clean up sloppy sections. So when you start restating finished things, perhaps you're finished.

GETTING READY and BULLWINKLE READS THE FUNNIES
by Kris Nugent

Both paintings were done by the same artist within the same period. The drawing in both is good, with nice, personal, exaggerated forms. Both compositions are well considered. Yet there's a difference. Study them. What makes them so different? Don't let yourself make generalizations like, "I like this one because it's fresher." Be sure to be specific about what areas and things you like and why. Make sure you understand what's been done in each picture to make you like or dislike it.

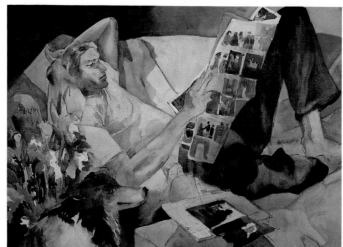

MORE ON FINDING A FINISH

My copy of The American Heritage Dictionary of the English Language described "finish" in terms of "polish and thoroughness," then goes on to say it can mean "to bring about the ruin of; to vanquish and destroy." Sattina, a character in John Updike's novel The Coup put it this way: "I can't bear to finish things, beyond a certain point they get heavy. There's something so dead about a finished painting." My sentiments exactly, so when my editor asked for an example of a finished painting I decided to send this along.

CONNIE OF EL PASO

"Wait a minute!" you might say. "That painting isn't finished. Look at all the white paper you've left. You didn't put in all of the stripes; and what about the right eye? What about the drips and smudges and the fuzzy arm?" I'd certainly go along with you. I wish I could carry things further and still have a painting that I'm not ashamed of. I had specific goals: to catch a particular person and a certain attitude and gesture. I wanted to "weave" the figure into the background and the background into the figure, and I wanted to paint two acceptable hands. Although somewhat imperfectly, I felt I accomplished these goals. When I think this way I stop. If you don't have specific goals, perhaps just one or two, you might find yourself in the role of a "space-filler." Space-fillers tend to keep filling in until there's nothing else to do and then they are very sad.

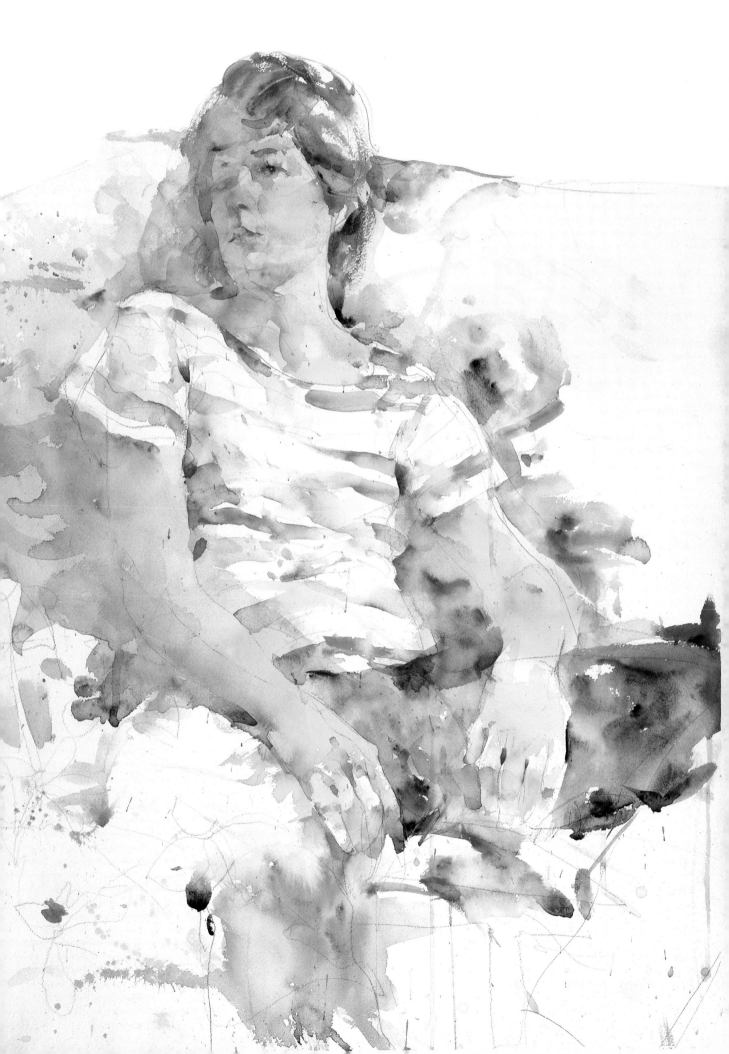

DEMONSTRATION SKETCH

This was a sketch I did for a class. I find that rather rough and crude demonstrations can often be more instructive than finished paintings, and so I've included this in the hope that you'll see beyond its lack of finish and focus instead on the ideas I'm trying to demonstrate.

Background. Most of us have trouble with backgrounds. They are often ill-considered, and it isn't until we've gotten into a painting and suddenly find we have a lot of empty space to fill that we start thinking about the background. One way to solve the problem of what to put in the background is to crowd the picture area with the subject, coming in close, letting it touch the picture's borders. Here I let the flowers run out of the top.

Lost-and-found edges. Most students paint an object, let it dry, then add the cast shadow. But this results in a hard edge between object and shadow in-stead of making them a single mass. To avoid this, you have to let every object have at least two sections of blurred edges (edges merged with adjacent areas). You also have to paint the shadow on the object and its cast shadow as one piece.

Controlling darks. Many students feel that a weak painting can be saved with heavy darks. Darks aren't bad—I've used some in this sketch. But you can't rely on them to save a painting. Use strong local color instead as the backbone of the picture. For example, notice the strong color of the fruit out in the light. If you use washed-out color here, you'll have to use heavier darks for substance. I prefer strong color.

Leaving whites. Leave some areas of white paper untouched in both the objects and in the background. You can always wash in a tone, but it's difficult to lift it out once it's there.

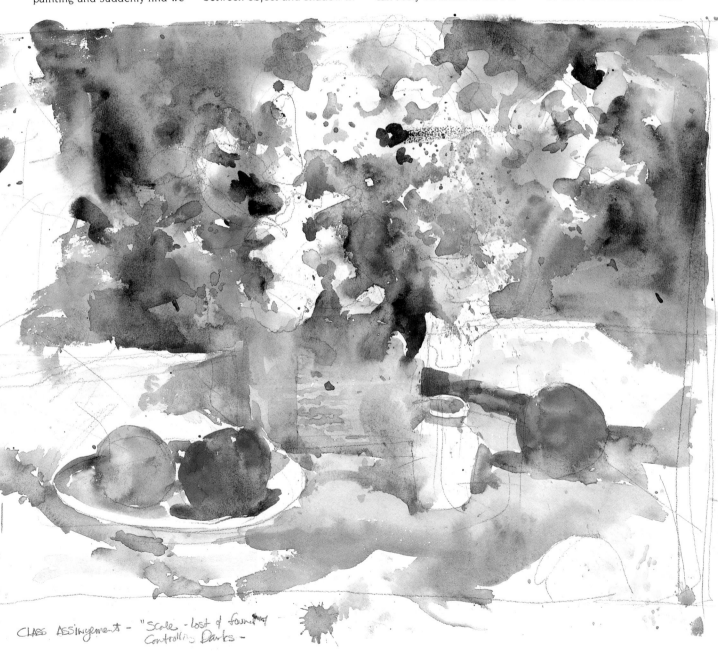

CLASS ASSIngement - "Scale - Lost & found
Controlling Darks -

DANCER FROM DALLAS
watercolor on Fabriano
Esportazione, 22″ × 30″
(5.5 × 76.2 cm).

This was done as a demonstration for a workshop class in Dallas. It was the last demonstration of the week, and I told the class I wouldn't be talking as I worked. Instead, I gave them a list of pointers and asked them to check them off as they saw me do them on the painting. See how many you can find here.

PAINTING CHECKLIST

1. Fifty percent or more of a painting should be negative shapes.

2. At least two negative shapes should describe parts within the figure itself.

3. The background (negative) and figure (positive) should connect to at least three of the picture's borders.

4. The boundaries on the figure should be lost into the background in at least three places.

5. All shadows should describe the form on which they rest. No shadows or halftones should be used unless they describe something. They can't be added just because they're there.

Now turn at random to paintings and drawings in this book and look again. Where have I followed these pointers there?

ASSIGNMENT

Make a painting that fulfills the following requirements:

1. Let your subject butt up against the picture border in one or more places.

2. Let every object have at least two lost or blurred edges.

3. Paint the shadow and cast shadow as one piece.

4. Use strong local color instead of light and dark contrasts.

5. Remember to leave some areas white.

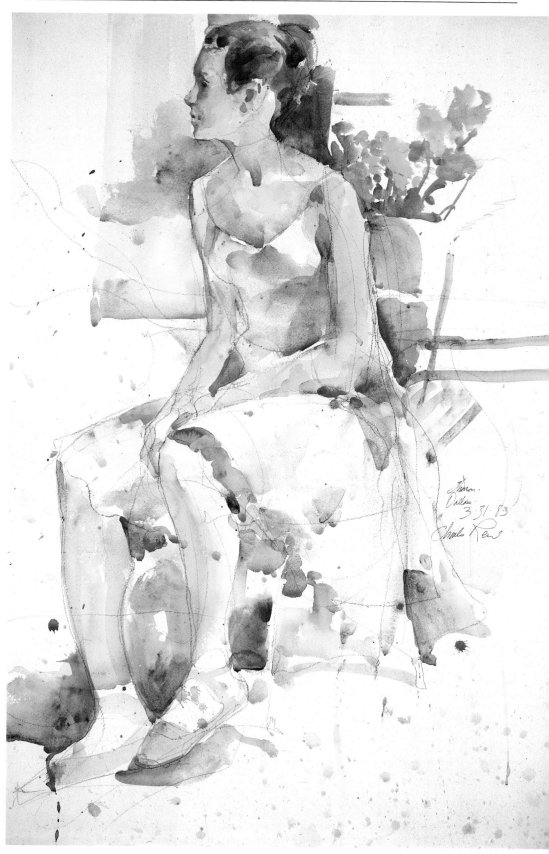

Index